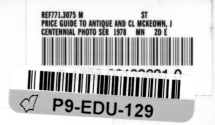
PRICE GUIDE TO ANTIQUE
AND CLASSIC STILL CAMERAS
Second Edition

edited by James M. McKeown
and Joan C. McKeown

Second Edition on press. Published April 16, 1978.

Library of Congress Catalog Card Number: 78-55498

ISBN 0—931838—00—2

This book is dedicated
to the fact
that the price of
an antique camera
is entirely dependent
upon the moods
of the buyer and seller
at the time of
the transaction.

CONTENTS

ACKNOWLEDGEMENTS

This second edition is profusely illustrated, which should be of great help to experienced and novice collectors. With the exception of the few early line drawings, all illustrations are used with the generous permission of four major dealers in photographica, and the photographs have been reproduced from their catalogs.

Two of these dealers, operating in the United States, are John Craig and Allen Weiner. Both have been prominent and reputable dealers for years, and their catalogs have provided historical notes and reasonable prices on average to rare items in addition to the illustrations.

John Craig is currently producing a series of catalogs, each of which is about forty pages. Approximately eight issues can be expected per year. He continues to reprint early photographic catalogs as well. For further details, contact: John S. Craig, Photographic Historian, P.O. Box 656, Norwalk, Connecticut 06058.

Allen and Hilary Weiner produce catalogs of "Fine Antique Cameras and Photographic Images", each of which is approximately twenty pages. These catalogs are issued quarterly, in March, June, September, and December. The Weiners sell and also buy through their catalog. Write: Allen & Hilary Weiner, 80 Central Park West, New York City 10023.

We also greatly appreciate the use of pictures from the catalogs and lists of Vintage Cameras, Ltd., 256 Kirkdale, London, England SE26 4NL. In addition to maintaining a shop and showroom, they publish monthly lists with photographs which they circulate in Europe, and an annual color catalog with world wide circulation. (If you plan to visit their store, telephone first for directions, as it is not centrally located.)

Another of our sources for photos, as well as price data reflecting the European market, was the photographica auction catalogs of the Augsburger Kunst-Auktionshaus, Petzold, 89 Augsburg, Maximilianstrasse 53, Germany. Their catalogs appear at least three times a year, in April, September, and December. The text is in German and bidding is in Marks, but there is a large array of good quality photographica. Cost of catalogs is about $10.00 each including postage to the U.S.A.) At Centennial Photo Service, our multi-lingual staff has been translating and cataloguing these auction sales for several years and has made up a quick-reference German-to-English translation guide for some of the common technical and descriptive terms used in these catalogs. It is available for $1.00 plus a stamped, self-addressed envelope from: Centennial Photo, Translation Guide, P.O. Box 36, Grantsburg, Wisc. 54840. Similar guides could also be made available to or from other languages.

Thanks are also due to Mead Kibbey, The Black Diamond Company, 7701 17th Avenue, Sacramento, California 95820. A knowledgeable collector and dealer in Zeiss-Ikon cameras, Mr. Kibbey was able to help fill in gaps in our chart of Zeiss catalog numbers. We feel that this will help readers to identify Zeiss-Ikon cameras, and thus benefit more from our research.

Thanks are also due to Marvin Kreisman of Missouri and Wisconsin for reviewing the manuscript and final proofs prior to publication. He was able to spot errors which would be apparant only to a collector who knows intimately the majority of the cameras listed herein, not only from a technical viewpoint, but also viewed for historical significance. These valuable insights served to substantiate those price statistics which, lacking this background, could seem to be out of line with the norm.

Appreciation is due to the American Photography Museum for the opportunity to view and closely inspect many of the rare cameras which would have been difficult to compare or even accurately describe. The scope and caliber of this collection is beyond imagination, and any serious historian or collector should treat himself to a tour. The museum is located in Baraboo, Wisconsin.

Perhaps last on the list, but certainly first in my heart — my tireless wife, Joanie, who spent countless hours writing, testing, and operating computer programs, cross-checking, double-checking, researching original source materials, and keeping my nose to the grindstone as well. Without her help, this edition would not exist.

<div align="right">J. M. M.</div>

INTRODUCTION

The first edition of Price Guide to Antique and Classic Still Cameras was published in April, 1974. It was the pioneer price guide in the field of antique cameras, and it has been used by thousands of photographica collectors around the world. It was a compilation of average prices for over a thousand commonly traded cameras in the U.S. market, based on detailed research. Without that sort of research, a reliable price guide in this field would not have been possible. It provided the first and only published reference for a large number of camera prices. Until the appearance of this edition, there has been no other guide which has come close to matching that first little brown booklet. When it appeared, it was the most expensive book per pound in the collecting field. It was nicknamed "the collectors' bible", and if we can believe the hundreds of letters from users, it was and still is the most often-used book in the collecting field, regardless of its size.

Now, after four more years of research, we believe we have a significantly better price guide. It lists over 2,000 cameras, (more than twice as many as the first edition, and more than five times as many as any other price guide in the field.) It has over 500 illustrations. It is based on over 50,000 verifiable sales, trades, offers, and auction bids. It lists cameras from over 500 manufacturers. It contains thousands of little bits and pieces of photographic history and trivia, many of which are not to be found in other reference works. It is a reference work — a research report. The prices in this guide are not inflated or affected by personal opinions. They do not tell you what I think a camera is worth, but they tell you what the former owner and the present owner thought it was worth at a crucial moment in the life of that camera. That brings us to the dedication of this book. If you haven't read it, you should. It may well be the most important information in this book.

We believe that we have made significant improvements, and we are proud to offer this new edition. The major drawback is that it will no longer fit in your pocket, but if enough users write to us and request a pocket edition, it may become feasible to produce one.

We would appreciate your comments, both praise and criticism, and suggestions for improvement. We would like to make the third edition better still.

Note: Additions or corrections to this edition
In the event that it becomes necessary to mail out additions, corrections, or supplements to this edition, we can only do so if we have your correct name and mailing address on record. If you purchased this book directly from Centennial Photo Service, we will maintain your name and address on tape. If you bought this book in a bookstore or from a club or dealer, please send us your name and address on a post card, stating that you bought the book from a dealer. If you change address, send a card stating "address change" and listing your old and new address. Thank you.

Instructions for use of this guide:
All cameras are listed by manufacturer, and manufacturers are in alphabetical order. (A few are listed by model name if we were not sure of the manufacturer.) Cameras of each manufacturer are listed alphabetically, in general. Occasionally we grouped cameras into families, occasionally by size if size had more influence on value than model variations.

Abbreviations used in this book are listed inside the front cover.

Photos appear immediately above the listing which describes them.

Interpretation of price figures:
All price figures are in United States Dollars. Prices listed apply to cameras in Very Good to Excellent condition. More cameras are found in this condition than any other, so it is the most practical price to use as a standard. To determine the value of a particular camera, the user of this guide should consider any variation from this condition when assessing it and vary his value estimate accordingly.

Generally speaking, condition will affect prices as follows. However, these are only approximations. Condition affects price differently on various types and ages of cameras. Suggested allowances below are given as percentages of the listed price.

New, Like New - Perfect condition. Just like the day it left the factory. 125-150%.
Mint - Showing no signs of wear, or very minimal ones. 110-140%.
Excellent - Showing some signs of normal use, but no other faults. 100-125%.
Very Good - Complete and working with only minor refinishing needed. 90-110%.
Good - Restorable, no major parts broken or missing, some refinishing necessary. 80-100%.
Fair - restorable, but in need of replacement parts and major refinishing. 30-70%.
Poor - For parts only. $10-30%.

Collectors tend to be more lenient in applying these or any set of standards to older and more rare cameras, and more strict in applying them to newer or common models.

Prices in the United States and Europe:
Prices generally are higher in Europe than in the U.S.A. Common European models (e.g. folding-bed style plate cameras) are lower in Europe, just as our numerous folding rollfilm cameras are lower here. Medium range cameras ($25-100) are often about the same. Higher-priced cameras (with the notable exception of the Leicas) tend to be higher in Europe.

The prices listed in this edition, unless otherwise noted, are the figures which best represent the U.S.A. average, (and quite often the European average as well). Where a significant difference appeared, we listed two prices. We did not always have a good average from both markets, so the reader must use his own judgement in interpreting the data provided. A few models list only European prices, because we had none on record for the U.S.A.

General comments on price trends:

These comments and the notes you take at the end of the book should allow you to remain abreast of current trends within the field of camera collecting.

The lower priced items in this guide and on the market tend to be slightly overpriced, simply because the cost and bother of advertising, selling, and shipping a $5.00 item is not much different from the same costs and efforts to sell an item valued for hundreds or thousands of dollars.
The middle priced items show the most accurate averages. They are the most commonly traded; they are in large supply; and thus the market is very stable.
The higher priced cameras of any particular style, brand, or age of camera tend to be the most volatile, and also invite more speculation from dealers and traders.

The most rapid increases have been in the more rare and unusual styles, models, and variations. This is very understandable in a field with a growing number of collectors. Cameras which are old, rare, or unusual tend to be more desirable to a larger number of collectors, and thus increase in value. Cameras with all three of these qualities bring the top prices.

Leica cameras and products are hot items and likely to remain that way. They are a dignified, refined, orderly family of collectibles, and have always imparted a pride of ownership — even before the collecting craze. The more rare models bring better prices in the U.S.A. than abroad, which indicates a speculative market, but the growing number of Leicaphiles will probably support this trend.

Subminiatures are strong. Generally they show interesting designs, and like the Lord's Prayer written on the head of a pin, many are crammed with a variety of technical features. They are also easy to store and/or display because of size.

Detective and disguised cameras will always have good appeal. Although most are of simple design, the disguised shape always was the selling point.

Tropical model cameras have been strong but somewhat erratic. Limited numbers and speculation have caused a wide variety of prices which are reflected here. They should stabilize during the life of this guide as most other cameras did during the life of the first edition.

Special purpose cameras do not yet have a big following, but there are indications that the market will start taking shape on these within the next few years. We're watching!

Stereo cameras and related items are experiencing a better than average rise in price toward the end of the four-year period upon which these statistics are based. Since this is a relatively recent trend, it is not reflected strongly in the statistics included in this edition. We predict that this trend and speculation will cause significant increases in the prices of stereo cameras during the next few years. These prices have been very stable for seven years, and the current fluctuation may indicate either an increased interest in stereo, or an increased amount of speculation in that field.

ACMA (Australia)
Sportshot - 620/120 film. $25

ACRO SCIENTIFIC PRODUCTS CO.
Acro 127 - $47

ADAMS & CO. (London)

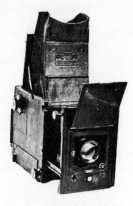

Minex - Single lens reflex ca. 1895 for 3¼x 4¼ exposures. Similar to the Graflex. $160.

Yale No. 2 - ca. 1895 detective magazine camera for 12 plates 8x11cm. Lens: f6.5. Adams Patent Shutter to 1/100. Focus by internal bellows. $180.

ADAMS & WESTLAKE CO. (Chicago)

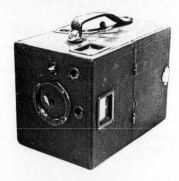

Adlake Cameras - Manual plate changing box cameras for 12 plates in 3¼x4¼ and 4x5 inch sizes. ca. 1897. $44.

ADINA - 6x9cm. camera. f6.3/105 Rodenstock Trinar lens in Adina shutter to 1/100 sec. $19

ADORO - see Contessa, Zeiss

ADOX KAMERAWERK (Wiesbaden)
Adox - 35mm camera ca. 1936 $20

Adrette - 35mm camera with telescoping front. Identical to Wirgin Edinex. Steinheil Cassar f3.5/50mm or Schneider Radionar f2.9/50mm in Prontor or Compur shutter. $21 USA, $44 EUR.

Blitz - Bakelite box camera for 6x6cm. exp. on 120 film. f6.3/75mm. $5.

Golf - 6x6cm. folding camera. Adoxar f6.3 lens. $15.

Sport - Rollfilm camera for two formats, 4.5x6 or 6x9cm. on 120 film. Folding bed type. Steinheil Cassar f6.3 or Radionar f4.5. Vario shutter. Quite common. $14.

AFIOM (Italy)
Wega IIa - 24x36mm. Trixar f3.5/50mm. Focal plane shutter to 1000. Coupled RF. Sync. $184.

AGFA KAMERAWERKE (Munich)
Originally "Aktien Gesellschaft für Anilin-Fabrikation" established in 1897. Agfa is an abbreviation from the original name. Eventually, it became part of the Agfa-Ansco and then GAF companies.

Ambi-Silette - 35mm. 2.8/50 in Compur. f4/35mm and f4/90mm lenses also avail. Complete outfit $140. With normal lens only $55

Antar - Box camera for 116 film. $5

Billy (Record, Clack, etc.) - folding rollfilm ca. 1938 for 6x9 cm on 120 film. Apotar f 4.5/105 or Solinar 4.5/105, or Agnar 6.3/105 or Igestar 6.3/105. $10

Box cameras- misc. sizes, styles $6

Cadet - All metal box camera. $5

Captain - Box camera. $6

Clack, Click - Box cameras $6

Clipper - Metal bodied collapsible camera with a rigid rectangular section which pulls out to the shooting position. For 16 exposures on 616 (PD-16) film. Single-speed shutter and meniscus lens. $4.

Clipper Special - Like Clipper, but with f6.3 Anastigmat lens, and shutter 25-100, Time & Bulb. Optical finder. $8

Folding Rollfilm cameras— Common models for 116 and 120 films. $7

Iso, Isoflash, Isomat - $14

Isolar - 9x12 cm folding plate camera, Solinear f4.5/135mm. Dial Compur —200. DEB. Metal body. GGB. $54

Isolette - folding rollfilm cameras similar in style to the Zeiss Ikonta and Nettar cameras. For 16 exp 4.5x6cm or for 12 exp. 6x6cm on 120 film. Models I-V, normally with f4.5/85 Apotar or Agnar lens in Pronto, Vario, or Compur shutter. $17.

Isolette Super - Folding 6x6cm on 120 film. f3.5/75 Solinar. CRF. Sh. to 500. MX sync., self-timer. $71

Karat - (models 12 and 36) ca. 1937-1940 Folding 35mm with self-erecting front. For 24x36mm on Agfa Rapid Cassettes Many varied shutter/lens combinations from f6.3 to f2. $27

Karomat - f2.8 Schneider Xenar or f2 Xenon lens. $39

Major - folding bed camera for 6x9 cm exposures on 120 film. $10

Memo - ca. 1939. Folding 24x36mm format on 35mm film. (18x36mm "half-frame" added as additional model in 1940) Agfa Rapid cassettes. Rapid advance lever on back. f3.5, 4.5, or 5.6 Agfa Memar lens. $43

Nitor - 6.5x9 plates or 6x9 rollfilm choice. Helostar f4.5/105. Compur to 250. $22

Optima - 24x36mm - 35mm Rangefinder. f2.8/45 Color Apotar. Compur. $34

PD-16 - *PD-16 was Agfa's number for the same size film as Kodak 116 film. Several of the Agfa cameras use this number in their name, however we have listed them by their key word. (Clipper, Plenax,etc.)*

Plate Cameras - 6x9cm with f 4.5/105 and 9x12cm size with f4.5/135 Double-Anastigmat or Solinar lenses. Compur dial-set shutter. $39

Plenax - ca. 1940 folding rollfilm cameras, models PD-16 & PB-20. f6.3 Hypar. $10.

Readyset - folding rollfilm. Models 1, 1A, PB-20, Special, Royal, Eagle, Traveler, etc. $11.

Schul-Prämie Box - Originally given out as a school premium in Germany, which accounts for the inscribed title. A blue metal and plastic box for 6x9cm rollfilm. (None on file in USA) $24 EUR.

Selecta - M - ca. 1965 fully automatic motor camera for 24x36mm. Shutter speed regulated by BIM. Solinar f2.8/45. Compur 30-500 +B. $120

Shurflash, Shurshot - Box cameras $5

Silette, Super Silette - ca. 1950's 24x36mm f3.5/45mm Apotar. $26

Solinette, Super Solinette —(w/CRF), **Solinette II** - pre-war folding 35mm cameras. f3.5/50 Apotar. Prontor. $16

Speedex - ca. 1935 folding 4.5x6cm styled like the Jiffy Kodak Cameras. $20
- ca. 1940, styled like the Agfa Isolette for 6x6cm. f4.5 lens. $20.

Standard - ca. 1930's folding camera for 616 rollfilm. f6.3/130mm or 135mm. lens. $15
-- -- for 6.5x9 sheet film. f4.5/105mm $28
-- --9x12 sheet film. f4.5 Anastigm. $41

Synchro - metal box for 6x9cm on 120 rollfilm. $6

Ventura - Ventura Deluxe - folding 120 film camera. f4.5 Apotar. Prontor. $12

View Cameras - 3¼x4¼ & 4x5 inch sizes. Wood constr, brass trim. No lens. $30

Viking - folding cameras for 120, 620, and 116 rollfilms. f6.3 or 7.7 lenses. $9

AIRES CAMERA CO. (Japan)
Aires IIIc - Leica-styled 35mm camera. f1.9/50mm. Coral lens. $47.

Aires 35 III L - Coral f1.9/50mm. RF. $39.

Aires 35 V - ca. 1957. 35mm. camera with rangefinder & meter. f1.5/45mm coated lens. $50.

Airesflex - 6x6cm. TLR. f3.5/75 Coral. $75.

Aires Reflex 35 - 35mm. SLR. f2.8/50. $40.

Aires Viscount - 35mm. RF camera. Coral f1.9 or f2.8/45mm. lens. $35.

AKA - an abbreviation for Apparate & Kamerabau. See listing under full name for Akarelle, Akarette, Akarex.

ALETHOSCOPE - see Joux.

ALLIED - Carlton Reflex - cheap 6x6. $6.

ALPA - see Pignons.

ALPENFLEX - 6x6cm. TLR ca. 1953. $25.

ALPIN - see Voigtlander.

ALTA - see Reichenbach, Morey, & Will Co.

ALTESSA - see Boyer.

ALTIFLEX - see Altissa, below and also Hofert.

ALTISCOP - see Hofert.

ALTISSA KAMERAWERK - B. Altmann, (Dresden) - Also associated with E. Hofert of Dresden. see also Hofert.
Altiflex - ca. 1930's 6x6cm. TLR. Ludwig Victor f4.5/75mm, Rodenstock Trinar f4.5/75mm, Trinar f3.5/75mm, Laack Pololyt f2.4/80mm, - $30.

Altissa - 6x6cm. rollfilm box camera. Rodenstock Periscop f8 lens. $16.

Altix - ca. 1950's 35mm camera. Some models have focal plane shutter and interchangeable lenses such as Laack Tegonar f3.5/35mm. or Meyer Trioplan f2.9/50mm. $10.

ALTURA - see Contessa

AL-VISTA - see Multiscope & Film Co.

AMBI-SILETTE, AMBION - see Agfa.

AMEREX - Japanese 16mm subminiature styled like a 35mm camera. Made in post-war occupied Japan. $16.

AMERICAN ADVERTISING & RESEARCH CORPORATION (Chicago)
Cub - ca. l940's box camera for 3x4 cm. exp. on 828 film. All plastic construction. Simple lens and shutter. Toothpaste premium. $10.

AMERICAN CAMERA MFG. CO., INC. (Northboro, Mass. USA). *This company was founded by Mr. Blair, formerly of Blair Camera Co., in1895 and subsequently sold to the Eastman Kodak Co. in 1899 and moved to Rochester, N.Y. It is not to be confused with the American Optical Company listed below. Having been in business such a short time, its well-made cameras are not as common as many other brands.*
Buckeye Cameras:
No. 2 Buckeye - ca. 1899 rollfilm box camera for 4x5 exp. Similar to the Blair box cameras such as the Weno Hawkeye. $33.

No. 3 Buckeye - folding rollfilm camera ca. 1895. Maroon leather bellows. f8 lens. $27.

No. 1 Tourist Buckeye - ca. 1895. Folding rollfilm camera for 3¼x4¼. Maroon bellows, wooden lens standard. $75.

4x5 folding plate camera - No. 4 Sylvar f6.8/7" lens. Wollensak Auto shutter. Red leather bellows. $125.

AMERICAN MINUTE PHOTO CO. (Chicago)
American Sleeve Machine - A street camera for tintypes. Similar to cameras by the Chicago Ferrotype Co. $125.

AMERICAN OPTICAL CO. (New York)
Acquired by Scovill ca. 1867. See also Scovill.
Henry Clay Camera - 5x7inch folding plate camera ca. 1895. A well-made camera with many desirable features. $250.

Plate camera - 5x8 size - horizontal format. Complete with lens, back etc. $140.

View camera 11x14 inch - with lens $200.

AMERICAN SAFETY RAZOR CORP. (N.Y.)
ASR Foto-Disc - ca. 1950.. A modern try to recreate the success of the Stirn Vest camera.. Takes 8 exposures 22x24 mm. on a disc of film. $385.

ANGO - see Goerz.

ANIMATIC - see Bencini.

ANSCHUTZ - see Goerz.

ANSCO (Binghamton, N.Y. USA)
Formed by the merger of Anthony and Scovill & Adams in 1902, the name was shortened to Ansco in 1907. Merger with Agfa in 1928 formed Agfa-Ansco. See also Agfa, Anthony, Scovill.

Anscoflex, Anscoflex II - Cheap all-metal 6x6 cm. TLR for rollfilm, ca. 1950's. Built-in close-up lens & yellow filter. w/flash. $8.

Anscoset - 35mm. RF, BIM, f2.8/45mm Rokkor lens. $32.

Automatic - ca. 1925 folding rollfilm camera for 6 exp 2½x4¼ in six seconds. Spring-wound automatic film advance. f6.3 Anastigmat lens. Orig. price about $75. -- – $158.

Automatic Reflex - ca. 1947-1949 120 rollfilm TLR for 6x6cm. exp. f3.5 Anastigmat 83mm lens. $8l. (about ½ orig. price).

Buster Brown Cameras:
 No. 1 Folding Buster Brown Mod. B $18
 No. 2 Buster Brown -Box camera for 2¼x 3¼ exp. on 4A film. $6
 No. 2A Buster Brown - Box for 2½x4¼ on 118 size film. $9
 No. 2C Buster Brown - Box for 2-7/8x4-7/8 exposures. $11.
 No. 3 Buster Brown - Box for 3¼x4¼. $13.
 No. 1 Folding Buster Brown - Mod. B. $18.
 No. 2A Folding Buster Brown - $15.
 No. 3 Folding Buster Brown - $10.

No. 3A Folding Buster Brown - the postcard size. Deltax or Actus shutter. $15.
Buster Brown Junior - folding 116 roll. $14.

Cadet - There are at least two common models. The Model B-2 box camera, and the more recent 127 film model with flash. In either case, they currently average just $4.

Clipper, Flash Clipper, Clipper Special - $7.

Commander - folding. f6.3 Agnar. $18.

Craftsman - a construction kit to build your own 2¼x3¼ box camera. ca. 1940's. Original unused kit with assembly instructions - $23.

"Dollar" box camera - simple 4x3½x2½ box camera ca. 1910. $16.

Goodwin Cameras - *Named in honor of the Rev. Hannibal Goodwin. Dr. Goodwin, it seems, invented rollfilm, or something similar, just a small step ahead of George Eastman. Goodwin's patent was applied for in 1887, but "owing to interference procedings in the United States Patent Office," it was not issued until 1898.*

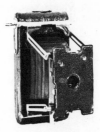

No. 1 Goodwin Jr. - Ca. mid-1920's folding camera. Front pulls straight out. $20.
No. 2 & 3 Goodwin box cameras - $6.

Karomat - ca. 1950's 35mm camera. $40.

Lancer - $6.

Memo - ca. 1927. For ½-frame exposures, 18x23mm. 50 shots on 35mm film in special cassettes. f6.3/40mm Wollensak Cine-Velostigmat or Ilex Cinemat lens. A rigid-bodied upright box style with tubular optical finder on top. Lever film advance, automatic exp.

counter. Some models focus, others are non-focusing types. NOTE: This is not to be confused with the 1960's motor-driven ½-frame imported from Japan. It is, however, the forerunner of the Agfa Memo of ca. 1937. $48.
"Official Boy Scout Memo Camera" - The wooden body is painted olive-drab color, and bears official insignia. Much less common than the standard model. $105.

Panda - 120 & 620 rollfilm box cameras. A cute name for a camera, but still worth $5.

Photo Vanity - ca. 1930's camera outfit designed as a lady's purse. Grey colored. Our records show only one offered for sale since 1970... in May, 1977 for $600.

Pioneer - a cheap plastic box camera. $4.

Plenax, PD-16 - folding rollfilm cameras ca. l940. (Agfa-Ansco). $10.

Readyflash - another cheapie. Complete with case, flash, and Instructions - still just $6.

Readyset - (No. 1, 1A, Viking Readyset, Readyset Royal, etc.) - folding models. $18.

Rediflex - ca. 1950 $5.

Regent - 35mm non-RF camera. f3.5/50mm Apotar. $25.
- Super Regent - The same, but with RF. and Solinar f3.5/50mm. $35.

No. 3A Speedex - $28.
Speedex, Speedex Special - ca. 1940 horizontal style folding camera for 12 exp. 6x6 cm. on 120 film. f4.5/85mm Agfa Apotar. Vario or Prontor shutter. $16.

Vest Pocket Ansco:
No. 0 - ca. WWI for 1-5/8x2½ inch exp. f6.3 Ansco Anastigmat or f7.5 Modico Anastigmat. Front pulls straight out. $17.
No. 1 - for 6x9cm. Straight pull-out front. Actus shutter. Patents to 1912. f8 lens or (rarely) f4.5/3.5 inch Goerz. $16

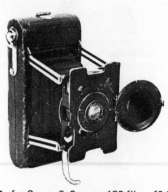

No. 2 - for 8 exp. 6x9cm on 120 film. f6.3 Ansco Anast. or f7.5 Modico Anast. lens. Bionic or Gammax shutter. Straight pull-out front and hinged lens cover. $20.

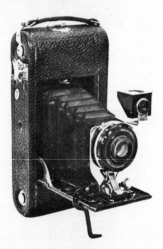

Semi-Automatic Ansco - folding rollfilm camera ca. 1924 for 6 exp. 2½x4¼. Lever on left rear of drop bed actuates spring-wound advance system. $146.

Shur-flash, Shur-shot - box cameras - $4.

Speedex - No. 1A - ca. 1916 rollfilm camera for 116 film. 2½x4¼. f6.3 Anastigmat. Ilex Universal shutter. $18.

Vest Pocket Model A - Designed with folding bed, unlike the other vest pocket models above. B&L Zeiss Tessar lens. Ansco sh. $21.
Vest Pocket Junior - 8 exp 6x9cm on 120 rollfilm. $13.

Viking - ca. 1950's folding 6x9cm 120 film camera mfd. by Agfa in Germany. f7.7 Major Anastigmat, or f4.5/105 Agnar or Somar. $12.

Box cameras - misc. models (black) $5; Misc. colors other than black $9.

Folding cameras : (misc.)

No. 1 Ansco Deluxe - RR lens, Ilex sh. $25.

No. 1 Special Folding Ansco - introduced ca. 1924. The cheap version of the No. 1 Ansco Speedex. f7.5 Anast. Ilex sh. $14.

No. 1 Folding Ansco. - f7.5 Anast. Ilex sh.$14.

No. 1A Ansco Jr. - $14.

No. 1A Folding Ansco - for 116 film. f7.5 Ansco Anast. lens. Ilex Universal sh. $14.

No. 2C Ansco Junior - $12.

No. 3 Folding Ansco - 118 film. $15.

No. 3 Ansco Junior - 118 film. $18.

No. 3A Folding Ansco - common post-card size. Lenses: Wollensak, RR, Ansco Anast. Shutters: Ilex, Deltax, Bionic, Speedex. $17.

No. 4 Folding Ansco - ca. 1905. Models C&D. 3¼x4¼ on 118 film. Horizontal format. Mahogany drop bed. Wollensak lens, Cyko Auto shutter. Nickel trim. $23.

No. 5 Folding Pocket Ansco - ca. 1905. Wollensak lens. Cyko Automatic sh. black bellows. $24.

No. 6 Folding Ansco - ca. 1907. Models C& D. 3¼x4¼. Wollensak f4 lens. Red leather bellows. For roll or cut film. $28.

No. 7 Folding Ansco - (Anthony & Scovill Co.). Postcard-sized rollfilm camera. Last patent date 1894. Red bellows, brass-barrel Wollensak lens. $25.

No. 9 Ansco, Model B - Horizontal style folding rollfilm for 3¼x5½. Cherry wood body, leather covered. Red bellows. Cyko shutter in brass housing. (Later models had black bellows & nickeled shutter.) - $24.

No. 10 Ansco - pat. Jan. 1907. Folding rollfilm for 3½x5 on 122 film. (Model A has removeable ground glass back. Ansco Automatic shutter.) $34.

Ansco View Camera - 11x14 inch size. Doub. Extension bellows, sliding back, convertible lens. $200.

ANTAR - see Agfa.

ANTHONY - *The oldest American manufacturer of cameras and photographic supplies. Begun by Edward Anthony in 1842 as E. Anthony. Edward's brother Henry joined him in 1852, and in 1862 the firm's name was changed to E. and H,T. Anthony and Company. In 1902, they merged with the Scovill Company, and five years later, the firm name was shortened to Ansco, a contracted form of the two names. At the same time, they moved from their original location on Broadway to Binghamton, N.Y.*
See also: *Agfa, Ansco, Scovill.*
Note: The plate and hand camera division of E. & H.T. Anthony Camera Co. which made the Ascot Cameras merged with several other companies in 1899 to become the Rochester Optical and Camera Co.

Ascot - folding plate cameras ca. 1899.

Ascot Cycle No. 1 - 4x5 size. Orig. price in 1899 - $8.00. $60.

Ascot Folding No. 25 - 4x5 size. $75.

Ascot Folding No. 29 - 4x5 size. Original price in 1899 $15.00. - -Currently $75.

Ascot Folding No. 30 - The big brother of the above cameras, this one takes 5x7 plates. Like the others, it has a side door for loading and storage of plate holders. $80.
Ascot cameras are quite uncommon, since they were made for such a short time.

Box Cameras -
Ca. 1905 leather covered box for 3¼x4¼ on rollfilm $32.
Ca. 1903 - focusing model for 4x5 exposures on plates or with roll holder. $65.

Buckeye - Box cameras ca. 1896 for 12 exp. on daylight-loading rollfilm. (Some models equipped for either plates or rollfilm.) Made in 3¼x4¼ and 4x5 sizes, these were Anthony competition for the Boston Bullseye and the Eastman Bullet cameras of the day. $40.

Daylight Enlarging Camera - ca. 1888. A view camera & enlarger for plates to 11½x11½ in. Rotating back and bellows. Masking back for enlarging. - - without lens $150.

Klondike - fixed-focus box-plate camera ca. 1898. Adjustable shutter speeds and diaph. 3¼x4¼ size. $65.

Normandie - According to the Anthony 1891 Catalog, this was the "lightest, most compact, and easily adjustable, reversible back camera in the market." The spring-loaded ground glass back was a relatively new feature at that time. Made in sizes from 4x5 to 14x17. Current value of 5x7 to 8x10 with lens $200.

Novelette, Patent Novelette - View cameras ca. 1885. Back and bellows rotate as a unit (Anthony's patent). Lightweight brass front standard assembly. Originally made in all standard sizes from 4x5 to 11x14 inches in basic, single swing, and double swing models ranging from $12 to $54. Presently, they range from $75 to $200.

PDQ - Detective plate box camera, ca. 1890. 4x5 plates or films. Orig. price $20. Now valued at about $500.

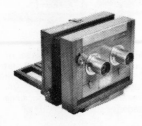

Stereo plate camera - 5x8 inch. Collapsible bellows style. Some models had folding bed, others had rigid bed. With orig lens & shutter $332.

View cameras -
4x5 folding bed, collapsible bellows type ca. 1890. 'E.A.' lens, case, and holders $82.
5x7 - $85.
5x8 - rigid "studio" or folding "field" types. ca. 1888-1890. With lens (and occasionally with accessory shutter). $157.
6½x8½ - with RR lens in brass mount. $65.
8x10 - less lens $80. With lens $90.
11x14 - studio or field types $150-250, depending on type of lens.

ANTIQUE OAK DETECTIVE CAMERA - see Scovill.

APOLLO - 120 film. Westar Anast. f3.5/75. Shutter 1-200. With case $20.

APPARATE & KAMERABAU (Friedrichshafen, Germany)
Akarelle - ca. 1954, 24x36mm. various lens types f2 to f3.5. Prontor shutter. $31.
Akarette I & II - ca. 1950. Various lenses $30.

Akarex - ca. 1953 35mm rangefinder camera. Rangefinder and lens are interchangeable as a unit. Normal lens: Isco Westar f3.5/45mm. Also available: Schneider Xenon f2/50mm, Tele-Xenar f3.5/90, and Xenagon f3.5/35mm. $87 USA, $25 EUR.

APTUS - see Moore.

ARETTE - **Model W** - German made non-rangefinder 35mm. f2.8/50 Wilow lens. $15.

ARGUS (Monocular-shaped camera) - see Nettel.

ARGUS, INC. (Ann Arbor, Michigan and Chicago, Illinois.)
Originally International Research Corp., Ann Arbor, Michigan.

A - 35mm cartridge camera mfd. ca. 1936-1941. f4.5/50mm fixed focus anast. lens in collapsible barrel. $15.

AF- (1937-1938) - similar but with focusing lens mount. $15.

AA - (1940-1942) Also known as Argoflash. Similar to above, but with fixed focus lens, shutter for I & T, synched. $18.

A2 - (1939-1950) - Similar to the "A", but with extinction meter. Focus 6' to infin. $12.

A2B - (1939-1950) $15.

A2F - (1939-1941) - Similar to all the other "A" series cameras, but with focus from 1¼ ft. to infin. Extinction meter. $16.

FA - (1950-1951) - The last of the "A" series with the original style. f4.5/50mm Anastigm. Two position focus. 25-150, B, T. Sync. $14.

A3 - (1940-1942) - As all of the above , this camera is for 35mm film. However, the style of this model (and the CC) is more sleek with rounded ends. Extinction meter, f4/50mm Anast. Shutter 25-150. $16.

A4 - (1953-1956) - A newly styled body, later appearing as the C-20. f3.5/44mm Cintar. Full focus. Sync. $18.

C20 - (1956-1958) - Similar to model A4, but with brown simulated leather covering and coupled rangefinder (not too trustworthy, in general.) $17.

C33 - (1959-1961) - f3.5/50 Cintar. CRF & coupled meter. Single stroke advance. $18.

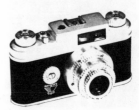

K - (1939-1940) - f4.5/50mm Anastigmat. Coupled extinction meter. (It is probably this feature which makes it so desirable and thus high-priced, especially when compared to the other Argus cameras.) $138

C - (1938-1939) - f3.5/50mm Cintar. The original "brick" shaped camera with a non-coupled rangefinder. $15.

CC - (1941-1942) - "Colorcamera" - similar to the A3, but has non-coupled selenium cell meter instead of extinction type. $40.

21 - (Markfinder) - (1947-1952) - f3.5/50mm Cintar (coated). Interchangeable mount. $18.

Argoflex - Twin lens reflex cameras in various body styles and model numbers from 1948 to 1958. Models: E, EM, EF, 40, 75 black, 75 brown, Super 75 (order of introduction). $12.

Autronic - Autronic 35 or Autronic C3. Although the camera bore both designations during its short life (1960-1962) it was really just one model. f3.5/50mm Cintar. Sync shutter 30-500, B. Automatic electric eye, rangefinder. $21.

ARNOLD, KARL (Marienburg)
The abbreviation KARMA comes from KArl ARnold, MArienburg.

C2 - (1938-1942) - Like the "C", but rangefinder is coupled. Introduced just after the model C in 1938. An early "brick". $16.

C3 - (1939-1966) - The most common "brick". Like the C2, but with internal synch. $15.

C3 Matchmatic - Basically a face-lifted C3 in two-tone finish. Designed for use with a non-coupled clip-on selenium meter.
Price listed here is for camera & meter. $20.

C4 - (1951-1957) - f2.8/50mm Cintar. Coupled rangefinder. $23.

C4R - (1958) - Like the C4 above, this model is built on the style of the Model 21 which was introduced in 1947. The C4R features a rapid film advance lever, which gave it its "R" designation. $28.

C44 - (1956-1957) - Similar to C4. f 2.8/50 Cintagon lens in interchangeable mount. $26.

C44R - (1958-1962) - Similar to C44 but with rapid advance lever. $28.

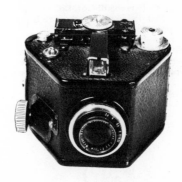

Karma - 6x6cm rollfilm "box" camera for 120 film. Meyer Trioplan f3.5/75 coated lens. Focal plane shutter 25-500, T. Non-coupled rangefinder. Helix focus. Trapezoid-shaped metal body with black leatherette. $194.

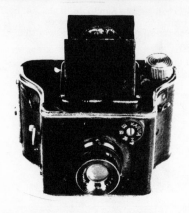

Karmaflex - 4x4cm format SLR for 127 film. ca. 1937. Ludwig Vidar f4.5/60mm on Laack Ragolyt f4.5/60. Guillotine shutter 25-100. Black leatherette covered metal body. $144.

ARROW - 14mm subminiature novelty. $8.

ASCOT - see Anthony.

ASTRAFLEX - *A successor to the Bentzin Primarflex. Apparently the Bentzin company became the Feinoptische Werke Görlitz and continued the Primarflex line of cameras under the Astraflex name.*
Astraflex II - ca. 1958 6x6cm SLR. Interchangeable coated f3.5/105mm Tessar. Focal plane shutter to 1000, T,B. $69.

ATOM - see Huttig, Ica.
AUTOCORD - see Minolta.

AUTOFLEX - (Kiyabashi Opt. Co. Tokyo) 6x6cm TLR styled like Rolleiflex. f3.5 Tri-Lausar lens. $26.

AUTOGRAPHIC - All Autographic cameras were made by the Eastman Kodak Co. See the various models of cameras under Eastman.

AUTOMATICA - see Durst.
AUTOMATIC - see Ansco.

AUTOMATIC RADIO MFG. CO. (Boston)

Tom Thumb Camera Radio - ca. 1948. Iden-tical in appearance to the "Cameradio" mfd. by Universal Radio Mfg. Co. $76.

AUTRONIC - see Argus.
AVUS - see Voigtlander.

BALDA-WERK (Max Baldeweg- Dresden)
Baldalette - folding 35mm ca. 1950. f2.9/50 Schneider Radionar. Compur Rapid or Pronto shutter. $26.

Baldarette - folding camera for 5x8cm on 127 film. Rodenstock Trinar f4.5/85. Vero sh., T, B, 25-100. Brown leathered body, brown bellows. $20.

Baldax - compact folding camera for 16 exp. 4.5x6cm on 120. ca. 1930's. Available in a large variety of lens/shutter combinations, f2.8-f4.5. $20.

Baldaxette - **Model I** - for 16 exp. 4.5x6cm on 120 film. f2.9/75 Hugo Meyer Trioplan or f2.8/80 Zeiss Tessar. Rimset Compur or Compur Rapid sh. w/ self-timer. $21.
-**Model II** - for 12 exp. 6x6cm on 120. $21.

Baldessa Ib - f2.8 Isco lens & meter. $30.

Baldi - ca. 1930's for 16 exp. 3x4cm on 127. f2.9 or 3.5/50mm Trioplan. $30.

Baldina - ca. 1930's folding 35 (similar to the early folding Retina Cameras.) Common combinations include: f3.5/50 Baldanar, F2/45mm Xenon, f2.9/50 Xenar. Prontor-S or Compur Rapid shutter. $24.
---**Super Baldina** - similar, but with CRF, Zeiss Tessar f2.8, Compur Rapid. Late 1930's. $38.

Baldinette - ca. late 1930's Retina-style 35mm. various shutter/lens combinations. $22.
--- **Super Baldinette** - with CRF, f2 lens. $38.

Beltica - *(see also Belca Beltica)* - ca. 1949 folding camera for 35mm. Ludwig Meritar f2.9/50 or Zeiss Tessar f2.8/50 in Cludor or Ovus shutter to 1/200 sec. $19.

Jubilette - ca. 1938 (the 30th anniversary of Balda-Werk, thus the name) - a folding 35mm similar to the Baldina. f2.9/50mm Baltar or Trioplan. Compur shutter. $22.

Juwella - 6x9cm folding rollfilm camera. f4.5 Juwella Anast. Prontor T, B, 25-125, self-timer. $12.

Piccochic - a vest-pocket camera for 16 exp. 3x4cm on 127 film. Normal lens: Ludwig Vidar f4.5/50mm. Also available: f3.5 Trioplan, f2.9 Vidar, f2.9 Schneider Xenar. Compur, Prontor, or Ibsor shutters. New prices ranged from $12.50 to $37.50. $33.

Poka - Metal box camera for 6x9cm exp. on 120 rollfilm. Meniscus lens, simple sh. $12.

Rigona - ca. 1937 folding camera for 16 exp. 3x4cm on 127. Similar to the Baldi. Normal lenses: f4.5 Vidanar, f2.9 Schneider Radionar, f2.9 Meyer Trioplan, - Prontor sh. $21.

Rollbox 120 - all metal 6x9cm box. $9.

Super Pontura - folding camera for 8 exp. 6x9cm on 120 film. CRF, automatic parallax compensation. f3.8 or 4.5 Meyer Trioplan. Compur Rapid to 400. Camera adaptable for 16 exp. 4x6cm. $39.

Wara - folding camera for 6x9cm on rollfilm. f4.5/105 Xenar. Ring Compur to 250. $16.

BALDI - see Balda-Werk.

BALDUR - see Zeiss.

BANTAM - see Eastman

BAUER - folding camera for 8 exp. 6x9cm or 16 exp. 4x6cm on 620.. f4.5/105 Schneider Radionar. Vario sync. sh. $16.

BAUSCH & LOMB - Camera Obscura - Made of oak with metal on front. $184

BAZIN & LEROY - (Paris)
Le Stereocycle - ca. 1898 jumelle-styled stereo camera for 12 plates 6x13cm. Ross Rapid Rectilinear lenses. Guillotine shutter. $770.

BEACON - see Whitehouse Products.

BEAU BROWNIE - see Eastman.

BEAUTY, BEAUTYCORD, BEAUTYFLEX: see Taiyodo Koki.

BECK - (R & J Beck, Ltd., London)

Frena - Detective box cameras ca. 1897. Magazine cameras for special sheetfilms. Made in three sizes: 2-5/8 x 3½, 3¼x4¼, 4x5". $132.

Frena Deluxe - ca. 1897. for 40 exp. 6.5x9 cm. on special perforated sheet film. Covered with brown calves leather. Metal parts gold plated. $306.

BEBE - see Ica, Zeiss.

BEICA - Japanese 14mm novelty cam. $8.

BEIER - (Woldemar Beier, Freital, Germany)
Beiera - 35mm camera ca. early 1930's. f2.7/ 50mm Dialytar. RF. Compur Rapid. $38.

Beierax - ca. 1930's folding 6x9cm rollfilm camera. E. Ludwig Victar f4.5/105. Prontor or Vario shutter. $9.

Beierette - Compact folding 35mm camera. (Horizontal style). Rodenstock Trinar lens: f2.9, 3.5, or 3.9 in Compur or Comp. Rap. shutter. $21.

Beier folding sheet film cameras - 3¼x4¼" or 9x12cm sizes. Rodenstock Trinar Anast. f4.5 or Betar f4.5 in Compur shutter. $35.

Precisa - folding camera for 120 rollfilm. 75mm lenses range from f2.9 to f4.5. AGC, Compur, or Compur Rapid shutter. $25.

Rifax - 6x9cm rollfilm. Rodenstock Trinar f3.8/105. Prontor II, 1-150. CRF. $36.

BEIL & FREUND - (Berlin)
Plate Camera - 9x12cm. ca. 1890. f8 Anastoskop Meniscus lens. $83.

BELCA-WERKE - (Dresden)
Belfoca - folding camera, post WWII, for 8 exp. 6x9cm on 120. Prontor sh, f4.5 Ludwig Meritar lens. $23.

Belpasca - ca. 1952 stereo 24x36mm on 35 mm. film. f3.5/37.5 Tessar lenses. Synch. shutter 1-200. $240 (EUR).

Beltica - Post-war folding 35mm. Ludwig Meritar f2.9/50 or Zeiss Tessar f2.8/50. Ovus or Cludor shutter. $21.

BELL CAMERA CO. - (Grinnell, Iowa)

Bell's Straight-Working Panorama Camera -
ca. 1908 panoramic camera in which neither
the film nor lens swings, pivots, or moves,
which justified the cumbersome name. This
camera is basically an extra-wide folding cam-
era for 5 exp. 3¼x11½ on rollfilm. (Also for
10 exp. 3¼x5½ if you prefer post-cards.)
Knobs on top of camera allow user to change
format in mid-roll. $325.

BELL KAMRA - Model KTC-62 - Combina-
tion 16mm cassette camera & shirt-pocket
sized transistor radio. $95.

BELL 14 - Novelty 16mm subminiature cam-
era styled like a 35mm. $10.

BELL & HOWELL - (Chicago)
Colorist - (TDC Stereo Colorist) - Stereo cam-
era for 35mm film. f3.5 Rodenstock Trinar
lenses. $52.

Dial 35 - Half-frame 35mm. Auto wind.
Current value w/ case & flash: $50.

Foton - ca. 1948 35mm spring-motor driven.
6 frames per sec. $375.

Vivid - (TDC Stereo Vivid) - f3.5 Trinar. $68.
- - - **Stereo Vivid Projector -** $275.

BELLIENI -(H. Bellieni & Fils, Nancy,France)
Jumelle - for 36 plates 9x12cm. Zeiss Protar
f8/136mm. Leather covered wood body. $197.

Stereo Jumelle - ca. 1896 for 9x18 cm. stereo
plates. f6.8/110mm lenses in aluminum bar-
rel w/ brass diaphragm ring. 6 speed sh. $168.

BELTAX - 35mm camera - Leica styled. f4.5/
40mm Picner lens. Picny D sh. 3 speeds. $50.

BELTICA - see Belca.

BENCINI - (Italy) Animatic 600 - ca. 1955
cassette camera for 126 film. $5.

BENETFINK (London)
Lightning Detective Camera - ca. 1895 ¼pl.
Ilex string-cock shutter. $168.

BENSON DRY PLATE & CAMERA CO.
Street Camera - with cloth sleeve, tank, and
tripod. $120.

BENTZIN - (Curt Bentzin, Görlitz, Germany)
(Succeeded by VEB Primar, Görlitz)

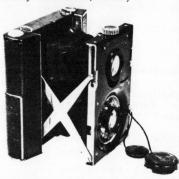

Planovista - ca. 1930. Twin-lens folding cam-
era (NOT a reflex). A "taking" camera top-
ped by a second "viewing" or "finder" camera.
Separate lens and bellows for each half. For
8 exp. 4x6.5cm on 127 film. Meyer Trioplan
f3.5/75mm in Pronto sh. 25-100, T, B. Top
lens tilts down for automatic parallax correc-
tion. *(The Planovista was made by Bentzin
to be marketed by the Planovista Seeing Cam-
era Co. Ltd. of London. The design is that of
the Primarette, but with a new name.)* $480.

Primar - Folding 120 rollfilm camera. Meyer
Trioplan f3.8 or Zeiss Tessar f4.5. Deckel
Compur shutter, 1-250. $15.

Primar (Plan Primar) - 6.5x9cm folding plate/
sheetfilm camera. Meyer Trioplan f3.8 or
Zeiss Tessar f4.5. Rimset Compur. $68.

Primar Reflex - 6.5x9 or 9x12cm. Tessar
f4.5 lens. $77.

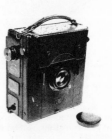

Primar folding (klapp) Reflex - 9x12cm.

Meyer Trioplan or Tessar f3.5/210mm. Focal plane shutter 1-300, T, B. $157.

Primarflex (Primar Reflex) - ca. 1930's 6x6cm SLR. f3.5/105 Tessar. FP shutter. $68.

Stereo Reflex - 6x13cm stereo reflex. GGB, FP sh. 20-1000. f6 Roja Detective Aplanat. $400.

BERGHEIL - see Voigtländer.

BERNING (Otto Berning & Co., Westphalia, & Düsseldorf, Germany.)

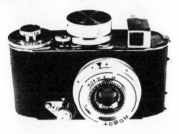

Robot I - ca. 1934. for 1"x1" exp. on 35mm film. Spring motor automatic film advance. Zeiss Tessar f2.8/32.5mm lens. Rotating shutter 2-500. $74 (USA) $118(EUR).

Robot II - ca. 1938. Improved model of Robot I. Various lenses f1.9,f2, f2.8, f3.8, in 37.5 or 40mm focal lengths. $78 (USA) $119 (EUR).

Robot Junior - Postwar. Schneider Radionar f3.5/38mm. $61.

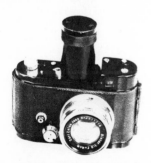

Robot - Luftwaffe Model - Most commonly found with 75mm lens. Pictured here with 40mm. lens. Note tall winding grip. $196.

Robot Star - f1.9 Xenon. MX sync. $80.

Robot Star II - $180.

Robot Royal 36 - 24x36mm full-frame size, rather than the 24x24 mm format of the other models. $198.

BESSA, BESSAMATIC - see Voigtländer.

BETTAX - Folding 6x9cm rollfilm camera. f4.5/100 Radionar. Compur shutter. $22.

BILLY - see Agfa.

BILORA - see Kürbi & Niggeloh.

BIOFLEX - 6x6cm TLR. Hong Kong. Plastic body. Two speed shutter. $10.

BINOCULAR CAMERAS - *Listed by manufacturer. See partial listing of manufacturers under the heading "Jumelle".*

BISCHOFF (V. Bischoff, Munich)

Detective camera - ca. 1890. Box camera for 9x12 cm plates. Polished wood body. Aplanat lens, iris diaphragm. 2-speed sh. $473.

BLAIR - (Blair Tourograph Co. - 1880; Blair Tourograph & Dry Plate Co. 1881-1885. Blair Camera Co. 1886-1899. Boston.) Blair Camera Co., Rochester, N.Y. 1899-1906. Blair Camera Division, E.K.C. after 1907.

Combination Hawkeye - Somewhat similar to the No.4 Screen Focus Kodak Camera. Allowed use of No. 103 rollfilm or 4x5" plates, and allowed use of the groundglass with either. Rollfilm holder pulls out from top like a drawer. Double extension red bellows. Wood interior. B&L RR lens. Blair/B&L pneumatic shutter. $400.

No. 3 Combination Hawkeye - ca. 1904. Similar to the above, but in 3¼x4¼ size. $265.

Detective & Combination Hawkeye - Box camera for 4x5" plates in plate holders. ca. 1890's. Top back door hinges forward to change holders. Leather covered wood constr. Front door hinges down to reveal lens & sh. Internal bellows focus. $128.

All wood detective Hawkeye - No leather covering. (An earlier style than the leather covered models.) 4x5 size: $188.

"Tool-box" style - large detective camera. Leather covered. $140.

Hawkeye Junior - 4x5" box for rollfilm or plates. ca. 1895-1900. $90.

Baby Hawkeye - miniature box camera ca. 1897. The smallest of the Hawk-eye cameras, comparable to Eastman's "Pocket Kodak" Cameras. For 12 exp. 2x2½ on daylight loading "Blair's Sunlight Film". $165.

Folding Hawkeye - 4x5 - ca. 1895-1898. A 4x5 folding plate camera, basically a cube when closed. Similar to the No. 4 Folding Kodak Camera of the same period. Top back door for loading plate holders. Could also use roll holder. $155.

Folding Hawkeye 5x7 - ca. 1890's. Again, a cube-shaped camera when closed. Top back door accepts plate holders or Eastman Roll Holder. $213.

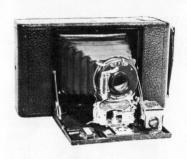

No. 3 Folding Hawkeye, Model 3 - ca. 1902 horizontal format folding rollfilm camera for 3x4" negatives. Wood interior, Maroon bellows. B&L RR lens. $35.

No. 4 Folding Hawkeye, Models 3 & 4 - ca. 1903. Horizontal format folding rollfilm camera for 4x5" exp. Red DEB. Rapid Symmetrical lens. Hawkeye pneumatic sh. Nickel trim. Wood focus rails. $60.

Stereo Hawkeye, Stereo Weno - Leather covered wood bodied stereo rollfilm camera for 3½x3½" exp. Maroon bellows, simple B&L stereo shutter in brass housing. $230.

Tourist Hawkeye - ca. 1898-1904 folding rollfilm camera. 3½x3½ or 4x5" size. Plain-looking wooden standard conceals lens and shutter. $101. (With optional accessory plate attachment - -$145.)

No. 2 Weno Hawkeye - (3½x3½) - Rollfilm box camera similar to the "Bulls-eye" series of the Boston Camera Co. $54.

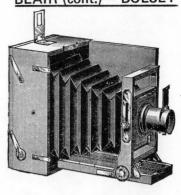

No. 3 Weno Hawkeye - (3½x4½) - box. $58.

No. 4 Weno Hawkeye - (4x5). Large box camera. Single speed shutter. 2 finders. $48.

No. 6 Weno Hawkeye - ca. 1891 box. $41.

No. 7 Weno Hawkeye - ca. 1897 box camera for 3¼x5¼ rollfilm. $36. (Most commonly found model of the Weno Hawkeyes.)

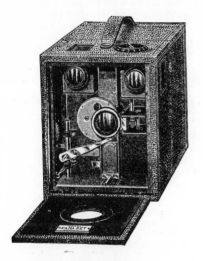

L Lens.
R R Film Rolls.
F F Focal Plane.

Kamaret - Introduced in 1891, this large box camera (5½x6½x8¾") was advertised as being "one-third smaller than any other camera of equal capacity" because it was the first American box camera to move the film spools to the front of the camera. Made to take 100 exposures 4x5" on rollfilm. Other features included double exposure prevention, automatic film counter, and an attachment for using plates or cut film. $371. (4x5 size).

Lucidograph - ca. 1885-1886. A folding plate camera with all wood body. Front door hinges to side, bed drops, and standard pulls out on geared track. Tapered black bellows. Brass-barrel single achromatic lens w/rotating disc stops. Made in several sizes: No. 1 for 3¼x4¼, No. 2 for 4¼x5½, No. 3 for 5x8". 5x8" model also has sliding front. These are not found often. $660.

Premier - ca. 1890 box camera for 4x5 plates. Internal bellows focus. Wooden body with black leather exterior. Dimensions: 6½x7x12. Side door to insert and store plate holders. Removeable ground glass back. $120.

View cameras:
5x7 or 5x8 field type, with lens. $145.
6½x8½ - with lens- $175. Without - $65.
11x14 - body alone $100. With lens $200.

BLITZ - see Adox.

BLOCK-NOTES - see Gaumont.

BOB - see Ernemann, Zeiss.

BOLSEY CORP. OF AMERICA (New York)
(see also Pignons for Alpa cameras which were designed by Jacques Bolsey.)
Bolsey B - ca. 1947-1956 compact 35mm camera with CRF. f3.2/44mm anastigmat in helical mount. Shutter to 200, T, B. $20.

Bolsey B2 - ca. 1949-1956 - similar to B, but with double exposure prevention and sync. shutter. $20.

Bolsey B22 - Set-O-Matic. Wollensak f3.2 Anastigmat lens. $18.

Bolsey C - ca. 1950-1956 35mm TLR. f3.2/44mm Wollensak Anast. Wollensak shutter, 10-200, B, T, synch. $39.
C22 - similar but with Set-O-Matic. $39.

Explorer - f2.8 lens. Rapid wind. $50.

Bolseyflex - 6x6cm TLR. 120 film. f7.7/80mm lens. $14.

Jubilee - ca. 1955-1956 - 35mm. Steinheil f2.8/45mm. Gauthier leaf shutter 10-200, B. Coupled rangefinder. $38.

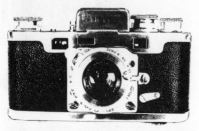

Bolsey Reflex - Original model, ca. 1938. (Mfd. by Pignons SA, Balaigues, Switzerland). This camera is identical to the Alpa I, both cameras being developed by Jacques Bolsey shortly before he moved to the United States. 35mm SLR. 24x36mm format. Interchangeable Bolca Anastigmat lens f2.8/50mm. Focal plane sh. 25-1000. Focus with ground glass or split-image RF. $200 (EUR).

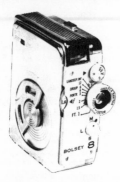

Bolsey 8 - Still or motion picture camera. Stainless steel body, size of cigarette pack. $68 (USA) $172. (EUR)

BOLTA (Nurnberg, Germany)

Photavit - A compact 35mm camera for 24x

24mm exposures on standard 35mm film, but in special cartridges. Film advances from one cartridge to the other. No rewinding needed, and the old supply cartridge becomes the new take-up cartridge. Wide variety of shutter & lens combinations. $58.

BO-PEEP - see Manhattan Optical Co.

BORSUM CAMERA CO. (Newark, NJ)
see also Reflex Camera Co. - - post 1909.
5x7 Reflex - patents 1896-1897. A very early American SLR, ca. 1900. Measures 15x11x8½ inches when closed. Goerz Dagor Ser. III f7.7/16½ inch lens. Focal plane sh. $260.

5x7 New Model Reflex - Large box with internal bellows focus. Small front door hinges down to uncover lens. Identical to the 5x7 Reflex of the Reflex Camera Co. $260.

BOSTON CAMERA CO. (Boston, Mass.)
The Boston Camera Co. was purchased by the Blair Camera Co. in 1890. Then Blair moved to Rochester from Boston in 1899 and by 1907 was "Blair Div. of Eastman Kodak Co."
Bullseye box cameras - ca. 1892-1895. Simple wooden box cameras, leather covered, for rollfilm. Very similar to the later Blair and Kodak Bullseye cameras. $40.

Hawk-eye "Detective" box cameras - ca. 1888-1892. Large wooden box camera for 4x5" plates. Rotating brass knob at rear of camera focuses by means of internal bellows.
All wood box model - - $160
Leather covered model - - $135.

BOWER-X - see Schleissner.

BOX CAMERAS - *The simplest, most common type of camera. Box cameras have been made by most camera manufacturers, and of most common materials from paper to plastic to metal. Many models are listed in this guide under the manufacturer, but to save you the trouble of looking, common boxes sell for Five Dollars or less, including sales tax, postage, and green stamps. They can make a fascinating collection, but without straining the average budget.*

BOX TENGOR - see Goerz, Zeiss.

BOY SCOUT CAMERA - see Ansco, Eastman.

BOYER (Paris)
Altessa - Folding camera for 8 or 12 exp. on 120 film. Tubular interchangeable Angenieux f3.5 lens. Synch. shutter. (We have only one of these on file, offered for sale in 1973 for $90., so do your own guessing from that.)

Boyer plastic 120 cameras - $11.

BRACK & CO. (Munich)
Field camera - **18x24cm.** - square cloth bellows (black with red corners) extend backwards. A fine wood and brass camera with Rodenstock WA Bistigmat 24x30 lens with brass revolving stops. $160.

BRAUN (Carl Braun, Nürnberg, Germany)
Colorette Super - $35.

Gloriette - Non-RF 35mm camera 24x36mm. f2.8/45mm Steinheil Cassar. Prontor SVS shutter. BIM. $20.

Pax - Models M2, M3, M4. f3.5 or 2.8/45mm coated lens. Sh. 10-300, B. $30.

Paxette I - Compact 35mm RF camera ca. late 1930's through 1950's. Various models. $17.

Paxette Automatic III - f2.8/50 Color Ennit lens. $35.

Paxina - 6x6cm rollfilm camera. Telescoping front. f3.5/75 Staebler Kataplast lens in Vario shutter. $14.

Super Paxette - 35mm. Xenar f2.8/50mm or Enna Color Ennit. Prontor sh. $45.

BRILLIANT - see Voigtländer.

BROOKLYN CAMERA CO. (Brooklyn, NY)

Brooklyn Camera - ca. 1885 ¼-plate (3¼x4¼) collapsible-bellows view camera with non-folding bed. $200.

BROWNELL (Frank Brownell, Rochester, NY)
Stereo Camera - ca. 1885. A square bellows dry-plate camera for stereo exposures. Historically significant, because Frank Brownell made very few cameras which sold under his own name. He made the first Kodak cameras for the Eastman Dry Plate & Film Co., and was later a Plant Manager for EKC. $500.

BROWNIE - see Eastman Kodak Co.

BUCCANEER - see Universal Camera Corp.

BUCKEYE - see American Camera Mfg. Co., Anthony, and Eastman Kodak Co.

BUESS (Lausanne)

Multiprint - A special camera for 24 small exp. on a 13x18cm plate which shifts from lower right to upper left by means of a crank on the back, Corygon lens. Rotating shutter 1-100. Reflex finder. *(Only 25 of these cameras were made, so our price figure is based on only 1 example sold at auction in 1976 in Germany.)* $819.

BULLARD CAMERA CO. (Springfield, MA)
Folding plate camera - 4x5" ca. 1900. Wood interior. Red bellows. Reversible back. B&L or Rauber Wollensak lens. Victor sh. $53.

Magazine camera - ca. 1898 for 18 plates in 4x5" format. Push-pull action of back advances plates. Front bed hinges down and bellows extend. Unusual, because the majority of the magazine cameras were box cameras, and did not employ folding bed or bellows. $166.

BULLET - see Eastman.

BULLS-EYE - see Boston, Eastman.

BURKE & JAMES - (Chicago)
Grover - 4x5 view. $65.
Ideal - 6½x8½ view. $78.

Ingento:
1A Ingento Jr. - f6.3 lens. $15.
3A Ingento Jr. - Vertical format. Ilex lens. Ingento shutter. $22.

3A Folding Ingento - Model 3 - Horizontal format. Ilex lens. Ingento shutter. $25.

Korelle - *Marketed by Burke & James, but manufactured by Kochmann. See Kochmann.*

Press 4x5 - f4.7/127 Kodak Ektar. $66.

Rexo cameras:
Box camera - for 6x9cm rollfilm. $7.
1A Folding Rexo - for 2½x4¼ on 116 film. Anastigmat lens. $10.
1A Rexo Jr. - Folding camera for 2½x4¼ on 116 film. Single Achromatic or RR lens. Ilex shutter. $10.
2C Rexo Jr. - folding camera. $9.
3 Rexo - folding 3¼x4¼ rollfilm. RR or Anastigmat lens. Ilex shutter. $15.
3 Rexo Jr. - 3¼x4¼, single achromatic lens. Ilex shutter. $9.
Vest Pocket Rexo - Wollensak Anastigmat lens in Ultex shutter. $12.
Rexoette - Box camera 6x9cm ca. 1910. $9.

Press/View cameras: (without lens)
2¼x3¼ & 3¼x4¼ - $40.
4x5 - $63.
5x7 - $75.
8x10 - $115.

Watson-Holmes Fingerprint Camera - If the good folks at B&J named this specialty camera after the famous sleuth and his side-kick, it is aptly named. However, they made other Watson cameras, which adds to the mystery which we leave to our readers. $125.

BUSCH CAMERA CO., Emil Busch Optical Co. (London)
Pressman - 4x5 - f4.7 Ektar, Optar, or Raptar lens. Press camera style like Graphic. $81.
Pressman 2¼x3¼ - Miniature press cam. $68.

Verascope F-40 - ca. 1950's stereo camera for 24x30mm pairs or singles. f3.5/40mm Berthiot lens. Guillotine sh. to 250. RF. $203.

BUSTER BROWN — see Ansco.

BUSY BEE - see Seneca.

BUTCHER (W. Butcher & Sons, London)
See also Houghton-Butcher for any cameras not listed here.
Cameo - 3½x5½ plate camera ca. 1912. Aldis f7.7 or f6.3 lens. Ibso shutter. $38.

Carbine cameras:
Folding rollfilm models ca. 1920 - Quite a variety of models with various lens and shutter combinations. Prices range from $18 for a good clean example with a normal lens and shutter to over $60 for a deluxe model with fast Tessar lens and Compur Rapid shutter. Prices tend to be somewhat higher in Europe. The overabundance of cheap folding rollfilm cameras in the United States has kept enthusiasm low, even for some of the better models like these.
Postcard size folding camera - f6.8/6½" Ross Homocentric lens. Compound shutter. $30.
Carbine No. 2 - ca. 1930s rollfilm box. $8.
Carbine Reflex - 6x9cm 120 film SLR ca. 1920's. f7.7/4¼" Aldis Uno Anastigmat. Two separate releases for T & I. Body of wood covered with black leather. $128.
Watch Pocket Carbine - Compact folding rollfilm camera, horizontal style, for 6x6cm exp. Normally with f7.7/3" Aldis Uno Anastigmat and Lukos II shutter. $34.

Klimax - 4x5 folding plate camera ca. 1912. DEB. Aldis f7.7 lens. With holders - $43.
Klimax - 5x7. Compound sh. f7.7 lens. $80.

Midg - Box cameras ca. 1905-1915. For film or plates. Numbers 0, 00, 1a, 1, 2, 3, 4, 4a, 4b. $40.

CADET - see Agfa, Ansco.

CADOT (A. Cadot, Paris)
Scenographe Panoramique - Jumelle style 9x18 cm plate camera. One lens rotates to center position to change from stereo to panoramic mode. $260.

CAMBINOX - see Möller.

CAM-CO CORP. (Kansas City, MO)
Ident - 35mm TLR. f9.5/114mm. $85.

CAMEL, Model II - Leica copy. f3.5 Camel lens. $60.

CAMEO - see Butcher, Houghton-Butcher.
CAMEO STEREO - see Ica.

CAMERA CORP. OF AMERICA - see Candid Camera Corp.

CAMERADIO - see Universal Radio Mfg. Co.

CAMERA-LITE - A cigarette-lighter spy camera. Resembles Zippo lighter. Made in USA in 1950's, similar to the Japanese Echo-8. $171 (USA) $260 (EUR).

CAMERA-SCOPE - A novelty item - kaleidoscope disguised as a camera. $25.

CANDID CAMERA CORP. OF AMERICA
(Original name 1938-1945 was shortened to "Camera Corp. of America" in 1945. It did

no great good, because in 1949, the company sold out to Ciro.)

Perfex Cameras - (listed chronologically):
Perfex Speed Candid - 1938-1939 - 35mm RF camera. Interchangeable f3.5/50mm or f2.8 Anastigmat. Cloth focal plane shutter 25-500,B. Non-coupled RF. $72.
Perfex Forty-Four · - 1939-1940 - 35mm CRF camera. Interchangeable f3.5 or 2.8/50mm Anastigmat. Cloth FP sh. 1-1250, B, sync. Extinction meter. $35.
Perfex Thirty-Three - 1940-1941 - f3.5/50mm Anastigmat. FP sh. 25-500, B, sync. CRF. Extinction meter. $36.
Perfex Fifty-Five - 1940-1947 - f3.5 or 2.8 lens. FP sh. 1-1250, B, sync. CRF. Extinction meter - exposure calculator on early models only. $28.
Perfex One-O-One - 1948-1950 - f4.5/50mm Wollensak Anast. Alphax leaf shutter. 25-150, T, B. $35.
Perfex One-O-Two - 1948-1950 - f3.5/50mm Ektar lens. Compur Rapid 10-200, T, B. $41.

CANON CAMERA CO. (Tokyo)
Demi - ½ frame 35mm. with meter. $30.
L - RF, Hexanon f1.9. Metal shutter. $102.
L-1 - RF, Hexanon f1.9. Chrome. $125.
P - ca. 1959-1963 - f1.2 to 1.9/50mm. Coupled rangefinder, and meter. $154.
VT - f1.8/50mm. ca. 1956-1958. $150.

II - ca. 1951. FP sh. to 500. No sync. $75.
II-B - similar to II, but with focus magnifier. with f1.9 Serenar - $71.
II-F - ca. 1955. Sh to 500. f1.8 or 1.9. $69.
II-S - ca. 1955. Similar to II-F. $74.

III - f1.8 or 1.9 Serenar - $66.
IIIA - f1.8 or 1.9/50mm Serenar. $95.
IV - 1951. Serenar f1.9. shutter to 1000. $150.
IV-F - f1.8/50 Serenar. ca. 1952. $64.
IV-S - similar to IV-F - $64.
IV-S2 - ca. 1952. f1.8 or 1.9 Serenar. $114.

7 - ca. 1961-1964. FP sh. to 1000. CRF. Body only - $143. With f.95/50 Canon - $270. With f1.8/50mm Canon - $176.
7-S - 1964-1966 - f.95 Canon - $412. With f1.2/50mm - $268.

Canonet - ca. 1960. f1.9 or 2.8 lens - $52.
Dial 35 - ½ frame. f2.8 lens. $35.

CAPTAIN - see Agfa.

CARBINE- see Butcher.

CARLTON - see Allied.

CARMEN (France) - **Pygmee** - ca. 1930's camera for 24x24 exp. on 828 size rollfilm. Meniscus lens, simple shutter. $130.

CARPENTIER, Jules (Paris)

Photo Jumelles - ca. 1890's rigid-bodied, binocular styled camera. One lens is for viewing, the other for taking single exposures. This is not a stereo camera, as many jumelle-styled cameras are. Magazine holds 12 plates. To change plates, a rod extending through the side of the camera is pulled out and pushed back in. Various models in 6x9cm and 4.5x6cm sizes. $196.

CARTRIDGE KODAK - see Eastman.

CASCA - see Steinheil.

CASPA - see Demaria.

CENTURY 35 - see Graflex, Inc.

CENTURY CAMERA CO. - *Century began operations in 1900, which probably explains the company name well enough. In 1903, The Eastman Kodak Co. bought controlling interest in the company, and in 1907 it became "Century Camera Div., EKC." Following that, it was in the Folmer-Century Division of EKC which became Folmer Graflex Corp. in 1926.*

Field cameras - (classified by size, less lens):
4x5 - $46.
5x7 - $64.
6½x8½ - $65.
8x10 - $95.
11x14 - $125.

Stereo plate camera - 5x7 folding style. $325.

CERTO KAMERAWERK (Dresden, Germany)
Certofix - 6x9cm folding rollfilm camera for 120 film. Steinheil Certar f4.5/105mm. Rim set Compur T, B, 1-250. $12.

Certonet - ca. 1926 - 6x9cm folding 120 film camera. f4.5/120mm Schneider Radionar. Vario sh. T, B, 25-100. $25.

Certosport - folding plate cameras ca. 1930's. 6.5x9 & 9x12cm sizes. DEB. Normally with f4.5 lens (Meyer or Schneider) in Compur or Ibsor shutter. $39.

Certotrop - folding plate cameras, 6x9 & 9x12 sizes. $34.

Dollina - folding 35mm camera ca. late 1930's.

Various shutter/lens combinations. $38.

Dollina II - $34.

Super Dollina - 35mm RF camera. f2.8/50 Tessar. $41 (USA) $68 (EUR).

Dolly - Compact folding camera for 16 exp. 3x4cm on 127 film. f2.9, 3.5, or 4.5 lens. Orig. price, about $20. - - -$30.

Supersport Dolly - ca. late 1930's folding camera for 12 exp. 6x6cm or 16 exp. 4.5x6cm on 120 film. Later models have CRF. Various lenses f2, 2.8, 2.9, Rimset Compur. $35.

Doppel Box - ca. 1935 box camera for 8 exp. 6x9cm or 16 exp. 4.5x6cm on 120 film. Format changeable by turning dial. Certomat lens, single speed shutter. $35.

Plate camera - 9x12cm. DEB. $45.

CHALLENGE - see Lizars.

CHASE MAGAZINE CAMERA CO., (Newburyport, Mass. USA)

Chase Magazine Camera - ca. 1899 for 12 plates 4x5". Plates advanced (dropped) by turning large key at side. Variable apertures, Shutter speeds I & T. $85.

CHAUTAUQUA - see Seneca.

CHEVRON - see Eastman Kodak Co.

CHICAGO CAMERA CO. (Chicago, III.)
Photake - a seamless cylindrical camera ca. 1896 made to take 5 exposures on 2x2" glass plates. f14/120mm achromat lens, Guillotine shutter. A very unusual camera

which originally sold for a mere $2.50.
We saw two offered for sale in the USA in
1977 for $3500 and $2500. That isn't
enough to make an average, but it points
a strong finger in the direction of $3,000.

CHICAGO FERROTYPE CO. (Chicago, Ill.)

Mandel No. 2 Post Card Machine.- A direct
positive street camera ca. 1913-1930. $125.

Mandelette - Direct positive street camera.
2½x3½ format. Camera measures 4x4½x6".
Sleeve at rear, tank below. Simple shutter
and lens. A widely publicized camera which
sold for about $10.00 in 1929. $80.

PDQ Street Camera - Direct positive street
camera. $69.

**Wonder Automatic Cannon Photo Button
Machine** - An unusual all-metal street camera
ca. 1910 for taking and developing 1" dia.
button photographs. $550.

CHIEF - see Seneca.

CHIYODO KOGAKU SEIKO CO. LTD.
Chiyoko - 6x6cm TLR. Seikosha MX shutter.
f3.5 Rokkor lens. $40.

Konan - 16 Automat - ca. 1952. 16mm sub-
miniature. The precursor of the Minolta-16.
$23.

Minolta - *Although the Minolta cameras were
made by Chiyoda, we have listed them under
the more widely recognized name -Minolta.*

CIRKUT CAMERAS - see Eastman.

CIRO CAMERAS, INC. (Delaware, Ohio).
Ciro 35 - Basically the same camera as the
Cee-Ay 35 camera from the Camera Corp.
of America. Ciro bought the design and dies
and made only minor cosmetic changes.
It still did not fare well, and soon was in the
hands of Graflex. Graflex sold the Ciro 35,
then modified it to make the Graphic 35.
The Ciro 35 is a 35mm RF camera ca. 1949-
1954. Three models: R- f4.5, S- f3.5, and
T- f2.8. $18.

Ciroflex - common 6x6cm TLR ca. 1940's.
Models A through F, all similar, with each new
model offering a slight improvement. $21.

CITOSKOP — see Contessa.

CLACK - see Agfa, Reitzschel.

CLARISSA - see Contessa.

CLAROVID - see Rodenstock.

CLARUS CAMERA MFG. CO. (Minneapolis)
MS-35 - Rangefinder 35mm camera, made
from 1946-1952. Interchangeable f2.8/50mm
Wollensak Velostigmat lens. Focal plane sh.
to 1000. (Shutters tend to be erratic and
sluggish, which would decrease the value from
the listed price.) $35. *Note: The Clarus
company never did well, because they could
not escape their reputation, although they
finally managed to make their camera work.*

CLICK - see Agfa.

CLIMAX - see Anthony.

CLIPPER - see Agfa, Ansco.

CLIX - cheap 120 box camera. $5.

CLOSE & CONE (Chicago, Boston, & NY)

Quad - Box-plate camera ca. 1896. The only
camera using the new "Quadruple plateholder",
an unusual mechanism which turned the four
plates into the focal plane. The camera which
measured 4-5/8x4-5/8x6" for 3½x3½ plates

29

was advertised in 1896 as "the largest picture and smallest camera combined ever made", and it cost $5.00 new. $78.

CMC - Japanese 14mm novelty camera. $8.

COCARETTE - see Contessa-Nettel, Zeiss.

COLLY - Japanese novelty camera. Takes 14x14mm exp on 16mm film. Simple shutter, Meniscus lens. $8 (USA) $16 (EUR).

COLORETTE - see Braun.

COLORFLEX - see Agfa.

COLORIST STEREO CAMERA - see Bell &H.

COLUMBIA OPTICAL & CAMERA CO. (London) - Pecto No. 1A - 4x5 plate camera. Red bellows. $55.

Pecto No. 5 - ca. 1897 folding bed camera for 9x12cm plates. B&L RR lens. Unicum sh. DEB. Rising front. Leather covered wood body. $55 (USA) $112 (EUR).

COMBINATION CAMERA - see Thompson.

COMMANDER - see Ansco.

COMPAGNIE FRANCAISE DE PHOTO-GRAPHIE

Photosphere - ca. 1888 - One of the first all-

metal cameras. For 9x12cm plates, or could take special roll back for Eastman film. Shutter in form of a hemisphere. $964.

COMPASS CAMERAS LTD. (London)

Compass Camera - *Mfd. by Jaeger LeCoultre & Cie., Sentier, Switzerland for Compass Cameras Ltd.* The ultimate compact 35mm rangefinder camera system. A finely machined aluminum-bodied camera of unusual design and incorporating many built-in features which include: f3.5/50mm lens, RF, right-angle finder, panoramic & stereo heads, level, extinction meter, filters, ground glass focusing, etc. For 24x36mm exposures on glass plates, or on film with optional roll back. $710.

COMPETITOR - see Seneca.

CONCAVA - see Tessina.

CONDOR - see Galileo Optical Co.

CONLEY CAMERA CO. (Rochester, Minn.)
In addition to the cameras marketed under their own label, Conley also made many cameras for Sears, Roebuck & Co. which were sold under the Seroco label, or with no identifying names on the camera.
Kewpie box cameras:
No. 2 - For 120 film. Loads from side. Rotating disc stops on front of camera. $7.

No. 2A - for 2¼x4½ exp. $11.
No. 3 - 3¼x4¼ - $10;
No. 3A - 3¼x5½ "postcard" size. $16.

Folding plate cameras:
3¼x5½ - postcard size - ca. 1900-1910. Vertical folding camera. Fine polished wood interior. Nickel trim. Red bellows. f8/6½"

lens in Wollensak Conley Safety Shutter. Double extension. $36.

Conley Junior - folding rollfilm cameras, similar in style to the better known Kodak folding rollfilm cameras. $14.

4x5 Folding Plate Camera - ca. 1900-1910. Black leathered wood body. Polished cherry interior. Red bellows. Usually with Conley Safety Shutter and one of the following lenses: Wollensak Rapid Symmetrical, Rapid Orthographic, Rapid Rectilinear, or occasionally with the Wollensak 6"-10"-14" Triple Convertible (worth more). Normally found in case side by side with holders "cycle" style. The 4x5 is the most commonly found size of the Conley folding models. $45.

5x7 Folding Plate Camera - except for size, similar to the two previous listings. $53.

Magazine Camera - Leather covered wooden box camera for 12 plates 4x5". Plates advanced by crank on right side of camera. $47.

Stereo box camera - For 4¼x6½" plates. Simple shutter, I & T. Meniscus lens. $350.

CONTAFLEX - see Zeiss.
CONTAX - see Zeiss.

CONTESSA, CONTESSA-NETTEL (Stuttgart) - *Contessa merged with Nettel in 1919. In 1926, a large merger joined Contessa-Nettel with Ernemann, Goerz, Ica, and the Carl Zeiss Optical Co. to form Zeiss-Ikon. See also Nettel, Zeiss.*
Adoro - 9x12cm folding plate camera. f4.5 Tessar. Compur. DEB. $27.

Altura - 3¼x5½ - Citonar 165mm lens in dial-set Compur shutter. $50.

Folding rollfilm camera - 3¼x5½ "postcard" size, on 122 film. Vitar Anastigmat f6.3 in B&L Compound shutter. Similar to the Kodak folding rollfilm cameras which are much more common. $22.

6½x8½ View Camera - The least common size among Conley cameras. $100.

8x10 View Camera - Prices vary depending on accessories, particularly lens and shutter, since large format shutters and lenses still have some value as useful equipment. $50-125.

Citoskop Stereo - ca. 1924. 45x107mm. f4.5/65mm Tessar lenses. Stereo Compur. $174.

Clarissa - Tropical model - 4.5x6cm plate camera. Light colored wood body with red bellows. Brass struts, standard, and lens barrel. Focal plane sh. 1/20 to 1000. Meyer Görlitz Trioplan f3/75mm. $513.

Cocarette - folding bed rollfilm cameras made in 2 sizes ca. 1930's. 6x9cm on 120 film & 2½x4¼" on 116 film. Many combinations of shutters & lenses. $39.

Deckrullo-Nettel - folding plate camera with

focal plane shutter. 9x12cm size with Zeiss Tessar f4.5/150mm, or 10x15cm size with Tessar f4.5/180mm. Black leather covered body. Ground glass back. $129.

Deckrullo (Tropical model) - ca. 1927 folding 9x12cm plate camera. Teakwood body partly covered with brown leather. Light brown bellows. f4.5/120mm Tessar. FP shutter to 1/2800 sec. $340.

Deckrullo-Nettel Stereo - 6x13 cm size. Focal plane sh. Tessar f4.5/90mm. $237.

Deckrullo Stereo (Tropical model) - folding teakwood bodied stereo camera for 9x12cm plates. f2.7/65mm Tessars. FP sh. to 2800. GG back, brown bellows, nickel trim. $620.

Donata - 6.5x9cm and 9x12cm sizes. Folding plate or pack camera ca. 1920's. f6.3 Tessar or f6.8 Dagor. Compur sh. GGB. $23.

Duchessa - 4.5x6cm folding plate camera ca. 1920's. f6.3/75mm Citonar Anastigmat. Compur 1-100. $68.

Ergo - Monocular-shaped camera for 4.5x6cm plates. *(Earlier model was the Nettel Argus, later model was the Zeiss-Ikon Ergo.)* Tessar f4.5/55mm. Compur 25-100, B. Right angle finder. $680.

Miroflex - Single lens reflex ca. 1924 for 9x12 plates. Tessar 4.5/150mm lens. FP sh to 2000. *The later Zeiss-Ikon Miroflex is more often found than the Contessa models.* $192.

Nic 63 - 9x12cm folding plate camera. Single extension bellows. GGB. Periskop Aplanat lens. Simple TBI shutter. $15.

Onito - 9x12cm. Nettar Anast. f4.5/135mm. Ibsor 1-100. $19.

Picolette - 1920's folding vest-pocket camera for 4x6.5cm exp on 127 film. f4.5/75mm Tessar, f6.3 Triotar, or f11 meniscus lenses. Dial Compur or Achro shutter. $52.

Sonnar - folding 9x12cm plate camera. DEB. f4.5/135 Contessa-Nettel Sonnar. Compur 1-200. $37.

Sonnet - folding plate camera ca. 1920's. 4.5x6cm and 6.5x9cm sizes with teakwood bodies. 4.5 Zeiss lens. Dial Compur 1-300. Light brown bellows. $204.

Stereax - stereo camera , 45x107mm size. Focal plane shutter. $240.

Steroco - a cheaply made stereo camera for 45x107mm. f6.3 Tessars, Compur. $105.

Taxo - 9x12cm folding plate camera. f8/135 Extra Rapid Aplanat. Duvall sh.to 100. $22.

Tessco - 10x15cm folding plate camera. DEB. GGB. Contessa-Nettel Sonnar f4.5/135mm. Dial Compur 1-200. $31.

Tropical model plate cameras - ca. 1920's 6x9cm size. Zeiss Tessar f4.5/120. Compur shutter 1-250. Finely finished wood, reddish-brown bellows, brass trim or combination of brass and nickel trim. *Because this is a misc. listing, we can only give you a general price range. Value of a particular example will depend on condition, features, etc.* $165-210.

CONTINA - see Zeiss.

CORFIELD (England)
Periflex - 35mm Leica copy ca. 1960 for 36 exp 24x36mm. Interchangeable f2.8/50mm Lumax or f1.9 or f2.8/45mm. Focal plane shutter to 1000. Unusual through-the-lens periscope reflex rangefinder. $183.

CORNU CO. (Paris)
Ontobloc - ca. 1935 35mm compact camera. Dark grey hammertone painted cast metal body. Som Berthiot Flor f3.5/50mm lens in Prontor II - T, B, 1-200. $40.
Ontoflex- TLR, Berthiot f3.5, Compur. $225.

Reyna II - Telescoping front 35mm camera. Berthiot Flor f3.5/50. Compur Rapid to 500. Front lens focus. Black hammertone painted cast metal body. $26.

Reyna Cross III - black painted cast aluminum bodied 35mm. f3.5 Berthiot or f2.9/45mm Cross. Two blade sh. 25-200, B. $20.

CORONET CAMERA CO. (Birmingham, GB)
Midget - a small dark red bakelite 16mm novelty camera. Taylor Hobson Meniscus lens f10. Single speed (1/30). Six exposures per special roll. (Orig. price $2.50). $24.

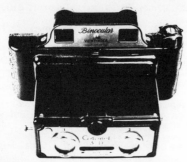

"3-D" Stereo Camera - an inexpensive plastic stereo camera for 4 stereo pairs or 8 single exp. 4.5x4.5cm on 127 film. Single speed shutter. Twin meniscus lenses. $26.

Vogue - a brown bakelite-bodied folding camera which uses "Vogue 35" film, a spool film similar to Eastman Kodak 828. Fixed focus lens. Simple B&I shutter. $30.

CORSAIR - see Universal Camera Corp.

COSMIC - Russian 35mm of the mid-1960's. f4/40mm lens. Shutter 1/5-1/250. $15.

COSMO-CLACK - see Reitzschel.

CRAFTSMAN - see Ansco.

CROSS - see Cornu.

CRYSTAR - novelty camera for 14x14mm exp on 16mm film (paper-backed rollfilm) $7.

CUB - see American Adv. & Research Corp.

CUPID - see Houghton.
CUPIDO - see Ica.

CYCLONE - *Cyclone cameras were originally manufactured by the Western Camera Co. until about 1899, when they were taken over by the Rochester Optical Co., which continued to produce Cyclone models. We have listed Cyclone models under each of these makers.*

CYCLOPS - 16mm Japanese binocular camera ca. 1950's. f4.5/35mm lens. Shutter 25-100. Identical to the Teleca camera. $203.

DACI - German red metal box camera for 12 exp. 6x6cm on 120 film. $8.

DAGUERREOTYPE CAMERAS - *The earliest type of camera in existence, many of which were one-up or limited production cameras. Since so few of even the commercially made models have survived time, most Daguerreotype cameras are unique pieces, and price averaging is senseless. However, to keep the novice collector or casual antique dealer from making any big mistakes before consulting with a recognized authority, we will give one*

example: A half-plate American sliding box-in-box style is likely to be in the $5,000. & up range.

DAIICHI KOGAKU (Japan)
Zenobia - ca. 1949 folding camera for 16 exp. 4.5x6cm on 120 film. Styled like the early Zeiss Ikonta cameras. f3.5/75mm Hesper Anastigmat. DOC Rapid shutter 1-500, B. (Similar to the Compur Rapid). $19.

DALLMEYER - (J. H. Dallmeyer, London)

Dallmeyer "Speed" Camera - mid-1920's camera for 4.5x6cm exposures. This press-type camera is equipped with the Dallmeyer "Pentec" f2.9 lens, the fastest anastigmat lens of its time. This lens, as well as the 1/8 to 1/1000 sec. FP shutter account for the camera's name. $186.

DALO Detective camera - $40.

DAN 35 - ca. 1950 compact camera for 15 exp. 24x24mm on 828 film. Dan Anastigmat f4.5/40mm. Shutter B, 25-100. $27.

DANCER - (J.B. Dancer, Rochester, England) **Stereo Camera** - ca. 1856. For stereo pairs on 12 plates 3½x7". A nicely finished wooden camera which recently set a new record for the highest price paid for an antique camera. $37,500.00 .

DANGELMEIER (Reutlingen, Germany)
Decora I - folding camera for 12 exp. 6x6cm on 120. Eunar f3.5/75. Prontor 1-100. $10.

DARLING-16 - subminiature $25.

DAYDARK SPECIALTY CO. (St. Louis, Mo)
Photo Postcard Cameras - "Street" cameras for photo postcards or tintypes, complete with developing tank, dark sleeve, RR lens, and Blitzen Daydark shutter. $150.

Tintype Camera - small amateur model. Measures 4½x5x7¼. $85.

DAYLIGHT ENLARGING CAMERA - see Anthony.

DAYLIGHT KODAK - see Eastman.
DAYSPOOL - see Lizars.
DAY-XIT - see Shew.

DEBRIE (Ets. Andre Debrie, Paris)

Sept - ca. 1920's spring motor drive camera for still, rapid sequence, or cine. 18x24mm on 35mm film. Roussel Stylor f3.5/50mm. One model has square motor, the other style has round motor. $121.

DECKRULLO - see Contessa, Nettel.
DECORA - see Dangelmeier.

DEHEL - French 120 rollfilm camera. f3.5/75mm lens. AGC shutter. $13.

DEJUR - TLR. f3.5 lens. 10-200 sh. $23.

DELMAR - see Seroco .
DELTA - see Krugener, also Delta (below).

DELTA STEREO - American 35mm stereo camera ca. 1950's. $25.

DEMARIA (Demaria Freres, Demaria-La-Pierre, Paris)

Jumelle Caspa - (Demaria Freres) - 6x13mm stereo camera. $118.

Stereo camera for 45x107mm plates - RR lenses. Ca. 1910. $162.

DERLUX - (France) - folding camera with polished aluminum body. Gallus Gallix f3.5/50mm. FP sh. B, 25-500. $40.

DEROGY - (Paris) -
Wooden plate camera - ca. 1880. 9x12cm. Derogy Aplanat No. 2 brass barrel lens. Black tapered bellows, polished wood body, brass trim. $158.

DETECTIVE CAMERAS - *The earliest "Detective" cameras were simply designed as a box or case. Before long, they were disguised in all shapes and sizes. Disguised and detective cameras seem to have a special appeal and therefore the prices have been staying well ahead of our inflationary economy. The original box, case, and satchel cameras are commonly referred to by the name "detective" cameras, while the later disguised/concealed varieties normally are not. In either case, they are listed by name of manufacturer.*

DETROLA CORP. (Detroit, Michigan)
Model B - 127 film camera. Duomicroflex f7.9 lens. $8
Model D - similar, f4.5 lens. $8.
Model E - similar, f3.5 lens. $8.
Model GW - small 127 film camera ca. 1940. basic f4.5 model. $23.
Model HW - similar, but with meter. $23.
Model KW - with anastigmat f3.5 lens. $23.
Model 400 - A Leica-inspired CRF 35mm camera with interchangeable Wollensak Velostigmat f3.5 or f2.8 lens. Focal plane shutter to 5000. Sync. (Orig. cost abt.$70). $48,

DEVIN COLORGRAPH CO. (New York)
Tri-Color Camera - for making color separation negatives. Original professional size for 5x7". Apo-Tessar f9/12" lens. Dial Compur shutter. $270.
– – 6.5x9cm size - introduced ca. 1938. Goerz Dogmar f4.5/5½" lens. Compound shutter. $295.

DEVRY (QRS DeVry Corp., Chicago)

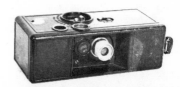

QRS Kamra - Brown bakelite camera introd. in 1928, taking 35mm film in special 40 exp. cartridges. Graf 7.7 Anastigmat lens. Single speed shutter trips by counter-clockwise motion of winding crank. (Winding cranks often broken and missing. Bakelite bodies tend to warp occasionally.) $34.

DIAL 35 - see Bell & Howell.
DIAX - see Voss.

DICK TRACY - Plastic camera for 127. $14.
DIPLOMAT - 14mm novelty camera. $8.

DIRECT – DURST

DIRECT POSITIVE CAMERA - see Wabash.
DIVA - see Phoba.
DOLLAR CAMERA - see Ansco.
DOLLINA, DOLLY - see Certo.
DONALD DUCK CAMERA - see Herco.
DONATA - see Contessa, Zeiss.
DOPPEL BOX - see Certo.

DORIS - Post-war folding 120 camera. f3.5/75mm lens. $8.

DOSSERT DETECTIVE CAMERA CO., NYC.

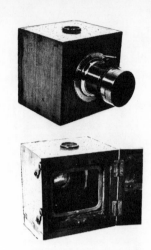

Detective Camera - 4x5 box-plate detective camera with reflex viewing. ca. 1890. Leather covered to look like a satchel. Sliding panels hide lens and ground glass openings. Entire top hinges forward to reveal the plate holders for loading or storage. $550.

DOVER FILM CORP. -
Dover 620 A - A plastic & chrome camera ca. 1950 for 16 exp. 4.5x6cm on 620 film. Somco f9 meniscus lens. 5 rotary disc stops. Single speed shutter. Built-on flash. $18.

DUAFLEX, DUEX, DUO - see Eastman.

DUBRONI - (Maison Dubroni, Paris)
The name Dubroni is an anagram formed with the letters of the name of the inventor, Jules Bourdin. Although anagrams and acronyms have always had a certain appeal to writers and inventors, the story in this case is quite interesting. It seems that young Jules, who was about twenty-two years old when he invented his camera, was strongly influenced by his father. The father, protective of the good reputation of his name, didn't want it mixed up with this new-fangled invention.

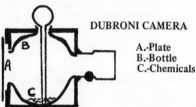

DUBRONI CAMERA

A.-Plate
B.-Bottle
C.-Chemicals

Le Photographe de Poche - ca. 1860's wooden box camera with porcelain interior for in-camera processing. Several models and sizes were made. Recent offers to sell ranged from $1800.00 to $2500.00.

DUCA - see Durst.

DUCATI - (Milan, Italy)
Half-frame 35mm. RF camera - for 15 exp. 18x24mm on 35mm film in special cassettes. ca. 1938. Interchangeable lenses. Normally with f3.5 or 2.8 Vitor, or f3.5 Ducati Etar lens, 35mm focal length. FPsh. to 500. $213.

DUCHESS - British ½-plate field camera ca. 1887. Mahogany body, brass trim, maroon bellows. RR brass barrel lens. $198.

DUCHESSA - see Contessa.

DUPLEX - see Ihagee, Iso (Duplex Stereo), Joux (Ortho Jumelle Duplex) , Thornton-Picard (Duplex Ruby Reflex).

DURST S.A.
Most photographers know Durst for their enlargers. However, at one time they made some solid, well constructed, innovative cameras.

Automatica - ca. 1956 for 36 exp. 24x36mm

on standard 35mm cartridge film. Schneider Durst Radionar f2.8/45mm. Prontor 1-300, B, and Auto. (Meter coupled to shutter by pneumatic cylinder.) $117.

Duca - ca. 1946 for 12 exp. 24x36 on Agfa Karat Rapid cassettes. Ducan f11/50mm. T & I shutter. Zone focus. Rapid wind. Aluminum body. $54.

Durst 66 - ca. 1950 compact camera for 12 exp. 6x6cm on 120 film. Light grey hammertone painted aluminum body with partial red leather covering. Durst Color Duplor f2.2/80mm lens. Shutter ½-200, B, sync. $44.

EASTMAN DRY PLATE & FILM CO.
EASTMAN KODAK CO.

The first camera produced by the Eastman Dry Plate & Film Co. was called "The Kodak", and successive models were numbered in sequence. The first seven cameras listed here are the earliest Kodak cameras, and the remainder of the listings under Eastman Kodak Co. are in alphabetical order by series name and number. Some of the Eastman models listed are continuations of a line of cameras from another company which was taken over by Eastman. Earlier models of many of these cameras may be found under the name of the original manufacturer.

The Kodak Camera.

The Kodak Camera - (original model) - ca. June , 1888 through 1889. Made by Frank Brownell for the Eastman Dry Plate & Film Co. Factory loaded with 100 exposures 2½" diameter. Cylindrical shutter, string set. Rapid Rectilinear lens f9/57mm. This was the first camera to use rollfilm, and is a highly prized collectors' item. $2,500 (USA), $4300. (EUR).

No. 1 Kodak Camera - 1889-1895 - Similar to the original model, but with sector shutter rather than cylindrical. Factory loaded for 100 exp. 2½" dia. RR lens f9/57mm. $845.

No. 2 Kodak Camera - Oct. 1889-1897 - Also similar and still quite rare, but more common than the previous models. Factory loaded for 60 exp. 3½" dia. $424.

No. 3 Kodak Camera - Jan. 1890-1897 - A string-set box camera, factory loaded for either 60 or 100 exp. 3¼x4¼. Bausch & Lomb Universal lens, sector shutter. $358.

No. 3 Kodak Jr. Camera - Jan. 1890-1897. A relatively scarce member of the early Kodak family. Factory loaded with 60 exp. 3¼x4¼ on rollfilm. Could also be used with accessory plate back. B&L Universal lens, sector shutter, Overall size: 4¼x5½x9". $373.

No. 4 Kodak Camera - Jan. 1890-1897 - String-set box camera, factory loaded for 48 exp. 4x5", but with capacity for 100 exp. for prolific photographers. B&L Universal lens, sector shutter. $365.

No. 4 Kodak Jr. Camera - Jan. 1890-1897. Similar to the No. 3 Kodak Jr. Camera, but for 4x5". Factory loaded for 48 exp. on roll-film. B&L Universal lens, sector shutter. Can also be fitted for glass plates. $365.

Anniversary Kodak Box Camera - A special edition of the No. 2 Brownie Kodak, issued to commemorate the 50th anniversary of Eastman Kodak Co. Approximately 400,000 were given away to children 12 years old in 1930. Covered with a tan colored reptile-grained paper covering with a gold-colored foil seal on the upper rear corner of the right side. (On a worn example, the gold coloring of the foil seal may have worn off and left it looking silver). $9. (Mint Cond. - $15).

AUTOGRAPHIC KODAK CAMERAS
The Autographic feature was introduced by Kodak in 1914, and was available on several lines of cameras. Listed here are those cameras without any key word in their name except Autographic, Kodak, or Special.
AUTOGRAPHIC KODAK
No. 1A - for 2½x4¼ exp. on No. A-116 film. RR lens f7.7/130mm. BB sh. 25-100. Black leather and bellows. $15.
No. 2 - 2¼x3¼ $8.
No. 2A - 2½x4¼ on 116. $12.
No. 2C - ca. 1916-1924. 2-7/8 x 4-7/8" on 130 film. $12.
No. 3 - ca. 1914-1926 - 3¼x4¼ on 118 film. f7.7/130mm lens. BB shutter. $16.
No. 3A - ca. 1914-1924. 3¼x5½ (post-card size) on 122 film. Kodak Anastigmat f7.7/170mm. Ilex or BB sh., 25-100 sec. This is the most common size of the Autographic Kodak Cameras. $20.
No. 4 - 4x5" size. Red bellows. $40.

AUTOGRAPHIC KODAK JUNIOR CAMERAS
No. 1 - for 2¼x3¼ on 120 film. ca. 1914-1924. Kodak Anastigmat f7.7 lens. BB sh., 25-100. $10. ($21. EUR).

No. 1A - for 2½x4¼ exp. on 116 film. $10. ($25. EUR).
No. 2C - ca. 1925-1927 for 2-7/8 x 4-7/8. A very common size in this line. $13.
No. 3 - 1914-1927. 3¼x4¼" on 124. $14.

AUTOGRAPHIC KODAK SPECIAL CAMERA
No. 1 - B&L lens. $31.

No. 1A - 1914-1927. Models with CRF, 1917-1928. 2½x4¼. $37.
No. 2C - 1923-1928 - $45.
No. 3 - 1914-1926. 3¼x4¼ on 118. $31.

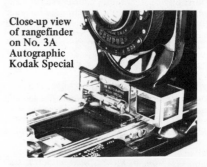

Close-up view of rangefinder on No. 3A Autographic Kodak Special

No. 3A - 1914-1927. Models with CRF, 1916-1933. 3¼x5½ on 122. $49. ($82. EUR).
No. 3A, Model B - $42.

BANTAM CAMERA - *June 1935-1941. For 28x40mm exp. on 828 rollfilm.*
f8 - 1938. Kodalinear f8/40mm. Rectangular telescoping front rather than bellows. $7.
f6.3 - 1935. Kodak Anastigmat f6.3/53mm. Collapsible bellows. $15.
f5.6 - 1938 - Kodak Anastigmat f5.6/50mm. Collapsible bellows. $22.
f4.5 - ca. 1938. Kodak Anastigmat f4.5/47mm Bantam sh. 20-200. Bellows. $23.
f3.9 RF - ca. 1953. Non-interchangeable f3.9/50mm Kodak Ektanon Anast. Sh. 25-300. Coupled rangefinder 3' to infinity. $25.

Flash Bantam Camera - 1947-1953. Kodak Anastigmat Special f4.5/48mm. Sh. 25-200. Bellows. (Orig. price around $50.) - $22.

Bantam Special Camera - 1936-1948. Compur Rapid Shutter (1st model ca. 1936-1940) is more common than the later model (ca. 1941-1948) with Supermatic shutter. Both models have coupled RF 3' to infinity.
With Compur Rapid shutter - - - $93.
With Supermatic shutter - - - $134.

BOY SCOUT KODAK CAMERA - ca. 1930-1934. For 1-5/8 x 2½" on 127 rollfilm. This is a vest-pocket camera in olive drab color with official Boy Scout emblem engraved on bed. $28.

BROWNIE CAMERAS -

No. 0 - (box) - A small (4x3¼x2½") box cam-

era of the mid-teens for 127 film. Slightly larger than the earlier "Pocket Kodak" of 1895. $13.

No. 1 - (box) - Introduced in February, 1900, this box camera was made to take a new-size film, No. 117 for 2¼x2¼ exposures. The back of the camera fit like the cover of a shoe-box. Constructed of cardboard, and measuring 3x3x5" overall, this camera lasted only four months in production before the back was re-designed. A rare box camera. $245.

No. 1 (box) (Improved) - In May or June of 1900, this improved model of the above was introduced, and became the first commercially successful Brownie camera. Although not rare, it is historically interesting. $31.

No. 2 - (box) - ca. 1901. Cardboard construction. For 6 exposures 2¼x3¼ on 120 film, which was introduced for this camera. Meniscus lens, rotary shutter. Later models even came in colors. $9.

Note: A special model of the No. 2 Brownie Camera was produced to celebrate the 50th Anniversary of Eastman Kodak Co. It is commonly called the Anniversary Kodak Box Camera, and is listed under "Anniv."

No. 2A - (box) - ca. 1902, cardboard box for 2½x4¼ on 116 film. Some later models came in colors. $7.

No. 2C - (box) - ca. 1916 for 2-7/8 x 4-7/8 on 130 film. $7.

No. 3 - ca. 1902 for 3¼x4¼ on 124 film. $9.

Baby Brownie Camera - Box ca. 1937 made of brown or black plastic. For 4x6.5cm exp. on 127 film. $6.

Beau Brownie Camera - ca. 1930-1932 - A simple No. 2 Brownie camera (box) for 120 film, but in classy two-tone color combinations. $15.

Brownie Bullet Camera - ca. 1957 - a premium version of the Brownie Holiday Camera. 4.5x6cm (1-5/8 x 2½") on 127. $4.

Brownie Bullseye Camera - ca. 1954 for 6x9cm on 620 film. $4.

Brownie Fiesta Camera - ca. 1962-1965 - $5.
Brownie Flash Camera - 2¼x3¼ on 620. $4.

FOLDING BROWNIE CAMERAS
Identifiable by their square-cornered bodies and horizontal format.

No. 2 - ca. 1904. Maroon bellows, wooden lens standard. For 2¼x3¼ on 120 film. $13. ($52. EUR).
No. 2A - 2½x 4¼ on 116 film. $20.

No. 3 - ca. 1903. 3¼x4¼ on 124. $20.

No. 3A - ca. 1909-1915. 3¼x5½ "postcard" size. Maroon bellows. $21.
Note: Of the Folding Brownie Cameras, the No. 3 and No. 3A are at least ten times more commonly found for sale than the other sizes, although prices are much the same. These cameras sell for about double the USA price in Europe.

FOLDING AUTOGRAPHIC BROWNIE CAMERAS—
No. 1A - $10.
No. 2 - 2¼x3¼ on 120 film. Ca. 1916. Very common. $11.
No. 2A - ca. 1921. 2½x4¼. The most common size of this line by far. $10.
No. 2C - ca. 1916. 2-7/8 x 4-7/8" exp. $10.
No. 3 - 3¼x4¼. $10.
No. 3A - ca. 1916-1926. 3¼x5½. $10.

FOLDING POCKET BROWNIE CAMERAS
No. 1A - 2½x4¼ - $10.

No. 2 - introd. 1907. 2¼x3¼" (6x9cm) $14. ($42 EUR).
No. 2A - ca. 1909 - 2½x4¼ on 116 film. Some with red bellows, some with black. $15.
No. 3 - ca. 1909. 3¼x4¼ on 124. $17.
No. 3A - ca. 1909. Red bellows. $18.

Brownie Hawkeye Camera - molded plastic box camera for 6x6cm exp. on 620 film. $4.
Brownie Holiday Camera - 1953-1957. 4x6.5 cm. exp on 127 film. $5.
Brownie Junior Camera - 616 or 620 box. $4.
Brownie Reflex 20 Camera - ca. 1959-1966. Various models: Twin 20, Flash 20, Flashmite 20, Fiesta. $5.
Brownie Special Camera - ca. 1940. Trapezoid-shaped box. Six-16 or Six-20 models. $4.
Brownie Six-16 Camera - ca. 1930 - box. $5.
Brownie Six-20 Camera - cardboard box camera for 620 film. $6.
Brownie Starflex Camera - ca. 1957-1963 for 4x4cm on 127 film. $5.
Brownie Starlet Camera - ca. 1956-1962 for 4x6.5cm on 127. Made in England. $3.
Brownie Starmatic Camera - 1959-1961. 4x4cm on 127 film. $8.

Stereo Brownie Camera - No. 2 - The successor to the Weno Stereo Camera, 1905-1910. For pairs of 3¼x2½" exposures on rollfilm. Red bellows. Stereo Brownie Cameras are much less common than comparable Stereo Hawkeye Cameras. $169. ($256 EUR).

Brownie Target Camera - 616 or 620. Metal and leatherette. $5.

exp. on No. 103 rollfilm, or could be used with single plate holder which stores in the rear of the camera. A large leather box. $70.

BULLET SPECIAL CAMERAS - *Similar to the Bullet cameras No. 2 & 4 above, but with a higher quality RR lens in Eastman Triple Action Shutter.*
No. 2 - $50.
No. 4 - $98.

BULLS—EYE KODAK CAMERAS - *After Eastman took over the Boston Camera Co., they continued Boston's line of cameras under the Kodak name. (See also Boston Bulls-Eye.) Bulls-Eye cameras are often stamped with their year model as were other early Kodak cameras. Leather exterior conceals a beautifully polished wooden interior.*
No. 1 - ca. 1896. $30. (Least common size).

BUCKEYE CAMERA - ca. 1899 when Eastman Kodak Co. purchased the American Camera Mfg. Co., who originated this model. The Eastman camera is nearly identical to the earlier version. A folding bed camera of all wooden construction, covered with leather. Lens standard of polished wood conceals the shutter behind a plain front. An uncommon rollfilm model. $87.

BULLET CAMERAS —
Bullet Camera - (Plastic) - cheap & simple torpedo-shaped camera with fixed focus lens mounted in a spiral-threaded telescoping mount. Common, inexpensive, yet novel. $8.

No. 2 - ca. 1896-1913. Leather covered wood box which loads from the top. 3½x3½ exp. on 103 rollfilm or double plateholders. Rotary disc shutter. Rotating disc stops. $30. USA, $55. Eur.

No. 2 Bullet Camera - (1895-1896) and improved model (1896-1900) - Box camera for 3½x3½ exp. on glass plates or on No. 101 rollfilm which was first introduced in 1895 for this camera. Measures 4¾x4¾x6¼". Some models named by year and marked on the camera. $40.

No. 3 - 1908-1913 - This model loads from the side. 3¼x4¼ on No. 124 film. Less common than the No. 2 and No. 4. $37.

No. 4 Bullet Camera - 1897-1900. For 4x5"

No. 4 - 1896-1904 - Nine models. Side-loading

4x5" box for 103 rollfilm. Internal bellows focus by means of outside lever. $58.

FOLDING BULLS-EYE CAMERA - No. 2 - ca. 1899. For 3½x3½ exp. Scarce. $85.

BULLS-EYE SPECIAL CAMERAS: *Similar to the Bulls-Eye (box) cameras above, but with higher quality RR lens in Eastman Triple Action Shutter.*

No. 2 - 3½x3½", ca. 1898. $65.
No. 4 - 4x5" exp. on 103 rollfilm. ca. 1896-1904. $68.

CARTRIDGE KODAK CAMERAS - *Made to take "cartridge" film, as rollfilm was called in the early years.*
No. 3 - ca. 1900-1907, for 4¼x3¼ exp. on No. 119 rollfilm, which was introduced at the same time. This is the smallest of the series. Eastman Triple Action pneumatic sh. $66 USA, $108 EUR.

No. 4 - ca. 1897-1907. for 5x7" exp. on 104 rollfilm, which was introduced for this camera. This is the first of the series. Leather covered wood body, polished wood interior. Red bellows. B&L RR lens, Kodak Automatic Shutter. (Orig. price about $25.) $54 USA, ($92 EUR).

No. 5 - ca. 1898-1900. (First model with wood lens board and bed.) Later model with metal lens board 1900-1907. For 7x5" exp. on No. 115 rollfilm, which was introduced in 1898 for this camera, or on plates. No. 115 rollfilm was 7" wide to provide the 7x5" vertical format. Red bellows. Bausch & Lomb Rapid Rectilinear lens. $91.

CHEVRON - 1953-1956 for 2¼x2¼ on 620. Kodak Ektar f3.5/78mm or Wollensak f2. Synch. Rapid 800 shutter. $88.

CIRKUT CAMERAS, CIRKUT OUTFITS: *Manufactured by the Century Camera Division of Eastman Kodak Co. beginning about 1905. Basically, a Cirkut OUTFIT is a revolving-back cycle view camera with an accessory Cirkut back, tripod, and gears. A Cirkut CAMERA is designed exclusively for Cirkut photos and cannot be used as a view camera. Both types take panoramic pictures by revolving the entire camera on a geared tripod head while the film moves past a narrow slit at the focal plane and is taken up on a drum which is connected via a pinion gear to the large stationary gear which is part of the tripod head. These cameras are commonly numbered according to film width, the common sizes being 5, 6½, 8, and 10".* NOTE: All prices listed here are for complete outfits with tripod and gears.

No. 5 Cirkut Camera - with Turner Reich Triple Convertible lens - $300.

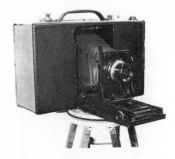

No. 6 Cirkut Camera - Triple convertible. $360.

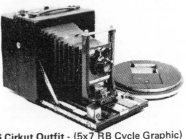

No. 6 Cirkut Outfit - (5x7 RB Cycle Graphic) With Series II Centar lens - $400. With Graphic Rapid Rectilinear convertible 5x7 lens - $450.

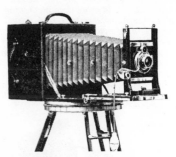

No. 8 Cirkut Outfit - (also uses 6" film.) 6½x8½ RB Cycle Graphic. With Triple Convertible lens - $570.
No. 10 Cirkut Camera - (also uses 6 or 8" film.) With Triple Convertible lens. $876.
No. 16 Cirkut Camera - (also for 8, 10, or 12" film.) $1,200.

DAYLIGHT KODAK CAMERAS : *The Daylight Kodak Cameras are the first of the Kodak string-set cameras not requiring darkroom loading. All are rollfilm box cameras with Achromatic lens and sector shutter. Made from 1891 to 1895, each took 24 exposures on daylight-loading rollfilm.*

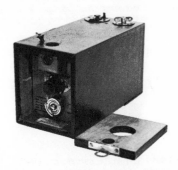

"A" - 2¾x3¼". (orig. cost - $8.50) $1,000.
"B" - 3½x4". (orig. cost.- $15.00) $385.
"C" - 4x5". (orig. cost - $25.00) $555.

DUAFLEX - cheap TLR for 6x6cm on 620. Models I-IV, 1949-1960. f8 Kodar lens. $4.

DUEX - 1940-1946 for 4.5x6cm on 620 film. Doublet lens. $17.

DUO-620 - 1934-1937 folding camera for 16 exp. 4.5x6cm (1-5/8 x 2¼") on 620 film. Made in Germany. f3.5/70mm Kodak Anast. or Zeiss Tessar lens. Compur or Compur Rapid shutter. $46.

Duo-620, Series II - 1937-1939. (Rangefinder model 1939-1940). With Kodak Anastigmat f3.5/75mm lens - $47. With Schneider Xenar f3.6 lens - $155.

EASTMAN PLATE CAMERA - No. 4, Series D. - (ca. 1903) - 4x5" folding-bed cycle style

plate camera with swing back more typical of some of Rochester Opt. Co. earlier models. Double ext. bellows. RR lens. Kodak sh. $90.

EKTRA - 35mm RF camera ca. 1940's. Interchangeable lenses & magazine backs. FP shutter to 1000. A precision camera which originally sold for $375 with the f1.9/50mm. lens.
With f1.9/50mm lens only - $207.
With f1.9/50, f3.5/90mm, & f3.3/35. - $475.
With all of the above plus f3.8/135mm. $890.

EUREKA - *1898-1899 box camera for glass plates in standard holders which insert through side-opening door. Storage space for additional holders.*
No. 2 - 3½x3½ exp. on plates or on No. 106 Cartridge film in roll holder. $68.
No. 2, Jr. - same size, but less expensive model when new. $54.
No. 4 - made in 1899 only. For 4x5 " exp. on No. 109 Cartridge film in roll holder. $78.

FLEXO - No. 2 - 1899-1913. Box camera for 12 exp. 3½x3½" on No. 101 rollfilm. The most unusual feature is that the sides and back come completely off for loading, and are held together only by the leather covering. It is very similar in outward appearance to the Bulls-Eye series, but was slightly cheaper when new. The same camera was marketed in Europe under the name "Plico". Achromatic lens, rotary shutter. (Orig. cost $5.00) - $40.

FLUSH BACK KODAK CAMERA - No. 3 - ca. 1902 - an uncommon folding camera for 3¼x4¼ exp. on 118 film, or for glass plates. B&L RR lens in B&L Auto shutter. $63.

FOLDING KODAK CAMERAS - *There are two distinct styles of "Folding Kodak" cameras which share little more than a common name. The earlier models, numbered 4, 5, and 6 by size, resemble a carrying case when closed, and are easily identifiable by the hinged top door which hangs over the sides like a box cover. The later models can be distinguished from the early ones by their vertical format, rounded body ends, etc. in the more common style. We are listing the early models first, followed by the later ones.*

FALCON - No. 2 - 1897-1899 rollfilm box cameras for 3½x3½" exp. on No. 101 rollfilm. Knob on front of camera to cock shutter. Leather covered wood. $46.

FIFTIETH ANNIVERSARY BOX CAMERA - see Anniversary Kodak Box Camera.

FLAT FOLDING KODAK CAMERA - 1895. Kodak's first folding camera with integral roll-film back. $412.

No. 4 Folding Kodak (Satchel-style) - ca. 1890-1892. (Improved model 1893-1897) - For 48 exp. 4x5" on glass plates or rollfilm in roll-holder. Non-tapered black bellows. $458.

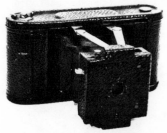

(Original) - 1898-1904 for 2¼x3¼ exp. on No. 105 rollfilm. Leather covered front pulls straight out. Double finders concealed behind leather covered front. Red bellows. The very earliest production models had brass struts, and sells for $125. Normally found with the nickeled struts indicative of later production models. $43.
No. 0 - Similar in style to the original. Made from 1902-1906 for 1-5/8 x 2½" exposures on No. 121 film which was introduced also in 1902. It is the smallest of the series. $74.

No. 5 - Similar specifications, but for 5x7" film or plates. B&L shutter. $452.
No. 6 - Similar, but for 6½x8½. This size is even less common than the others. $1,000.

FOLDING KODAK CAMERAS (Later models)

No. 1A - ca. 1902. f6.3/100mm lens in Diomatic shutter. $21.
No. 2 - $14.
No. 3 - ca. 1902. For 3¼x4¼ on 118 rollfilm. f5.6/130. Diomatic shutter. $16.
No. 3A - 3¼x5½ on 122. f7.7/ lens in Diomatic shutter. Red bellows. $23.

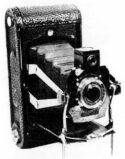

No. 1 - 1898-1904. for 2¼x3¼ exp. Recognizable by the domed front door, red bellows, and the twin sprung struts for the lensboard. Wooden lens standard. Some models had a single finder ($28), others had two ($38).

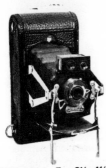

No. 4, Models A & B - 1907-1914. For 4x5" exp. Red or black bellows. Wood trim on bed. B&L RR lens, Kodak Automatic sh. $47.

No. 4A - April 1906-April 1915, for 6 exp., 4¼x6½ on No. 126 rollfilm. (126 rollfilm was made from 1906-1949, and is not to be confused with the more recent 126 cassettes.) B&L RR lens, B&L Auto sh. Red bel. $92.

FOLDING POCKET KODAK CAMERAS :

No. 1A - 1899-1904 - For 2½x4¼" exp. on 116 rollfilm. Domed front door, twin sprung struts,

red bellows. Later models (lettered through D) with Pocket Automatic Shutter until 1915. (Orig. cost -$12.) - $23 USA, ($42. EUR).

No. 3 (Later models) - ca. 1904-1915. Flat rectangular front door. B&L lens & shutter. $23.

No. 2 - 1899-1903 - A horizontal styled camera for square exposures 3½x3½ on No. 101 rolls. This model did not have a self-erecting front, as the two previous listings. Bed folds down, and front standard pulls out on track. First model has leather covered lensboard with recessed lens and shutter. Later models have wooden standard with exposed shutter & lens. $26.

No. 3A - 1903-1908 (Later models to 1915.) 3¼x5½ on 122 film. Flat, rectangular front door. Red bellows. Polished wood insets on bed. By far the most common model of the FPK series. $23.
No. 4 - 4x5" size on No. 123 film. ca. 1906-1915. Red bellows, polished wood insets on bed. f8 RR lens. No. 2 B&L or Kodak BB sh. (Orig cost, $20-25) $51 USA. ($79 EUR).

FOLDING POCKET KODAK SPECIAL CAMERAS- *Similar to the above, but fitted with a better lens, shutter, or leather covering.*
No. 1A - ca. 1900-1912, 116 film. Red leather bellows, RR lens & Kodak shutter. $25. With Cooke or Zeiss-Kodak Anastigmat lens in Compound shutter - $32.
No. 3A - with Zeiss-Kodak Anastigmat f6.3 in Compound shutter. $42.

No. 3 (Early models, A & AB) - ca. 1900-1903. Vertical style folding-bed type. Leather covered lensboard conceals rotary shutter. For 3¼x4¼ exposures on 118 rollfilm. $25.

HAWKETTE No. 2 - ca. 1930's British made folding Kodak camera for 2¼x3¼ exp. on 120 rollfilm. Folding style like the Houghton Ensignette with cross-swinging struts. Body of bakelite plastic. $15.

HAWKEYE CAMERAS - *The Hawkeye line originated with the Blair Camera Co. and was continued by Kodak after they absorbed the Blair Co. See also Blair Hawkeye.*

CARTRIDGE HAWKEYE — (Box cameras)
No. 2 (2¼x3¼) ca. 1924-1930. $8.
No. 2A (2½x4¼) ca. 1924-1930. $8.

FILM PACK HAWKEYE - No. 2 - ca. 1899-1916. Box camera for 2¼x3¼ film packs. All metal construction. $10.

FOLDING CARTRIDGE HAWKEYE -
No. 2 - ca. 1913-1930. 2¼x3¼ on 120 film. Kodex sh. Horizontal format. $12.
No. 2A - 1913-1930 - 2½x4¼ on 116 film. Single Achromatic or RR lens. $11.
No. 3A - 1913-1933 - 3¼x5½ on 122 film. Kodex sh, RR or Achromatic lens. $21.

GIFT KODAK CAMERA - ca. 1930-1931. A No. 1A Pocket Kodak Camera for 2½x4¼" exposures on No. 116 film, but in a special rendition. The camera is covered with brown genuine leather, and decorated with an enameled metal inlay on the front door, as well as a matching metal faceplate on the shutter. The case is a cedar box, the top plate of which repeats the art-deco design of the camera. Orig. price in the 1930 Christmas season was just $15.00. Now $112.

Girl Scout Kodak in case, showing insignia plate.

FOLDING FILM PACK HAWKEYE - No. 2 - ca. 1923. Hawkeye sh. Meniscus Achromatic lens. 2¼x3¼ exp. on film packs. $10.

FOLDING HAWKEYE -
No. 1 - 2¼x3¼ ". $20.
No. 1A - 1913-1915 - 2½x4¼. Red bellows, Various lens/shutter combinations.

GIRL SCOUT KODAK CAMERA - 1929-1934. For 1-5/8 x 2½" on 127 film. Bright green color with official GSA emblem engraved on bed. $45.

With Meniscus Achromat or RR lens in Kodak Ball Bearing shutter - $16.
With Zeiss-Kodak Anastigmat or Tessar IIB lens in Compound shutter - $27.
No. 2 - ca. 1930-1940. 2¼x3¼ exp. on 120 film. $13.
No. 2A - ca. 1917. Kodex sh. $8.

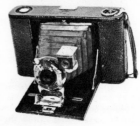

No. 3 - Various models 1904-1915. 3¼x4¼ on 118 film. Horizontal format. $22.
No. 3A - Various models 1908-1915. 3¼x5½ on 122 film. Horizontal format. $26.
Folding Hawkeye Six-16 and Six-20 - ca. 1933-1934. (Orig price $9-16 depending on lens & shutter.) - $11.
Folding Hawkeye Special - 1930. Kodex sh., Kodak Anast. f6.3 lens. $17.

RAINBOW HAWKEYE CAMERAS : *In Green, Red, Brown, Black, or Blue. (Box cameras.)*
No. 2 - 1931-1932. Same as No. 2 Cartridge Hawkeye, but in colors. $10.
No. 2A - same, but in 2½x4¼ size. $9.

FOLDING RAINBOW HAWKEYE - *This series, made in 1931&1932 is similar to the regular Folding Hawk-eye series, but in colors.*
No. 2 - For 120 film. Kodex sh. Single or double lens. $24.
No. 2A - same, but for 2½x4¼"(6.5x11cm) on 116 film. $14.
No. 2 & 2A Special - $28.

HAWKEYE SPECIAL, No. 2 & 2A - 1928-1930 rollfilm box cameras. f6.3 lens. $12.

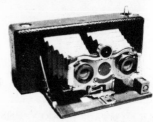

STEREO HAWKEYE - A continuation of the Blair Stereo Hawkeye series, and labeled "Blair Division of Eastman Kodak Co." A folding stereo camera taking twin 3½x3½ exposures. Various models 1904-1914 numbered in sequence. B&L RR lenses in Hawkeye shutter.

Mahogany interior, brass trim, red bellows. $130.

Target Hawkeye - No. 2, 2A, Six-16, Six-20 box cameras. $4.

Vest Pocket Hawkeye - ca. 1927-1931 - With single or double lens. $16.

Weno Hawkeye - Box cameras of various sizes: No. 2 for 3½x3½, No. 4 for 4x5", No. 5 for 3¼x4¼, No. 7 for 3¼x5½, etc. $19.

HOLIDAY, HOLIDAY FLASH - see Brownie Holiday under the Eastman heading.

JIFFY KODAK CAMERAS - *Common rollfilm cameras with pop-out front with twin sprung struts. Twindar lens, zone focus.*
Six-16 - 1933-1946. 2½x4¼ on 616. $9
Six-20 - 1937-1939. 2¼x3¼ on 620. $9.
Vest Pocket - 1935-1942. 1-5/8 x 2½ on 127. Black plastic construction. $10.

KODAK JUNIOR CAMERAS - *(see also "Autographic Kodak Jr." under the Eastman heading.) Note also: Two of Eastman's first cameras bore the name Junior along with their number. They are the No. 3 Kodak Jr., and the No. 4 Kodak Jr. Both are box cameras with string-set shutters, and are listed at the beginning of the Eastman Kodak section.*
No. 1 - ca. 1914. 2¼x3¼ on 120 film. f7.7 Anastigmat lens. $13.
No. 1A - ca. 1914 - 2½x4¼ on 116. $8.
No. 2C - 2-7/8 x 4-7/8 on 130 film. $15.
No. 3A - ca. 1915. 3¼x5½ on 122. $11.

KODET CAMERAS

No. 4 Kodet Camera - 1894-1897. For 4x5" plates or rollfilm holder. Leather covered wood box. Front face hinges down to reveal brass-barrel lens & shutter. Focusing lever at side of camera. $320.
No. 4 Folding Kodet Camera - Folding-bed camera ca. 1894 for 4x5 plates or special roll-holder. Basically cube-shaped when closed, very similar in appearance to the Blair Folding Hawkeye (illustrated in the Blair section). Variable speed shutter built into wooden lens standard. Brass barrel lens with rotating disc stops. $450.

MEDALIST CAMERAS- For 2¼x3¼ on 620 film. Ektar f3.5/100mm.
Medalist I - 1941-1946 - no flash sync. Supermatic shutter to 400, B. Split image RF. $117.

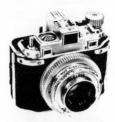

pivots and projects the image to the curved focal plane. Although designed basically for wide views, it could also be used vertically.

Medalist II - 1946-1952 - Flash Supermatic shutter. $156.

MONITOR - folding rollfilm cameras:
Six-16 - 1939-1946. for 2½x4¼ on 116 film. f4.5/127mm in Supermatic sh. 10-400. (The less common of the two models.) $20.
Six-20 - 1939-1946 - 2½x3¼ on 620 film. $23.

MOTORMATIC 35 - 1960-1969 35mm camera with spring-motor film advance. Ektanar f2.8/44mm. Auto Flash sh. 40-250, sync. $33.

NAGEL CAMERAS - *These cameras were made for Eastman Kodak Co. by the Dr. August Nagel Works in Stuttgart.*
Nagel Jr. - 620 film. f7.7 Kodak lens. Compur shutter. $7.
Nagel Pupille - see Pupille, below.
Nagel Ranca - see Ranca, below.

ORDINARY KODAK CAMERAS : *A series of cheap Kodak cameras made from 1891-1895. They were called "Ordinary" to distinguish them from the Daylight, Folding, Junior and Regular Kodaks, as they were called at that time. All are made for 24 exposures on rollfilm. All have Achromatic lens, sector shutter. They differ only in size and price.*

"A" - 2¾x3¼ - (orig. cost: $6.) - $1,400.
"B" - 3½x4" - (orig cost: $10.) - $750.
"C" - 4x5" - (orig cost: $15.) - $750.

PANORAM KODAK CAMERAS - *A series of rollfilm panoramic cameras in which the lens*

No. 1 Panoram Kodak Camera - April 1900 - 1914. For 2¼x7" exp. on No. 105 rollfilm for an angle of 112 degrees. (orig. cost: $10.) Models A, B, C, and D. $126.
No. 3A - 1926-1928. Takes 3¼x10-3/8 exp. on 122 rollfilm. This is the least common of the series, having been made for only two years. $155.
No. 4 - Original model (1899-1900) has no door to cover the swinging lens. For 3½x12" on No. 103 rollfilm. 142 degree angle. Rapid Rectilinear lens. (orig. cost: $20.) · $228.
Later models of the No. 4 (B, C, and D) made through 1924. Same as original model, but have door over lens. $129.

PETITE - 1929-1934. A Kodak Vest Pocket, Model B in colors. For 1-5/8 x 2½" on 127. Meniscus lens, rotary shutter. $24. (Also was available as the Kodak Petite Ensemble, with matching lipstick, compact, and mirror, but we haven't seen any for sale.)

POCKET KODAK CAMERAS - *Except for the first camera listed here, the Pocket Kodak cameras are of the common folding rollfilm variety.*

The Pocket Kodak - ca. 1895-1900. A tiny box camera for 1½x2" exp. on No. 102 rollfilm, which was first introduced in 1895 for this camera. There are two models: One has the shutter mounted on the inside of the camera, and it is removed when loading film. The other model, which is less common, has the shutter mounted on a separate board. Both types could also be used with auxiliary plateholder. Single lens, rotary shutter, Pebble-grained leather. $84.

No. 1 Pocket Kodak Camera - May 1926-1931. 2¼x3¼ on 120. $10.
No. 1 (Autographic) - f7.9 Kodar lens in Kodex shutter. Like above, but w/ Autographic feature. $15.
No. 1, Series II - 1922-1924. $13.
No. 1A - ca. 1926-1931. 2½x4¼ on 116 film. Folding bed style. $10.
No. 1A (Autographic) - $10.
No. 1A, Series II - 1923-1931. $8.
No. 1A (Colored models) - 1929-1931. $18.
No. 2C - 1925-1932. 2-7/8 x 4-7/8 exp. on 130 film. Kodar f7.9. Kodex sh. $16.
No. 3 - 1926-1934. 3¼x4¼ on 118. $8.
No. 3A - 1927-1933 - 3¼x5½ on 122. $22.
No. 3A (Autographic) - $25.

POCKET KODAK JUNIOR CAMERAS

No. 1 - 1929-1931. 2¼x3¼ on 120 film. Meniscus Achromatic lens. Kodamatic sh. $13.
No. 1 - (Colored models) - $14.
No. 1 (Autographic) - $12.
No. 1A - 1929-1931. 2½x4¼ on 116 film. Achromatic lens, Kodamatic sh. In basic black or a variety of colors. $12.

POCKET KODAK SPECIAL CAMERAS
No. 1A - 1926-1934. 2½x4¼ on 116. $19.
No. 3 - 1926-1934, 3¼x4¼ on 118 film. With f4.5, 5.6, or 6.3 Kodak Anastigmat lens. $25.

PONY CAMERAS
II - 1957-1962. for 24x36mm exp. on 35mm film. Non-interchangeable Kodak Anastigmat f3.9/44mm. Bakelite body. $12.
IV - 1957-1961. 35mm. film. f3.5/44mm Kodak Anast. "Kodak Flash 250" shutter. $10.
135 - the first model for 35mm film. 1950-1954. (Models B & C through 1958). Non-interchangeable Kodak Anast. f4.5/51mm lens or f3.5/44 mm lens in focusing mount. $11.
828 - 1949-1959. The first in this series, it took No. 828 film. Easily distinguished from the later 35mm models by the lack of a rewind knob on the top right side of the camera next to the shutter release. $11.

PREMO CAMERAS - *The Premo line was taken over by Kodak from the Rochester Opt. Co., and was a very popular line of cameras. See*

also Rochester for earlier models. Cameras are listed here by size, since many models did not carry any model designation, and their identity is lost to all but an expert.

2¼x3¼ - ca. 1916-1922, such as Premo No. 12. Folding cameras for packs or plates. Various shutter/lens combinations. $25.
3¼x4¼ size - $20.

3¼x5½ - "Postcard" size cameras, such as No. 1, No. 8, or No. 9. B&L lens, BB shutter, red bellows. Black leather covered. $30.

4x5 size - including No. 8, and Sr. models. Box

r folding bed styles. RR lens, BB sh. $26.
5x7" - including No. 9, and Sr. Special - Protar
ens, Compur sh. red bellows. $52.

CARTRIDGE PREMO CAMERAS
No. 00 - ca. 1916. Simple box camera for exp.
1¼x1¾ on rollfilm. Meniscus lens. $23.
No. 2 - ca. 1918 rollfilm box for 2¼x3¼. $7.
No. 2A - similar but 2½x4¼" format. $10.

Film Premo No. 1 - 1906-1916. Wood-bodied
folding bed camera for filmpacks. Various
sizes: 3¼x4¼ through 5x7. Simple lens, BB
shutter. $23.

Film-Pack Premo - (box) - 1903-1908. Made in
3¼x4¼ and 4x5" sizes. Achromatic lens in
Automatic shutter. $13.

Film-Plate Premo - ca. 1910. Folding camera
for plates or packs. 3¼x4¼, 3¼x5½, or 4x5"
sizes - $28.

Film-Plate Premo Special - 1912-1916. Similar
to above, but with Zeiss-Kodak Anastigmat or
Tessar f6.3 lens in Compound or Optimo sh.
Common sizes: 3¼x4¼ or 3¼x5½. $56.

FOLDING CARTRIDGE PREMO CAMERAS
Folding-bed rollfilm cameras. Listed by size:
No. 2 - 2¼x3¼ on 120. RR lens, BB sh. $10.
No. 2A - 2½x4¼ on 116. RR & BB. $8.
No. 2C - 2-7/8x4-7/8 on 130. RR & BB. $12.
No. 3 - 3¼x4¼ on 124 film. RR & BB. $13.
No. 3A - 3¼x5½ on 122 film. RR & BB. $10.

PREMO JUNIOR CAMERAS - *Filmpack box
cameras.*

No. 0 - 1911-1916 - 1¼x2-3/8". $15.
No. 1 - 1909-1916 - 2¼x3¼" - $10.

No. 3 - 1909-1919 - 3¼x4¼". $16.
No. 4 - 1909-1914 - 4x5". $12.

LONG-FOCUS PREMO - see Rochester Opt.

POCKET PREMO CAMERAS

Pocket Premo - 2¼x3¼ - folding bed style cam-

era with self-erecting front. Made to take film packs only. $12.

Pocket Premo C - ca. 1904-1916. for 3¼x5½" exp. on plates. B&L f8/6¼" lens in Kodak BB shutter. Black bellows. $21.

PONY PREMO CAMERAS - *Folding plate cameras, Models A, C, D, E, 1, 2, 3, 5, 6, and 7. Model numbers not related to size, so we have listed them here by size only, which determines value.*
4x5" - B&L RR lens, Victor or Unicum shutter, all wood interior, red bellows. $29.
5x7" - B&L Auto shutter. B&L or Goerz Dagor lens. $55.
6½x8½ - much less common. $80.

Premo Senior - 6½x8½ - red bellows. $75.

Star Premo - ca. 1903-1908. 4x5". Various shutter/lens combinations. $35.

PREMOETTE CAMERAS - *The normal Premoette cameras, 1, 1A, and Special, are leather-covered wood-bodied "cycle" style cameras in vertical format.*
No. 1 - 1906-1908 - an inexpensive compact 2¼x3¼ film pack camera. Automatic shutter, Meniscus lens. $21.
No. 1A - ca. 1909-1912. 2½x4¼ filmpacks, otherwise like No. 1. $27.

PREMOETTE JUNIOR CAMERAS - *Leather covered aluminum bodied folding bed cameras. The bed folds down, but not a full 90 degrees. There is no track on the bed, but the front standard fits into one of several slots at the front of the bed for different focusing positions. Normal models have Achromatic lens.*
Premoette Jr. (no number) - ca. 1911. $17.
Premoette Jr. No. 1 - ca. 1912-1922. For 2¼x 3¼ filmpacks, like the original model. $21.

No. 1 Special - 1913-1918 - with Kodak Anast. f6.3 lens. $24.
No. 1A - 1912-1916 - 2½x4¼. $24.
No. 1A Special - Kodak Anast. f6.3. $26.
These cameras, although not terribly uncommon in the USA, are currently worth about double the US price in Europe.

PREMOETTE SENIOR CAMERAS - ca. 1915-1922. Similar in design to the Premoette Jr. models. Various sizes including 3¼x5½. (The 3¼x5½ size was not made in the other Premoette models.) $15.

PUPILLE - 1932-1934. Made in Germany by the Nagel Works, Stuttgart. For 3x4cm exp. on 127 film. Schneider Xenon f2/45mm. Compur sh 1-300. Rangefinder. $178.

QUICK FOCUS KODAK Camera, No. 3B - 1906-1911. Box camera for 3¼x5½ exp. on No. 125 film. Achromatic lens, rotary shutter. Orig. cost: $12.00. An unusual focusing box camera. Focus knob on side of camera is set to proper focal distance. Upon pressing a button, the camera opens (front pops straight out) to proper distance, focused & ready. $93.

RECOMAR CAMERAS - 1932-1940. Kodak's entry into the crowd of popular compact folding long-extension precision view cameras. Made in Germany by the Nagel Works.

in Stuttgart, Germany. 6x9cm (2¼x3¼") on 620 film. Schneider Xenar f3.5/105mm lens. Compur sh, 1-250. Coupled rangefinder. $40.

REGULAR KODAK - *"Regular" is the term used in early Kodak advertising to distinguish the No. 2, 3, and 4 "string-set" Kodak cameras from the "Junior", "Folding", "Daylight", & "Ordinary" models. The "Regular Kodak" cameras are listed at the beginning of the Eastman section, where we have called them by their simple original names: No. 2, 3, and 4 Kodak cameras.*

Model 18 - 2¼x3¼. Kodak Anastigmat f4.5/105mm in Compur shutter. $59.

RETINA CAMERAS - A series of 35mm cameras made in Germany.
Retina - **(original model)** - 1934-1937. Xenar f3.5/50mm. $47.
Model I - 1936-1950 - compact folding camera with Ektar f3.5 or Xenar f3.5 in Compur sh. Non-rangefinder type. $42.
Model IA - similar, but shutter cocking mech. coupled to film transport. Xenar f2.8 or 3.5, or Ektar f3.5. Compur Rapid or Synchro Compur shutter. $42. ($36. EUR)
Model IB - $51. ($43. EUR).

Model 33 - 3¼x4¼. Similar, but 135mm lens. More common than the smaller model. $51.

KODAK REFLEX CAMERAS - A series of 2¼ x2¼" twin lens reflexes for 620 film. Models I-IV. f3.5/80mm Anastar lens. Kodamatic shutter. $29.

Model II - 1937-1950. Coupled rangefinder. Xenon, Ektar, or Rodenstock f2. $49.
Model IIa - single window view/range finder. Shutter cocking coupled to film advance. Synch shutter. Xenon f2. $54.
Model IIc - single stroke film advance. Xenon f2.8/50mm. $58.
Model IIIc - BIM. f2/50mm lens. $85.
Model IIIC - $110.
Model IIIs - 1959-1961 - non-folding type. Retina Xenon f1.9 or 2.8. Sync. Compur. $64.
Automatic I - ca. 1960. f2.8/45mm. $46.
Automatic III - ca. 1960. Xenar f2.8/45mm. Compur 30-500. $49.

RETINA REFLEX CAMERAS
Retina Reflex - ca. 1958-1959 SLR. Xenon f2 or f2.8/50mm. Sync. Compur 1-500. $75.
Reflex-S - Xenon f1.9 or 2.8. Sync. Comp. $76.
Reflex III - f1.9 or 2.8. Sync. Compur. $107.
Reflex IV - f1.9 or 2.8. Sync. Compur. $140.

RETINETTE CAMERAS
Retinette (original model) - Folding 35mm camera with self-erecting front. Horizontal

REGENT - ca. 1935. Made by the Nagel works

EKC RETINETTE (cont.) — SPEED

style, not like other folding Retina cameras.
ca. 1939. f6.3/50mm Kodak Anastigmat. $60.
Retinette II - Vertical-style folding 35mm
camera with self-erecting front. Schneider An-
astigmat f4.5/50mm. ca. 1940's. $42.
Retinette IA - non-folding type. Schneider
Reomar f2.8, 3.5, or 4.5 lens. $31.

SCREEN FOCUS KODAK CAMERAS - *The first cameras to provide for the use of ground glass focus on a rollfilm camera. The rollfilm holder hinges up to allow focusing.*

No. 4 - 1904-1909. For 4x5" exp. on No. 123
film, which was introduced at the same time.
RR lens, Kodak Auto. shutter. $305.

No. 5 - $380.

SIGNET CAMERAS - A series of cameras for
24x36mm exp. on 35mm film.
Signet 30 - 1957-1959. Ektanar f2.8/44mm
anastigmat.. CRF. Sync. sh. 4-250. $19.
Signet 35 - 1951-1958. Ektar f3.5/44mm. in
Kodak Synchro 300 sh. CRF, Double exposure
prevention. $29. **(Special model for U.S.
Army Signal Corps** - black satin finish, no
serial number on body. We can't give you an
average on this one, but we saw one for sale
in March 1977 for $175., if that helps.)
Signet 40 - 1956-1959 - Ektanon Anastigmat
f3.5/46mm. Kodak Synchro 400 sh. $34.
Signet 50 - 1957-1960 - BIM. $32.
Signet 80 - 1958-1962 - Interchangeable f2.8/
50mm Ektanar in bayonet mt. Synchro 250
shutter. CRF, BIM. (orig. $130.) - $53.

KODAK SIX-16 CAMERAS
A whole series of cameras of the 1930's for
2½x4¼" exp. on 616 rollfilm. Model names
include: Six-16, Junior Six-16 (Series I,II, &III),
Senior Six-16. $13.
Six-16 Special - 1937-1939. Kodak Anastigmat
Special lens f4.5/127mm. Compur Rapid sh.,
1-400, T, B. $38.

KODAK SIX-20 CAMERAS
Another whole series of cameras of the 1930's,
for 2¼x3¼ exp. on 620 film. Models include:

Six-20, Junior Six-20 (Series I, II, & III), Seni
Six-20. $11.
Six-20 Special - 1937-1939. f4.5/Kodak Ana.
tigmat lens, Compur Rapid shutter. $22.
Super Six-20 - (see Super , below.)

SPECIAL KODAK CAMERAS

No. 1A Special Kodak Camera - 1912-1914.
Zeiss-Kodak f6.3. Compound sh. $50.

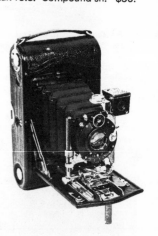

No. 3 - 1911-1914. For 3¼x4¼ on 118 film.
f6.3 Kodak Anast. in B&L Compound sh. $33.
No. 3A - 1910-1914. Like the others of the
series, this is a folding rollfilm camera, but this
is for 3¼x5½ postcard-size photos. Kodak An-
astigmat lens in B&L Compound sh. $45.

SPEED KODAK CAMERAS

54

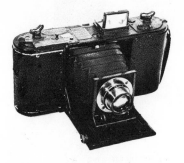

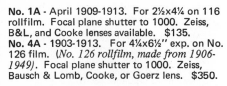

Kodak Stereo Camera (35mm) - 1954-1959.
For pairs of 24x24mm exp. on standard 35mm
cartridge film. Kodak Anaston f3.5/35mm
lenses. Shutter 25-200. Common. $52.

No. 1A - April 1909-1913. For 2½x4¼ on 116
rollfilm. Focal plane shutter to 1000. Zeiss,
B&L, and Cooke lenses available. $135.
No. 4A - 1903-1913. For 4¼x6½" exp. on No.
126 film. *(No. 126 rollfilm, made from 1906-
1949)*. Focal plane shutter to 1000. Zeiss,
Bausch & Lomb, Cooke, or Goerz lens. $350.

STEREO KODAK CAMERAS - *see also
Brownie Stereo and Hawkeye Stereo in the
Eastman section.*

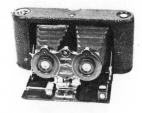

Stereo Kodak Camera, Model 1 - (original mo-
del 1917-1918. Ball Bearing Shutter model,
1919-1925.) - Folding camera for 3-1/8 x
3-3/16" pairs on No. 101 rollfilm. Kodak An-
astigmat f7.7/130mm lens. $163.

SUPER KODAK SIX-20 CAMERA - 1938-
1945. The first camera with coupled electric-
eye for automatic exposure setting. Takes 2¼x
3¼ exposures on 620 film. Kodak Anastigmat
Special lens, f4.5. $900.

KODAK 35 CAMERAS -
Kodak 35 Camera - 1938-1951. For 24x36mm
exp. on 35mm cartridge film. Five models w/
different shutter/lens combinations. $21.
Kodak 35 Camera (with Rangefinder) - 1940-
1951. Various models - $20. ($40 EUR).
Kodak Automatic 35 Camera - ca. late 1950's.
Ektanar f2.8/44mm. Synchro 80 shutter. $32.

TOURIST - 1948-1951 folding camera for
2¼x3¼ on 620 film. Kodak Anaston f8.8, 6.3,
or 4.5 lenses. $15.. (With Synchro-Rapid
800 shutter - $63.)
Tourist II - 1951-1958 - similar. $15. (With
Synchro-Rapid 800 shutter - $67).

No. 2 Stereo Kodak - (box camera) - 1901-1905
For stereo exposures 3½x6" on No. 101 rolls.
Periscopic f14/125mm lens. $325.

VANITY KODAK CAMERA – 1928-1933.
A Vest Pocket Kodak , Series III camera in
color. For 1-5/8 x 2½" exp on 127 rollfilm.

Also available as Vanity Kodak Ensemble, with lipstick, compact, mirror, & change pocket. Camera only - $27.

VEST POCKET KODAK CAMERAS - *All cameras listed here are for 1-5/8 x 2½" exposures on 127 film.*

Vest Pocket Kodak Camera - (1912-1914). Painted metal or leather covered models, Autographic models (1915-1926), Model B and Model B Series III, including Autographic, (1925-1934). $14.

Vest Pocket Kodak Special Cameras - including Autographic Special, and Autographic Model B Special. (1912-1934). $33.

VIGILANT CAMERAS - A series of cameras ca. 1939-1948. Folding cameras for rollfilm in two sizes: 2½x4¼ on 116 film, and 2¼x3¼ on 620 film. Various models of each: Six-16, Six-16 Jr., Six-20, Six-20 Jr. - $12,

VOLLENDA CAMERAS – 1932-1937. Mfd. for Kodak by Nagel-Werk in Stuttgart. **127 size** - Schneider Radionar f3.5/50mm. Compur Rapid shutter. $42. (With Leitz Elmar lens f3.5/50mm. - $220.) **616 size** - f4.5/120mm Radionar. $40. **620 size** - f4.5, 3.5, or 6.3 lens. Compur. $22. **620 Jr.** - f6.3/105mm. $30.

WORLD'S FAIR FLASH CAMERA - sold only at the 1964 New York World's Fair. The original box doubles the value of this camera. Camera only - $13.

ZENITH KODAK CAMERA, No. 3 - A rare box camera for 3¼x4¼ plates. Except for the name, it is identical to the Eureka cameras of the same period (1898-1899.) Accepts standard plateholders through side-opening door, and allows room for storage of extra holders. Not found often. $135.

VIEW CAMERAS - *Because of the many uses of view cameras, there are really no standard lens/shutter combinations, and because they are as much a part of the general used camera market as they are "collectible", they are listed here as good second-hand cameras, the main value being their lenses. Prices given here are for cameras in Very Good condition, with lens.* **5x7** - $80. **6½x8½** - $80. **8x10** - $112.

EBNER, Albert & Co. (Stuttgart)
Folding camera - for 8 exp. 6x9cm on 120 film. Bakelite body. Tessar f4.5/105mm lens. Rim-set Compur sh. 1-250. Very similar to the Nagel Regent of the same vintage. $78.

EBONY 35 - see Hoei Industrial.

ECHO 8 - Japanese cigarette-lighter camera, ca. 1954. Designed to look like a Zippo lighter, it also takes 5x8mm photos with its Echor f3.5/15mm lens on film in special cassettes. $225.

ECLIPSE - see Horsman, Shew
EDELWEISS - see Zenith
EDINEX - see Wirgin.
EDIXA - see Wirgin.
EHO - see Hofert.
EKA - see Krauss.
EKTRA - see Eastman.

ELANER - (Stuttgart, Germany) - folding camera for 120 film. Pronto shutter. $13.

ELCA - see Elop Camerawerk.

ELEGA - (Japan) - Leica-styled 35mm camera, ca. 1950's. f3.5 screw-mount lens (which does not interchange with Leica lenses.) $65.

ELF - see Spiegel.
ELJY - see Lumiere.

ELOP KAMERAWERK (Flensburg, Germany)
Also associated with the Uca Werkstatten of Flensburg. Makers of ELCA cameras. ELCA stands for ELop CAmera.
Elca - ca. 1954. 35mm camera with Eloca f4.5/35mm lens. Simple shutter. Black painted and nickeled metal body. $28.

EMMERLING & RICHTER (Berlin)
Field Camera - for 13x18cm plates. Wooden body. Nickel trim. - without lens - $86.

EMPIRE STATE VIEW - see View Cameras under the Eastman and Rochester headings.

EMSON - Japanese novelty camera. 14x14 mm exp. on 16mm paper backed rollfilm. $8.

ENCORE DELUXE CAMERA - ca. 1940's -

1950's. An inexpensive cardboard novelty camera. Factory loaded. User returns complete camera & film to factory with $1.00 for processing. (Vaguely reminiscent of the "You push the button..." idea which made Eastman rich and famous, but it didn't work.) $6.

ENOLDE - 3¼x4¼ sheet film camera. f4.5/135 lens. $42.

ENSIGN, ENSIGNETTE - see Houghton.
ERGO - see Contessa-Nettel, Zeiss.

ERKO - 9x12cm folding plate camera. Wood body covered with black leather. H. Bauer & Sons Splendar f4.5/135 lens. Ibso shutter, T, B, 1-150. $36.

ERMANOX - see Ernemann, below.

ERNEMANN - (Heinrich Ernemann Werke Aktien Gesellschaft - Dresden, Germany)
Merged with Contessa-Nettel, Goerz, Ica, and Carl Zeiss Optical Co. to form Zeiss-Ikon. This merger took place in 1926, and some Ernemann cameras continued under the Zeiss-Ikon name.
Bob 0 - folding camera for plates or rollf. $37.
Bob 1 - postcard size folding rollfilm or plate camera. f6.8 lens. $23.
Bob IV, Bob V - $53.

Bobette I - ca, 1923 folding camera for 22x33 mm. format on 35mm film. This is a bedless folding type. Front pops straight out with bellows & struts. $55.

Box cameras - ca. 1926, some models bearing the Ernemann name, others Zeiss-Ikon. Wood body, leather covered, for 8 exp. 6x9cm on 120 film. Two speed shutter. f12.5 Meniscus lens. $28.

Ermanox - 4.5x6cm rigid-bodied model, ca. 1924. Originally introduced as the "Ernox". Metal body, covered with black leather. Focal plane shutter, 20-1000. Ernostar f2/100mm or f1.8/85mm lens. $1,116.

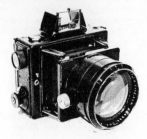

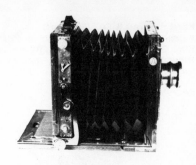

Ermanox - collapsible bellows model - 6.5x9cm size. f1.8 Ernostar lens. $550.

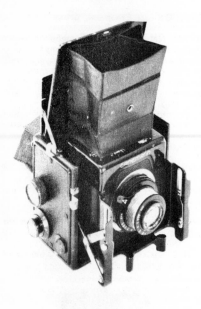

Globus - ca. 1900. 13x18cm folding camera. Double ext. bellows. Focal plane shutter. Goerz Double Anastigmat f4.6 brass-barreled lens. Polished wood body w/ brass trim. $301.

Heag - *An acronym for Heinrich Ernemann Aktien Gesellschaft.*

Heag 0 - folding-bed camera for 6x9cm. Single extension. Black leathered wood body. Detective Aplanat f6.8/135mm. Ernemann Automat shutter. $28.
Heag I - folding plate cameras. 6x9 & 9x12cm sizes. Most commonly found with f6.8 lens and Ernemann Pneumatic or Automat shutter. $25.
Heag II, series II - 9x12cm. Vilar f6.8/135 mm Double Anastigmat lens in Chronos shutter. Double extension bellows. $33.
Heag VII - 6x9cm. Radionar Anast. f6.3/105 Pronto shutter. $24.
Heag XIV - ca. 1910 - 4.5x6cm. Ernemann Doppel Anastigmat f6/80mm. Sh to 100. $48.

Ernoflex - ca. 1925. Strut-type folding reflex for 4.5x6cm plates. Ernon f3.5/75 or Tessar f4.5/80. Focal plane shutter to 1000. One of the smallest folding SLR cameras ever. $960.

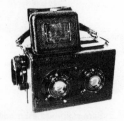

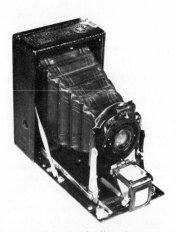

Ernoflex Simplex Stereo - A stereo reflex camera for 45x107mm. Ground glass focus on both sides, and reflex focus on one side only. Ernon f3.5/75mm. FP sh. 25-1000. Unusual. $800.

Heag XV - Vertical format folding plate camera, 4.5x6cm "vest pocket" size. Ernemann Double Anast. f6.8/80 in Automat sh.1-100. $71.
Heag (tropical model) - listed with "Tropical" cameras, later in this heading.

"Klapp" cameras - (focal plane shutters)

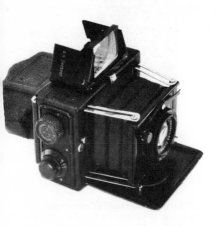

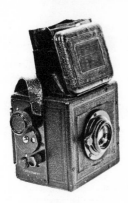

Reflex - 4.5x6cm format. A small box SLR with FP shutter & Ernoplast f4.5/75 lens. $167.

Reporter - ca. 1905 - folding camera for 9x12 plates. Meyer Anastigmat f5.5/120mm. FP sh. to 250. Wood body, black leathered. $76.

4.5x6cm "Miniature Klapp" - ca. 1925. Body style like the bellows model Ermanox, but with front bed/door. Ernostar f2.7/75mm. FP sh to 1000. (Possibly the smallest focal plane camera ever?) $488.

Rolf - folding vest pocket camera for 127 film. f12/75mm lens. 3 speed shutter. $25.

Klapp - 6.5x9cm. - folding bellows camera with focal plane shutter. f3.5 Ernon lens. $250.

Klapp - 9x12cm. - folding bellows camera. FP shutter to 1000. Tessar f4.5/150. ca. 1925. $172.

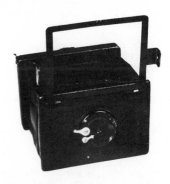

Simplex Stereo - ca. 1920. Non-collapsing, "jumelle" style stereo camera for 45x107mm plates. Ernemann Doppel lens f11/60. Guillotine shutter, T, B, I. $140. *(Not to be confused with the Ernoflex Simplex Stereo camera listed above.)*

Stereo box - ca. 1912, for 9x18cm stereo pairs. Fixed focus meniscus lenses. B & I sh. $120.

Tropical cameras - *All tropical cameras, including Ernemann are relatively scarce. Prices have increased rapidly in the last few years. There is quite a difference in price between the FP shutter models and inter-lens shuttered types.* **Tropical Heag** - 9x12cm. ca. 1920. Folding-bed style. (NOT focal plane type). Double ext. bellows. Mahogany body, brown bellows, brass fittings. Ernemann Vilar f6.8/135mm lens in Ernemann shutter 1-300. $272.

Liliput - 4.5x6cm folding bellows vest pocket camera ca. 1913. This economy model sports a fixed-focus achromatic lens & T,I sh. $51.

Liliput Stereo - ca. 1915 - folding stereo camera for 45x107mm. Meniscus lens, guillotine sh. $145.

Tropical Klapp - 9x12cm. Horizontal format folding-bed focal-plane camera in teakwood with brass fittings. Ernostar f4.5/150mm in Ernemann front shutter. FP sh. to 1000. $450.

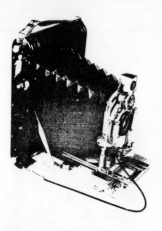

Tropical Klapp - 9x12cm. Focal plane camera in vertical style, ca. 1925. Mahogany body, brown bellows, brass fittings. Ernon f3.5/150 lens. Focal plane shutter to 1000. $960.

Tropical Klapp, Tropical Reporter - 10x15cm. focal plane cameras ca. 1915. Strut-folding style. Focal plane shutter to 1000. (Some models to 2500.) Tessar f4.5/165mm lens. Wood body, brown leather bellows, and brass trim. $825.

"Two-Shuttered Camera" (Zweiverschluss-kamera) - ca. 1912 folding bed camera for 9x12 plates. Goerz Dagor f6.8/120mm. Ernemann Pneumatic shutter 2-100 (front) and Focal-plane shutter to 2500 at rear. $164.

Unette - ca. 1925 miniature box camera for 22x33mm exposures on rollfilm. Overall size: 3x3½x2¼". Two speed (T&I) shutter. f12.5 meniscus lens. Revolving stops. $94.

ERNOFLEX - see Ernemann, above.
ERRTEE - see Talbot.

ESSEM - 5x7 folding camera. RR lens in B&L shutter. Mahogany interior, red bellows. $80.

ETUI - *A style of thin-folding plate camera ca. 1930's. The most common model using the word Etui in its name is the KW Patent Etui made by Guthe & Thorsch.*

EULITZ - (Dr. Eulitz, Harzburg)
Grisette - ca. 1955 camera for 35mm film. 45mm achromat lens. simple shutter. $11.

EUMIG - (Austria)
Eumigetta - 6x6cm rollfilm camera. Eumar f5.6/80mm lens. $17.

EUREKA - see Eastman.
EXA, EXAKTA - see Ihagee.
EXCELSIOR - see Semmendinger.

EXCO - simple box-type stereo camera, also useable for single exposures. Double anastigmat lenses. $120.

EXPLORER - see Bolsey.

EXPO CAMERA CO. (New York)
Easy-Load - ca. 1926. Small box camera for 1-5/8 x 2½" exp. on rollfilm in special cartridges, called Expo "Easy-Load" film. Meniscus lens, rotary sector shutter. $74.

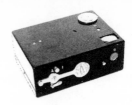

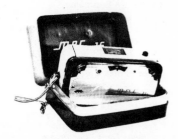

FEINOPTISCHE WERKE (Görlitz, Germany)
Successors to the Curt Bentzin Co.
Astraflex -II - ca. 1958. 6x6cm SLR modeled after the Bentzin Primarflex. Tessar f3.5/105 coated lens. FP shutter, T, B, to 1000. $69.

FEINWERK TECHNIK GmbH (Lahr)

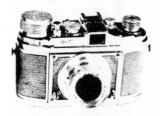

Police Camera - ca. 1915. A tiny all-metal box camera for 12 exposures on special cassettes. Fixed focus achromatic lens, 2 apertures. Cloth focal plane shutter, T & I. $180.

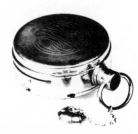

Watch Camera - Introduced ca. 1905 and produced for about 30 years. Disguised as a railroad-type pocket watch. Takes picture through the "winding stem", while the "winding knob" serves as a lens cap. Special cartridges. $85. (Finder, orig. box, etc. add to this figure.)

EXPRESS - see Murer & Duroni.
EXTRA - see Sida.
EYEMATIC - see Revere.
FALCON - see Eastman. (very early box)
 - see Utility (cheap 127 box).
FAVORIT — see Ica, Zeiss-Ikon.
FAVORITE - see Rochester.

FECA - German folding plate cameras, made in 6x9 and 9x12cm sizes. f4.5 Tessar or Xenar lenses. DEB, GGB. $39.

FED - Russian Leica copies. Various models, No. 1, 2, 3, & 4, dating from the 1930's on. Most models with Fed f3.5 lens, some with f2.8 Fed lens. $66.

FED-FLASH - cheap camera for 127 film. $8.

FEINAK- WERKE (Munich)
Folding plate camera - 10x15cm. - Horizontal format. Double ext. bellows. Schneider Xenar f4.5/165mm. Dial Compur to 150. Leather covered metal body. $112. EUR. (None on record USA).
Special Wiphot - 9x12cm folding bed plate camera. DEB. Reitzschel Linear f5.5/120mm lens in Compound shutter. $32.

Mec - 16 - ca. late 1950's gold-colored subminiature for 10x14mm exp. on 16mm film in cassettes. f2.8 lens. Shutter to 1000. $26.
Mec 16 SB - similar but with built-in coupled Gossen meter and f2 Rodenstock Heligon lens. $51.

FELICA - German 6x6cm metal box camera for 120 film. Meniscus lens, zone focus, simple sh. 25, 50, B. Light grey colored. $11.

FERRANIA - (Milan, Italy) *Associated with the Galileo Opt. Co. of Milan.*
Condor - see Galileo.
Rondine - Miniature all metal box camera for 4x6.5cm exp. on 127 film. Measures 3½x3x2½. Meniscus f7.5 Linear (focusing) lens. Simple shutter with flash sync. $23.

FERROTYPE - see Chicago, Keystone, Moore.
FIESTA - see Eastman Brownie Fiesta.
FILMET - see Seneca.

FINETTA WERK (P. Saraber, Goslar)

Finetta 99 - Spring motor camera ca. 1940's, for 36 exp. 24x36mm on 35mm film. Interchangeable Finetar f2.8/45mm lens. Focal - plane shutter 25-1000. Light grey. $104.
Finette - f5.6/43mm Achromat Finar. Simple shutter - T, B, I. Aluminum body. $12.

FINGERPRINT CAMERA - see Graflex, Burke & James.

FIRSTFLEX - ca. 1951 Japanese 6x6cm TLR for 120 film. f3.5 lens. Cheaply made. $6.

FLEKTAR - 6x6cm TLR made in USSR occupied East Germany. Row Pololyt f3.5/75. $20.

FLEXARET - see Meopta.
FLEXO - see Eastman.
FLUSH-BACK - see Eastman.

FOITZIK TRIER -
Foinix - ca. 1955 6x6cm folding camera. Steiner f3.5/75mm coated lens. Pronto 25-200. $6.
Unca - 6x6cm. f3.5 Prontor-S shutter. $33.

FOLDEX - see Photak Corp.

FOLMER & SCHWING -
Folmer & Schwing (NYC) - 1881
Folmer & Schwing Mfg. Co. (NYC) - 1890
Folmer & Schwing Co. (Rochester) (EKC)-1905
Folmer & Schwing Dept., Eastman Kodak -1908
Folmer Graflex Corp. - 1926
Graflex, Inc. - 1943
Because of the many organizational changes in this illustrious company which are outlined above, and in order to keep the continuous lines of cameras together, we have chosen to list their cameras as follows, regardless of age of camera or official company name at time of manufacture:
Cirkut Cameras - see Eastman Kodak Co.-Cirkut.
Graflex, Graphic Cameras - see Graflex.

FOTH - (C. E. Foth & Co., Berlin)

Fothflex - ca. 1934 TLR for 6x6cm on 120. f3.5/75mm. Foth Anastigmat. Cloth focal plane shutter 25-500 + B. $62.

Folding rollfilm camera - for 116 film. Foth Anastigmat f4.9/120mm. Waist level & eye level finders. $20.

FOTOCHROME, INC. (U.S.A.)
Fotochrome Camera - ca. 1965. "Unusual" is a kind description for this machine, designed by the film company to use a special direct-positive film loaded in special cartridges. The camel-humped body houses a mirror which reflects the image down to the bottom where the "color picture roll" passed by on its way from one cartridge to another. $19.

FOTOFLEX - cheap plastic TLR - $4.

FOTON - see Bell & Howell.
FOTRON - see Triad Corp.
FRANCIA - see Mackenstein.

FRANKA-WERK (Beyreuth, Germany)
Rolfix - ca. WWII, pre- and post. A folding camera for 8 exp. 6x9cm or 16 exp. 4.5x6cm on 120 film. Post-war models made in U.S. occupied zone from pre- and post-war parts. $22.

Solida - folding camera for 12 exp. 6x6cm on 120. f6.3/75mm. Pre- & post-war. $23.

FRANKE & HEIDECKE (Braunschweig)

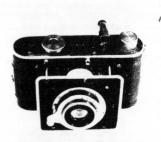

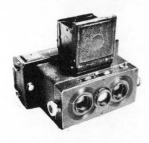

Foth Derby- Models I & II - ca. 1930's compact cameras for 16 exp. 3x4cm (1¼x1-5/8") on 127 film. Focal plane sh. 25-200 + B. Foth Anast. f3.5 or f2.5/50mm. (Model II has CRF). $39.

Heidoscop - ca. 1920's & 1930's Three-lens stereo camera for stereo pairs on plates or cut film, in two sizes: 45x107mm, and 6x13cm. It was named for the designer, Reinhold Heidecke.
45x107mm size - Zeiss Tessar f4.5/55mm Stereo Compound shutter. $231.
6x13cm size - Zeiss Tessar f4.5/75mm. lenses in Stereo Compound shutter. $286.

Rollei-16 - submini for 12x17mm exp. on 16 mm. film. Tessar f2.8/25mm. $52.

Rollei-35 - Tessar f3.5/50mm. $74.

I - Original model - (1929) - The "little sister" of the already well-known Heidoscop & Rolleidoscop. Readily identified by the rim-set Compur shutter and the film advance system, which on this early model was not automatic. (and so there is no exposure counter.) With f4.5, or more often with f3.8/75mm Tessar. This first model was made to take 6 exposures on No.117 film. Later models were switched to 120. The first version of this model had no distance scale on the focus knob, and the back is not hinged, but fits into a groove. The second version of the Rolleiflex I had focus scale & hinge. $98.
Standard model - ca. 1932 - $71.

Rolleicord - 6x6cm TLR. Introduced in 1933. Main identifying features listed with each model.
I - (first model) - Zeiss Triotar f4.5/75mm. Compur T,B,I-300. Nickel plated body. $54.
Ia - black leathered body. f4.5 Triotar. Compur to 300, not synched. $53.
II - f3.5 Triotar. Compur 1-300, no sync. $36.
III - f3.5 Triotar or f3.5 Schneider Xenar Compur Rapid 1-500 Synch. Eye level, Waist level, & Sports finders. $63.
IV - MX Synch. Double exposure prev. $78.
V - self timer. $84.

4x4 or "Baby" model- for 4x4cm on 127 film. f3.5/60 Xenar or f2.8/60 Tessar. Prices quite scattered on this model. Range $45-$125, and average $84.

Rolleidoscop - ca. 1926. The rollfilm version of the Heidoscop stereo camera. (Actually, some of the very earliest production models of the Rolleidoscop still bore the name Heidoscop. Perhaps the name which is now so famous was once an afterthought?) Like the Heidoscop, this is a three-lens reflex. The center lens, for reflex viewing, is a triplet f4.2/75mm. Taking lenses are Carl Zeiss Tessar f4.5/75mm. Stereo Compound shutter 1-300. For 6x13cm on 120 rollfilm. $687.
Rolleidoscop 45x107 - A smaller size- for 127 film. Tessar f4.5/55mm lenses. Much less common than the normal 6x13cm size. $1,200.

Rolleiflex - Twin Lens Reflex cameras:

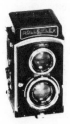

Rolleiflex Sport - ca. 1932. Tessar f3.5/75mm. Compur 1-300. ($94. EUR).

FRANKE (cont.) — GENIE

Rolleimagic - 6x6cm TLR cameras:
(I) - Xenar f3.5/75. Prontormat sh. $61.
II - ca. 1959 - Auto exp. control with built-in Gossen meter. $114.

FRENA - see Beck

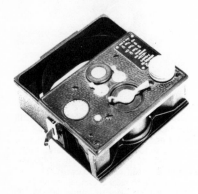

FT-2 - ca. 1955 Russian panoramic camera for 12 exp. 24x110mm on 35mm film. Industar f5/50mm. Shutter 100-400. $172.

FUJI PHOTO FILM CO. , FUJICA - (Japan)
Lyra - (Semi-Lyra) - Compact folding camera for 16 exp. 4.5x6cm on 120 rollfilm. Made before and after WWII. f3.5/75 anastigmat. Fujico shutter to 200. $14.

Mini - Very small half-frame camera for 35mm film in special cartridges. f2.8/25mm. $60.

FUTURA WERK, Fritz Kuhnert (Freiburg)
Futura-S - A very well constructed 35mm RF camera from pre-war Germany, continued through the 1950's. Kuhnert Frilon f1.5/50mm lens. Compur Rapid 1-400, B. CRF. $62.

GALILEO OPTICAL (Milan, Italy)
Associated with Ferrania, also of Milan.
Condor I - Leica copy - $60.
Gami 16 - ca. mid-1950's subminiature for exp. approx 11x17mm on 16mm film in cassettes. f1.9/25mm lens. Shutter 2-1000. Coupled meter, parallax correction, spring-motor wind for up to 3 rapid-fire shots. Original cost $350. Current price - $150. (Complete outfit with all accessories: f4/4x telephoto, flash, filter, 45 degree viewer, wrist strap, etc. sells for 2 to 3 times the cost of the camera & case only.)

GALLUS (Usines Gallus, Courbevoie, France)
Stereo camera - Rigid "Jumelle" style all metal camera ca. 1920's for stereo exposures in the two popular formats: 6x13cm or the smaller 4.5x10.7cm. Simple lenses. I&B shutter. $150.

GALTER PRODUCTS (U.S.A.)
Hopalong Cassidy Camera - ca. 1950 plastic box

camera for 8 exp. 6x9cm on 120 rollfilm. Simple shutter and meniscus lens. The front plate depicts the famous cowboy and his horse. $11.

GAMI - see Galileo Optical, above. *(because GAMI is an abbreviation for GAlileo, MIlano.)*

GAMMA - Italian Leica copy. $125.

GARLAND - (London, England)
Wet Plate camera - 8x10". ca. 1865. Ross lens. $1,295.

GAUMONT (L. Gaumont & Cie., Paris)

Block-Notes - 4.5x6cm - compact folding plate camera ca. 1904. f6.8 Tessar, Hermagis Anast., or Darlot lens. $130.
Block-Notes - 6x9cm - similar but larger. With f6.3 Tessar lens. $126. (less common than the smaller model.)

Block-Notes Stereo - Compact folding cameras like the other Block-Notes models, but for the 6x13cm & 45x107mm stereo formats. f6.3 lenses. Variable speed guillotine shutter. For single plateholders or magazines. $325.

Spido Stereo - Black leather covered jumelle style stereo camera for 9x18cm stereo plates. Krauss Zeiss Protar f12.5/189mm. Six speed Decaux Stereo Pneumatic shutter. ($160. EUR) (None on record in U.S.A., but would most likely sell for about twice that amount.)

Stereo cameras - Misc. or unnamed models, 6x13cm. f6.3/85mm lenses and guillotine sh. ($83. EUR). (None on record USA, but would most likely sell for twice that amount.)

GELTO - see Takahashi Kokaku.
GEM - see Rochester (Gem Poco), Wing (New Gem).

GEMFLEX - ca. 1954 TLR novelty camera for 14x14mm exp. Quite unusual, it stands out in a collection of novelty cameras. $62.

GENIE CAMERA CO. (Philadelphia, Pa.)
Genie - ca. 1892 focusing magazine-box camera for 3¼x4" plates. Push-pull action changes

plates and actuates exposure counter on brass magazine. String-set shutter. $650.

GENNERT (G. Gennert, NYC)

Montauk - Detective type plate camera ca. 1890 for plate holders which load from the side. Shutter-tensioning knob on the front next to the lens opening. Internal bellows focusing via radial focus lever on top of camera. $90.

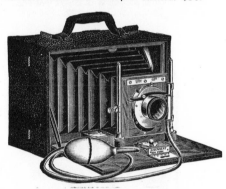

Folding Montauk - Folding plate cameras. Leather covered wood bodies. "Cycle" style. Wollensak Rapid Symmetrical, Ross Patent, or Rapid Rectilinear lens. 4x5 or 5x7". $72.

Montauk rollfilm camera - ca. 1914. $17.

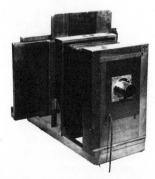

"Penny Picture" camera - ca. 1890. A 5x7 studio camera with sliding back & masks to produce multiple small images on a single plate. $200.

GENOS K. G. (Nurnberg, Germany)
Genos Rapid - ca. 1950 plastic camera for 12 exp. 6x6cm on 120 film. $9.

GEORGE, Herbert - see Herco.

GEVAERT - (Germany)
Gevabox - ca. 1950 box cameras for 120 film. Two sizes: 6x6 & 6x9cm. $5.

GEWIRETTE - see Wirgin.
GIFT KODAK - see Eastman.

GILLES-FALLER (Paris)
Studio camera - ca. 1900. 18x24cm. Hermagis Delor f4.5/270mm lens with iris diaphragm. Finely finished light colored wood. $300.

GIRL SCOUT CAMERAS - see Eastman, Herco.

GLOBAL - Japanese 14mm novelty camera. $8.

GLOBUS - see Ernemann.
GLORIETTE - see Braun.

GLUNZ - (S. Glunz Kamerawerk, Hannover.)
Folding plate camera - ca. 1920's. 9x12cm size. Dial Compur shutter. Goerz Tenastigmat f6.8, or Zeiss Tessar f4.5 lens. Double extension bellows. Wood body, leather covered. $48.
Folding rollfilm models- f6.3 Tessar. Compur shutter. $22.

GLYPHOSCOPE - see Richard.

GOEKER (Copenhagen, Denmark)
Field camera - 18x24cm. Carl Zeiss Series II f8/140mm lens. $124.

GOERZ (C. P. Goerz, Berlin, Germany)
Also associated with American Optical Co. Note: Goerz merged with Contessa-Nettel, Ica, Ernemann, and Carl Zeiss Optical Co. in 1926 to form Zeiss-Ikon. Some Goerz models were continued under the Zeiss name.
Ango - Strut-type folding camera with focal plane shutter, introduced ca. 1899 and produced for at least 30 years. Goerz Dagor f6.8, Dogmar f3.5, Syntor f6.8, Double Anastigmat f4.6, or Celor f4.8 are among the lenses you could expect to find. $99.

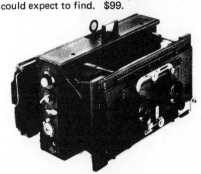

Ango Stereo - ca. 1906. Similar to the above

listing, but for stereo format. $184.

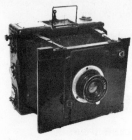

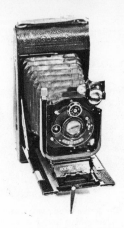

Anschutz - Another bedless "strut" type folding focal plane camera, introduced ca. 1890 and quite common with the press during the early part of the century. Most often found in the 6x9cm, 9x12cm, & 4x5" sizes. $95.

Folding rollfilm cameras - for 120 or 116 roll-films. Various models with Goerz lens and Goerz or Compur shutter. $22.

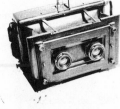

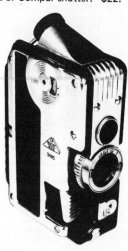

Anschutz Stereo - ca. 1890-1900. A focal plane strut-folding bedless stereo camera for paired exp. on 8x17cm plates. Panoramic views are also possible by sliding one lens board to the center position. With Goerz Dagor Double Anastigmat or Goerz Wide-Angle Aplanat lenses. A relatively uncommon camera. $276.

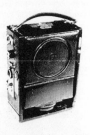

Minicord - (C. P. Goerz, **Vienna**) - ca. 1951 subminiature TLR for 10x10mm exp. on 16mm film in special cartridges. f2/25mm Goerz Helgor lens. Metal FP sh. 10-400, sync. $107. **Minicord III & IV** - $127.

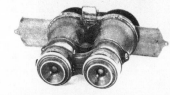

Folding Reflex - A compact folding single lens reflex camera for 4x5" plates. ca. 1912. This camera competed for attention with the Bentzin, Goltz & Breutmann Mentor, and Ihagee Patent Klappreflex, all of which were designed to operate as an efficient full-size SLR, but be as portable as an ordinary press camera when folded. $150.

Stereo Photo Binocle - ca. 1899. An unusual disguised detective binocular camera in the form of the common field glasses of the era. In addition to its use as a single-shot camera on 45x50

mm plates, it could use plates in pairs for stereo shots, or could be used without plates as a field glass. f6.8/75mm Dagor lenses. $2080.

Tenax - (folding cameras) -
4.5x6cm (Vest Pocket Tenax) - ca. 1909 strut-type folding camera for plates. Goerz Double Anastigmat Celor f4.5/75mm, or f6.8 Dagor or Syntor lens. Compound sh. 1-250+B. $71.
4x6.5cm (Vest Pocket Rollfilm Tenax) - for 127 film. Similar to the folding vest pocket cameras of Kodak & Ansco. f6.3/75 Dogmar in Compur shutter to 300. $21,
6.5x9cm (Coat Pocket Tenax) - for plates or film packs. Goerz Dagor f6.8/90 or Dogmar f4.5/100. Compound sh. T, B, 1-250. $90.

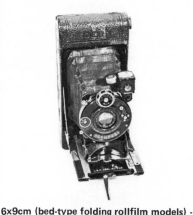

6x9cm (bed-type folding rollfilm models) - Style similar to the American cameras of the same period. Tenastigmat f6.3/100mm in Compur shutter 1-250. $19.
8x10.5cm (3¼x4¼) bedless strut-folding camera for plates. ca. 1915-1920. $62.
8x10.5cm - bed-folding type - for rollfilm. $26.
8x14cm (3¼x5½ postcard size) - Folding bed type rollfilm camera. Bed focus. $24.
9x12cm - (Tenax, Manufok Tenax, etc.) - Plate cameras ca. 1920. Folding bed type in common square-cornered plate camera style. Goerz Dogmar f4.5/150mm. Dial Compur 1-150. Double extension bellows. Ground glass back. $47.
10x15cm - Tenax folding-bed plate camera - ca. 1912. Goerz Dagor f6.8/168mm, or f6.3 Tenastigmat. Compound or Compur sh. $28.

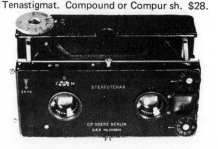

Stereo Tenax - Strut-type folding stereo camera

for 45x107mm plates or packs. Goerz Syntor f6.3/60 or f4.5/60 Dogmar or Celor. Stereo Compur or Compound shutter. $178.

Tengor (box) - ca. mid-1920's for 6x9cm exp on 120 film. Goerz Frontar f11 lens. $17.
Tengor (folding rollfilm) - Vest Pocket size for 4x6.5 cm. on 127 film. Goerz Frontar f9/45 lens. Shutter - T, B, 25-100. $38.

GOLDECK 16 - Subminiature for 10x14mm exp. on 16mm film. Interchangeable f2.8/20 Enna-Color Ennit lens. Behind the lens shutter, B, 1-200. Rapid wind lever, bright frame finder. $66.

GOLDI - ca. 1930 folding-bed camera for 16 exp. 3x4cm on 127 film. f2.9 or 4.5 Zecanar lens. Vario, Prontor, or Compur shutter. $32.

GOLDMANN (R. A. Goldmann, Vienna)

Press camera - ca. 1900 bedless strut-folding 9x12cm plate camera. Zeiss Tessar f6.3/135. Focal plane sh. T, B, ½-90. Black wood body, leather bellows, nickel trim & struts. $146.

Field camera - 13x18cm. ca. 1900. Reversible back, aplanat lens, mahogany body with brass trim. $120.

GOLDEN STEKY - see Riken.
GOLF - see Adox.

GOLTZ & BREUTMANN (Dresden, Germany and Görlitz, Germany) - *All Mentor cameras are listed here, including any manufactured by the "Mentor Kamerawerk, Dresden", or Rudolph Grosser, Pillnitz.*

Mentor Compur Reflex - ca. 1928 SLR box for 6x5x9cm plates. Zeiss Tessar f4.5/105 or f2.7/120mm lens. Compur shutter 1-250. Reflex viewing, ground glass at rear, and adjustable wire frame finder. Black metal body, partly leather covered. $177.

Mentor Folding Reflex - (Klappreflex) - Compact folding SLR ca. 1915-1930. 6x9cm, 9x12 cm, and 4x5'' sizes. Zeiss Tessar lenses, usually f2.7 or 4.5. FP sh. to 1000. $132.

Mentor Stereo Reflex - Bellows focusing focal plane box reflex for stereo pairs in the two common European stereo sizes: 45x107mm, with Tessar f4.5/75mm lens, and 6x13cm size with Tessar f4.5/90mm lens. Both sizes have focal plane shutter 15-1000. ($233. EUR).
Mentor Reflex - Like Graflex, basically a cube when closed. Fold-up viewing hood, bellows focus, focal plane shutter. Three common

sizes: 9x9cm (3½x3½''), 9x12cm, & 10x15cm. for plates or packs. Most common lenses are f4.5 Tessar, Heliar, and Xenar. $92.

Mentor II - ca. 1907 - A strut-folding 9x12cm plate camera (NOT a reflex). Paul Wächter Triplan f6/125mm. Focal plane shutter. Wood body covered w/ black leather. GGB. $91.
Mentor Dreivier - ca. 1930. An eye-level camera for 16 exp. 3x4cm on 127 film. Styled much like a 35mm camera. Tessar f3.5/50mm lens in Compur shutter, 1-300. $126.

Mentorett - ca. 1935 TLR for 12 exp. 6x6cm on 120 film. Mentor f3.5/75mm. Variable speed focal plane shutter. Looks somewhat like a Rolleiflex, but with FP shutter. $140.
Klein-Mentor - A relatively simple SLR for 6x9 and 6.5x9cm formats. Fold-up viewing hood. Measures 3½x4x4¾ when closed. $80.

GOODWIN FILM & CAMERA CO.- *Named for the Rev. Hannibal Goodwin, the inventor of flexible film, but taken over by Ansco. See Ansco for listing of "Goodwin" camera.*

GRAFLEX, INC. - *(Also including Folmer-Schwing and Folmer-Graflex products from 1881-1943 except Cirkut cameras which are listed under Eastman.)*
Century 35 - ca. 1961 Japanese-made 35mm camera. f3.5 or 2.8 lens. $24.
Century Universal 8x10 View- (less lens) $90.
Ciro 35 - ca. 1950 35mm RF camera. f4.5, 3.5 or 2.8 lens. Alphax or Rapax shutter. $25.

Graflex cameras:
Graflex Ia - for 2¼x4¼. B&L Tessar f4.5. $161.

Graflex 22 - TLR for 6x6cm on 120 film. Graftar f3.5/85. Century Synchromatic sh. $44.

3¼x4¼ - ca. 1909-1942. $118.
4x5 - $71.

Compact Graflex - 3¼x5½" postcard size. Although our price average is based only on complete and working examples, there have been numerous incomplete and/or not working examples on the market in recent years for considerably less. $124.

Graflex 3A - "postcard" size - 3¼x5½ on 122 film. Focal plane sh. With one of the many available lenses. $73.

Auto Graflex cameras: *All have focal plane shutter, and price listed is for cameras with normal lens.*
2¼x3¼ "Junior" - ca. 1915-1924. $74.
3¼x4¼ - ca. 1907-1923. $72.
4x 5 - $68.

Series B Graflex - ca. 1925-1942. Complete, working, with lens, G-VG condition:
3¼x4¼ - $65.
4x5 - $77. (Many inoperable examples available for lower prices.)
5x7 - less common. $180.

5x7 - $105.

RB Auto Graflex cameras:

RB Graflex Series B - Complete, working, with

lens, G-VG condition.
2¼x3¼ - ca. 1925-1951. $92.
3¼x4¼ - ca. 1925-1942. $71.
4x5 - ca. 1923-1942. $99.

RB Graflex Series C - ca. 1926-1935.
3¼x4¼ - $96.

Graflex "Inspectograph" Fingerprint Camera - A special-purpose camera for photographing fingerprints (or making 1:1 copies of other photos or documents.) Pre-focused lens is recessed to the proper focal distance inside a flat-black rigid shroud. To make exposure, camera front opening is placed directly on the surface to be photographed. Four flashlight-type bulbs provide illumination. $124.

RB Graflex Series D -
3¼x4¼ - $87.
4x5 - ca. 1929-1945. $114.

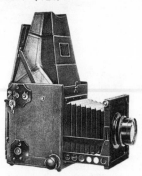

Home Portrait Graflex - ca. 1912-1942. A 5x7 focal plane SLR with an unusual feature: The focal plane shutter could be set to pass one, two, or more of the aperture slits for a single exposure, thus allowing a very broad range of "slow" speeds. $130.

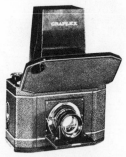

RB Graflex, Super D -
3¼x4¼ - ca. 1941-1963. $145.
4x5 - ca. 1948-1957. With f5.6/190mm Ektar or Optar. $253. *This price is considerably higher than other Graflexes, and we are listing the lens mainly because it is a very useable piece of equipment, and not so much a "collectible" to gather dust.*

National Graflex - Series I (1933-1935) and Series II - (1934-1941.) - SLR for 10 exp. 2¼x 3¼ on 120 film. Focal plane shutter. B&L Tessar f3.5/75mm. $128.

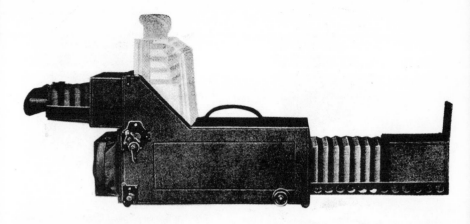

Naturalist's Graflex Camera - 1907-1921. Probably the rarest of the Graflex cameras, it has a long body and bellows to accomodate lenses up to 26" focal length. Viewing hood can be used from top or back position. $4,500.

stereo exposures on a 5x7" plate. The viewing hood featured a pair of stereo prisms so that the photographer could see one STEREO image on the ground glass. That has to be the ultimate composing aid for stereo photographers. B&L Kodak Anastigmat f6.3, or B&L Tessar f4.5/135mm lenses. Focal plane shutter. $1500.

Press Graflex - 5x7 - ca. 1907-1923. $163.

Tele-Graflex - Designed with a long bellows to allow the use of lenses of various focal lengths. ca. 1914-1924.
3¼x4¼ - $92.
4x5 - $125.

GRAPHIC CAMERAS:
The folding-bed type press cameras most common during the second quarter of the century. Rather than our normal alphabetical listing, we are listing these cameras chronologically by four major periods: Early, Pre-Anniversary, Anniversary, and Pacemaker. Other models of Graphic cameras follow the major period lists.

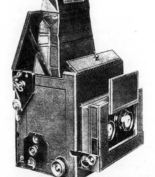

Stereo Auto Graflex - 5x7 - ca. 1907-1922. For **Early Graphic Cameras:**

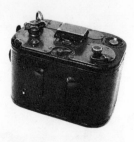

No. 0 Graphic - ca. 1909-1920's. Focal plane Graphic camera for 127 film. f6.3 Zeiss Kodak Anastigmat lens. $182.

RB Cycle Graphic - Wood body, leather covered. Folding-bed type w/ polished wood interior. Double or triple extension red bellows. 5x7 or 6½x8½ sizes with B&L RR lens $175. (Higher with convertible lenses.)

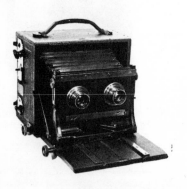

Stereo Graphic - ca. 1900. (Focal plane shutter added ca. 1908.) This was a professional camera used for making the commercial stereo views which were popular around the turn of the century. (Not to be confused with the Stereo Graphic 35mm camera ca. 1950's which appears near the end of the Graphic listing.) $700.

Pre-Anniversary Speed Graphic Cameras - Prior to 1940. Identifiable by the wooden bed with single focus knob. Pre-1938 models have Newton-finder (negative diopter lens with rear post sight). Sportsfinder is of the hinged rather than telescoping type. All pre-anniversary models are Speed Graphics with focal plane shutters. Made in 2½x3½, 3¼x4¼, 3¼x5½, and 4x5" sizes. $75. (Often found in poor condition or missing lens or back, or with stiff curtain, etc. for much less.)

Anniversary Speed Graphic Cameras - Ca. 1940-1947. Distinguished from the earlier models by the metal bed with two focus knobs telescoping sportsfinder. Distinguished from later models by lack of body release for front shutter. Made in 2¼x3¼, 3¼x4¼, and 4x5 sizes.
2¼x3¼ - $113.
3¼x4¼ - $70.
4x5 - $95.
4x5 "Combat Graphic" - The WWII olive-drab model for the armed forces. $175.

Pacemaker Graphic Cameras - Ca. 1947-on. Distinguishable from earlier models by the built-in body release with cable running along bellows. Metal lensboard. Adjustable infinity stops on bed are hinged type.
Pacemaker Crown Graphic - As described above but does not have focal plane shutter. Prices vary tremendously on these. 2¼x3¼ and 3¼x 4¼ usually range between $50 and $150. 4x5 models more stable, and averaging $162. All figures are for complete, working cameras with lens.
Pacemaker Speed Graphic - As above, but with focal plane shutter. Prices on all three sizes average nearly equal at $166.

Century Graphic - An economy model press camera with a plastic body instead of metal. ca. 1950. 2¼x3¼ size. $131.

Stereo Graphic - ca. mid-1950's for stereo pairs on 35mm film. Graflar f4/35mm lenses in simple 1/50 sec. shutter. $55.

Super Graphic - 4x5 press camera. Optar f4.7/ 135mm lens in synch. sh. 1-400. $234.

Graphic View - ca. 1941-1950's. 4x5" monorail view camera. With normal lens - $229.

Graphic 35 - ca. 1955-1958 35mm RF camera. Graflar f3.5 or 2.8/50mm in helical mount with unique push-button focus. Coupled split-image rangefinder. Prontor 1-300. $32.

GRAFTEX PRODUCTS
Hollywood Reflex - a cheap 6x6cm TLR. $12.

GRAY (Robert D. Gray, NYC)
View camera - 8x10" ca. 1880. Periscope No. 4 lens with rotary disc stops. $150.

GRIFFITHS, (Walter M. Griffiths & Co., Birmingham, England.)
Magazine camera - ca. 1890. For 3¼x4¼ plates. $150.

GRISETTE - see Eulitz.

GROSSER (Rudolph Grosser, Pillnitz)
Manufacturer of Mentor cameras during the 1950's. However, all Mentor Cameras are listed in this edition under Goltz & Breutmann.

GROVER - see Burke & James.

GUNDLACH Optical Co., Gundlach-Manhattan Optical Co. - (Rochester, N.Y.)

Korona cameras - classified here by size:

3¼x4¼ and 3¼x5½ - folding plate cameras, including "Petit" models. Cherry wood body, leather covered. Red bellows. $52.
4x5" size - folding bed view camera. $46.
5x7" size - as above two listings. $53.

5x7 Stereo - folding plate camera for stereo exp. on standard 5x7 plates. Leather covered wood body with polished wood interior. Simple stereo shutter. $275.
6½x8½ view - (less lens) - $59.
8x10 view - (less lens) - $73.
7x17, 8x20, and 12x20 "Banquet" view - (without lens, but with holder) - $146.

GUTHE & THORSCH KAMERA WERKSTATTEN. (Dresden, Germany)
KW Patent Etui - ca. 1930. As the name Etui denotes, this is an extremely flat folding plate camera. Folding bed style with double extension bellows, the whole works folds to a thickness of about an inch.
6x9cm size - Tessar f4.5/(100-120mm) with focus knob on bed. Ibsor or Compur shutter. Black leather & bellows. $47.
6x9cm Deluxe Model - Tastefully finished in brown leather with light brown bellows. $199.
9x12cm size - The most common size. f4.5 or f6.3 Rodenstock Eurynar, Schneider Radionar, Erkos Fotar, Zeiss Tessar, or Schneider Isconar. Shutter: Ibsor, Vario, or Compur. $43.

KW folding plate cameras:
6x9cm - f4.5/105 lens. Compur sh. $33.
9x12cm - f4.5/135mm. Compur. $36.

KW Reflex Box - ca. 1930. SLR for 8 exp. 6x

9cm on 120 rollfilm in horizontal format. KW Anastigmat f6.3/105mm, or f4.5/105mm KW or Steinheil. Three speed segment shutter 25-100, B. Folding top viewing hood. $77.

KAWEE - Compact "Etui" type folding bed plate camera in 6x9 and 9x12cm sizes. Schneider Radionar or Xenar; or Rodenstock Trinar. Compur or Gauthier sh. $43.

Pilot 6 - ca. 1930's SLR for 12 exp. 6x6cm on 120 film. Laack Pololyt f3.5/75 or 80mm. or KW Anastigmat f6.3/75mm. Metal guillotine shutter B, 20-200. $44.

Pilot Reflex - ca. 1930's. TLR for 16 exp. 3x4 cm on 127 film. Tessar f2.8/50mm. $62.

Pilot Super - SLR for 12 exp. 6x6cm on 120 film. Could also be used for 16 exp. 4.5x6cm with mask. Built on the same chassis as the Pilot 6, but easily distinguished by the addition of a small extinction meter attached to the viewing hood. Ennastar f4.5, Pilotar f4.5, or Laack f2.9 or 3.5. $48.

Prakti - ca. 1960- 35mm with automatic electric drive. Domitron or Meyer lens. $34.

Praktica - 35mm SLR - f2.8 lens $30.

Praktica FX - 35mm SLR. Westanar or Tessar f2.8 or 3.5 lens. FP sh 2-500. $27.

Praktica Nova - with f2.8 lens. $35.

Praktiflex - 35mm SLR ca. 1938. Victor f2.9/50mm or Tessar f3.5. FP sh 20-500. $31. ($62 EUR)

Praktiflex FX - Tessar f2.8 or Primoplan f1.9 lens. $41.

Praktiflex II - Victor f2.9/50mm. $40.

Praktina IIa - 35mm SLR. Jena T 2.8/50mm. Focal plane sh. to 1000. Spring motor drive. $94.

Praktisix - 6x6cm SLR. Interchangeable bayonet mount Meyer Primotar f3.5/80mm. FP sh. 1-1000. Changeable prism. $164.

HAKING (W. Haking, Hong Kong)
Halina - 35mm. f2.8 or 3.5. Sh. 25-200. $17.

HALL CAMERA CO. (Brooklyn, N.Y.)
Mirror Reflex Camera - ca. 1910 Graflex-style SLR. 4x5" size with f4.5/180 lens. $86.

HALLOH - see Ica.

HAMCO - Japanese 14mm novelty cam. $8.

HANDY - see Rochester Opt. Co.

HANEEL TRI-VISION CO. (Alhambra, Ca.)

Tri-Vision Stereo - Plastic & aluminum stereo camera for 28x28mm pairs on 828 rollfilm. f8 meniscus lenses with 3 stops. Usually found in excellent condition with original box, stereo viewer, etc. for $34.

HAPO - see Photo Porst. *(Because Hapo is just an abbreviation for HAns POrst.)*

HAPPY - Japanese novelty camera. $9.

HAPPY TIME - plastic camera for 127. $3.

HARBOE, A. O. (Altona, Germany)

Wood box camera - ca. 1870. For glass plates. Typical of the type of camera made in Germany during the 1870-1890 period. Although it pre-dated the "Kodak", it was made for the ordinary person to use. Brass barrel lens, simple shutter, ground glass back. $600.

HARE - (George Hare, London)
Tourist camera - ½-plate. ca. 1865. With Fallowfield Rapid Doublet lens with iris diaphragm. Changing box. $600.
Stereo camera - ca. 1865. Full plate size. For stereo views in two separate exposures using the same lens on a sliding panel. Mahogany body. Dark red bellows. Dallmeyer lens. $675.

HARMONY - Japanese . $6.

HARVARD - see Mason, Perry & Co.
HAWKEYE - see Blair, Boston, Eastman.
HEAG - see Ernemann.
HEIDECKE, HEIDOSCOP - see Franke & H.
HELIOS - see Huttig.

HEMAX - 9x12cm folding plate camera. H. Roussel Anastigmat f6.8/135mm. $28.

HENRY CLAY CAMERA - see American Optical Co.

HERCO (Herbert George Co.)
Donald Duck Camera - ca. 1940's plastic 127 film camera for 1-5/8 x 1-5/8" exposures. Figures of the Disney ducks (Donald, Huey, Louie, and Dewey) in relief on the back. Meniscus lens, simple shutter. $23. (With original cardboard carton, add another $5.)

Imperial - pre-war folding 127 camera. Ludwig f4.5/50mm lens. $12.

Imperial Reflex - ca. mid-1950's plastic 6x6cm TLR for 620 film. Simple lens & sh. $8.

Imperial Satellite Flash - $4.

Roy Rogers & Trigger - Plastic marvel for 620 film. *Note: The Trigger in this case is not a shutter release, but a horse. Pardon the pun.* $8.

Official "Scout" cameras - Boy Scout, Brownie Scout, Cub Scout, Girl Scout . . . in black or in official scout colors. $6.

HERLANGO AG, (Vienna)
Folding camera - for 7x8.5cm plates or rollfilm back. Tessar f4.5/105mm. Compur shutter 1-250. $40.

HERMAGIS (J. Fleury Hermagis, Paris)
Velocigraphe - ca. 1892 detective style dropplate magazine camera for 12 plates 9x13cm in metal sheaths. Polished wooden body built into a heavy leather covering which appears to be a case. Front and back flaps expose working parts. $400.

HESS-IVES CORP. (Philadelphia, Pa.)

Hicro Color Camera - ca. 1915 box-shaped camera for color photos 3¼x4¼" by the separation process via multiple exposures with filters. Meniscus lens. Wollensak Ultro shutter. (Made for Hess-Ives under contract by the Hawkeye Division of E.K.C.) $118. ($220 EUR).

HETHERINGTON & HIBBEN (Indianapolis)

Hetherington Magazine Camera - ca. 1892 Magazine camera for 4x5 plates. Dark brown leath. covered. Plate advancing, aperture setting, & shutter tensioning are all controlled by a key. This camera was once marketed by Montgomery Ward & Co. $473.

HEXACON - (Dresden)
35mm SLR. Contax copy. f2/50mm Cooke Amotal or Zeiss Tessar. $37.

HICRO - see Hess-Ives.

HIT - Japanese novelty camera for 14x14mm exp. on 16mm paper backed rollfilm. $7.

STEREO HIT - Japanese plastic stereo camera for 127 film. f4.5 lens. Synch. shutter. $38.

HOEI INDUSTRIAL CO. (Japan)
Ebony 35 - ca. 1950 bakelite camera for 25x37 mm exp. on 828 rollfilm. f11 meniscus lens. Simple B & I shutter. $4.

HOFERT (Emil Hofert, EHO Kamera Fabrik, Dresden, Germany) - *Emil Hofert (often abbreviated to "Eho" in camera names) worked closely with B. Altmann, founder of Altissa Kamerawerk, Dresden, and many cameras bear both names. See also Altissa.*
Eho Altiflex - ca. 1930's 6x6cm TLR for 120 films. f4.5/75mm Ludwig Victar, f4.5 or 3.5 Rodenstock Trinar, or f2.8 Laack Pololyt lenses. Prontor or Compur shutter. $30.

Eho Altiscop - 6x6cm on 120 film. f4.5/75 Ludwig Victar lenses. $42.

Eho-Altmann Juwel Altissa - ca. 1938. Psuedo-TLR box camera for 12 exp. on 120 film. The finder on this model is like many of the cheap TLR cameras - just an oversized brilliant finder. (not coupled to focusing mechanism.) Rodenstock Periscop f6 lens. Simple shutter. Black hammertone finish. $16.

Eho box camera - ca. 1932. for 3x4cm on 127 film. f11/50mm Duplar lens. Simple shutter, B & I. Metal body. $41.

Eho Stereo Box camera - ca. 1930's for 5 stereo pairs 6x13cm or 10 single 6x6cm exp. on 120. B & I shutter. f11/80 Duplar lens. $52.

HOLIDAY - see Eastman, - Brownie Holiday.

HOLLYWOOD - novelty mail-in camera. $10.

HOLLYWOOD REFLEX - see Graftex.
HOLOGON - see Zeiss-Ikon.
HOMEOS - see Richard.

HOMER 16 - Japanese novelty camera for 13x 13mm exp. on 16mm film. Meniscus lens, simple shutter. $9.

HOPALONG CASSIDY CAMERA - see Galter.

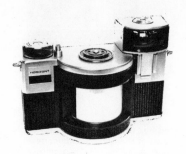

HORIZONT - Russian 35mm panoramic camera with f2.8 pivoting lens for 120 degrees. $191.

HORSMAN - (E. I. Horsman Co. N.Y.C.)

No. 3 Eclipse - ca. 1896. Folding bed, collapsible bellows, polished cherry-wood view camera for 4½x6½ plates. (Styled like the more common Scovill Waterbury camera.) Brass barreled meniscus lens. Rubber-band powered shutter. $165.

HOUGHTON - (George Houghton & Son Ltd., Houghton's, Ltd. - pre-1925. Houghton-Butcher - after 1925.) London, England.
All Distance Ensign Cameras - An euphemistic term for "fixed focus", this name was applied to box and folding model cameras for 2¼x3¼" (6x9cm) on rollfilm. Box models - $8. Rollfilm models - $12, including Ensign Pocket Models I & II.

Autorange 220 Ensign - ca. 1941. Folding camera offering a choice of 12 or 16 exposures on 120 film. F4.5 Tessar in Compur 1-250. Focus by radial lever on bed. $58.

Box cameras - (Ensign) - $11.

Cameo, Carbine - see Butcher

Cupid - ca. 1920. Simple camera for 4x6cm exp. on 120 film. Meniscus achromatic lens, f11. $25.

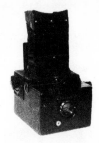

Ensign Rollfilm Reflex - ca. 1920's. For 6x9 cm exp. on 120 film. Two models: Non-focusing model, vertical format. - $58. Focusing model, horizontal format. - $64.

Ensignette - ca. 1910-1930. All-aluminum bodied folding rollfilm camera of the bedless strut type. Similar to the Vest-Pocket Kodak camera but has extensions on both ends of the front panel which serve as table stands. Made in two sizes: No. 1 for 1½x2¼ and No. 2 for 2x3". Originally available over a large price range, featuring different lens/shutter combinations. $43.

Sanderson cameras - *Even though manufactured by Houghton, all Sanderson cameras are listed under Sanderson.*

Selfix - **16-20** - ca. 1950's. For 16 exp. 4.5x6 cm on 120 film. (This style of camera was often called a "semi" at that time, because it took half-size frames on 120.) f4.5/75 Ensar or f3.8 Ross Xpress. $31.

Ensign folding rollfilm cameras - Postcard size for 3¼x5½" exp. on 122 film. $23.

Klito - ca. 1905 magazine box camera for 3¼x 4¼ plates. $44.

Folding Klito - for 3¼x4¼ sheet films. Double extension bellows. f6.8 Aldis Plano. $36.

May Fair - Metal box camera. T&I shutter. $15.

Ticka - ca. 1905. Pocket-watch styled camera manufactured under license from the Expo Camera Co. of New York, and identical to the Expo Watch Camera. For 25 exp. 22x16mm on special cassette film. Fixed focus f16/30mm lens (meniscus). I & T shutter. $131.

Midget (Ensign) - ca. 1912 compact folding camera for 3.5x 4.5cm exposures on 127 film. Meniscus lens. Shutter 25-100. $47.

Ensign Reflex & Popular Reflex - ca. 1915-1930 Graflex-style SLR for 3¼x4¼ plates. FP shutter to 1000. Cooke Luxor lens. $80.

Ticka - Focal plane model - With focusing lens. Rare. (Exposed works make it easy to identify.) $500.
Ticka Enlarger - to enlarge the 16x22mm Ticka negative to 6x9cm. Meniscus lens. $44.

HUCKELBERRY HOUND - Modern novelty camera for 127 film featuring the cartoon character on the side. $4.

HUNTER - **(R. F. Hunter, Ltd. London)**
Purma Special - ca. late 1930's bakelite & metal camera for 16 exp. 32x32mm (1¼" sq.) on 127 film. Three speed metal FP shutter. Speeds controlled by gravity. Fixed focus f6.3/2¼" Beck Anastigmat (plastic) lens. One of the first cameras to use a plastic lens. $32.

HURLBUT MFG. CO. (Belvidere, Ill.)

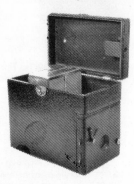

Velox Magazine Camera - ca. 1890. An unusual magazine-plate detective camera. Plates are dropped into the plane of focus and returned to storage by turning the camera over. $750.

HÜTTIG (R. Hüttig A.G., Dresden, R Hüttig & Son, Dresden.) *Claimed in 1910 advertisments to be the oldest and largest camera works in Europe.* *Close association with Ica of Dresden.*
Atom - ca. 1908 plate camera for 4.5x6cm. f8/90mm lens. Compound sh 1-250. $90.
Folding plate camera - ca. 1906. for 9x12cm plates. Black leathered wood body. Aluminum bed. Red bellows. Pneumatic shutter 25-100. $26.
Helios - strut-type folding plate camera. 9x12 cm. 185mm. Anastigmat lens. Focal plane shutter 6-1000. $56.

Ideal - ca. 1908 9x12cm folding-bed plate ca-

mera. Huttig Extra Rapid Aplanat Helios f8. Automat sh. B, T, 25-100. Aluminum standard and bed. Red bellows. $33.

Ideal Stereo - ca. 1908. 6x13cm plates. Extra Rapid Aplanat Helios f8/105mm. Huttig Stereo Automat sh. T, B, 1-100. $114.

Lloyd - Folding camera for 3¼x4¼ rollfilm or 9x12 plates. Goerz Dagor f6.8/135. Compound sh. 1-250. Double extension red bellows. $41.

Magazine cameras - ca. 1900, including varied **Monopol** models. 9x12cm drop-plate type box cameras, leather covered. Focusing Aplanat lens & simple shutter. ($115. EUR).

Record Stereo Camera - for 9x18cm plates. Hugo Meyer Aristostigmat f6.8/120mm lenses. Focal plane shutter. $121.

Stereolette - ca. 1909 small folding stereo camera for 45x107mm plates. f8/65mm Helios lens. I, B, T shutter. $185.

Tropical plate camera - 6x9cm folding-bed type. Double extension bellows (brown). Steinheil Triplan f4.5/135 lens in Compound sh. 1-150. Fine wood body w/ brass trim and bed. $280.

ICA A.G. (Dresden) *Ica became a part of Zeiss-Ikon in 1926, along with Contessa-Nettel, Goerz, Ernemann, & Carl Zeiss Optical Co. Some models were continued under the Zeiss-Ikon name.* *See also Zeiss-Ikon.*
Atom - ca. 1910-1920. Small folding camera for 4.5x6cm plates. In two distinctly different models, both in appearance and current value:

plates (or rollfilm back). Tessar f4.5/12cm lens. Compur dial-set shutter. $39.

Favorit - 425 - ca. 1925 folding-bed camera for 13x18cm (5x7") plates. Square black DE leather bellows. f6.3/210mm Tessar. Compur dial-set 1-150. An uncommon size. $120.

Folding plate cameras - (misc. models, in 6x9 & 9x12 cm sizes) $31.

Halloh - (Models 505, 510, 511) Folding rollfilm cameras (also for plate backs) in the 8x 10.5cm (3¼x4¼") size. f4.5/12cm Tessar, or f6.8/135 Litonar. Dial Compur shutter 1-250, B, T. $36.

Icar - ca. 1920 folding bed plate camera for 9x12cm. Ica Dominar f4.5/135. Compur dial-set shutter, T, B, 1-200. $28.

Icarette - folding bed rollfilm cameras for 120 film. Two basic styles - the horizontally styled body for 6x6cm exposures - such as the Icarette A, and the vertical body style for 6x9cm cm., such as the Icarette C, D, and L. Prices average the same for either style. $32.

Ideal - ca. 1920's folding-bed vertical style plate cameras. Double extension bellows. (see also Zeiss for the continuation of this line of cameras.) In three sizes:
6x9cm - f6.8/90 Hekla, f6.3/90 Tessar, or f4.5/105 Litonar. Compur 1-150. $33.
9x12cm. - f4.5/150mm Tessar. Compur. $45.
13x18cm (5x7") - f4.5/210mm Tessar in dial Compur sh. This larger size is much less common than the others. $82.

Juwel - (Universal Juwel) - ca. 1925. (Also continued as a Zeiss model after 1926.) A drop-bed folding plate camera of standard style, except that it has square format bellows and rotating back. It also incorporates triple extension bellows, wide angle position, and all normal movements. $96.

Lloyd - (Stereo model) - ca. 1910. Folding stereo (or panoramic) camera for plates or rollfilm. Stereo Compound shutter 1-100. f6.8/90mm Double Anast. Maximar lenses. $220.

Maximar - folding bed double extension precision plate camera. Although the Zeiss-Ikon Maximar is much more common, it originated as an Ica model. 9x12cm size with f4.5/135 Novar, f6.8/135 Hekla, f4.5/135 Litonar, in Compound, Compur, or Rulex sh. $38.

Minimal - folding bed double extension sheet-film camera. 9x12cm with f6.8/135 Hekla, or f6.8/120 Goerz Dagor. Ica Automat or Compound shutter. Leather covered wood body. $38.

Horizontal-format Atom - a folding bed type with self-erecting front. Generally with f4.5/65mm Tessar or f6.8 Hekla. Compound sh., 1-300. Unusual location of reflex brilliant finder: Viewing lens on front center of bed, but mirror and objective lens extend below the bed. $175.
Vertical format Atom - in the more traditional folding bed style. Reflex finder is still on the front of the bed, but remains above the bed. $88.

Bebe - (Bee-Bee) - folding plate cameras in the common sizes, but again two quite different styles, most easily distinguished by format orientation:
Horizontal format Bebe - such as the Bebe 40/2 for 4.5x6cm plates. Bedless strut-type folding style. Tessar f4.5/75mm in dial-set Compur shutter which is built into the flat front of the camera. $180.
Vertical format Bebe - in the normal drop-bed folding style, such as the Bebe A. Tessar f3.5 or 4.5 lens. Dial-set Compur shutter. $38.

Cameo Stereo - ca. 1912 folding bed stereo camera for 9x18cm plates. Extra Rapid Aplanat Helios lenses. Automat Stereo shutter, ½-1000, T, B. Twin tapered bellows. Black covered wood body. $138.

Cupido - Folding bed camera for 6x9cm

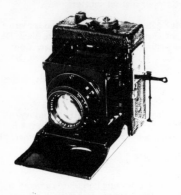

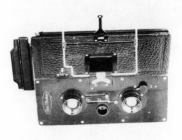

Minimum Palmos - ca. 1935 compact vertical format folding bed camera for 4.5x6cm plates. Most unusual feature is the focal plane shutter, T, B, 50-1000. This is Ica's smallest focal plane camera. Zeiss Tessar f2.7/80. $95.

Nelson 225 - ca. 1915 folding bed double-extension plate camera for 9x12cm. Tessar f4.5/150. Dial Compur T, B, 1-150. $41.

Plascop - ca. 1925 rigid-bodied stereo camera for 6x13cm plates or packfilm. Ica Novar Anastigmat f6.8/75mm lens in guillotine shutter, T & I. Black leather covered wood body with black painted metal parts. Reflex & wire frame finders. $94.

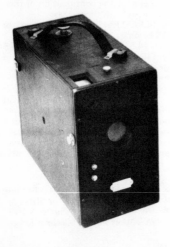

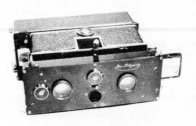

Polyscop - ca. 1910-1925 - Rigid bodied stereo camera in two common formats: 45x107 mm, and 6x13cm. Some models had plate backs, some had magazine backs. Could also be used as panoramic cameras by using one lens in the center position and removing the septum. f4.5 or 6.3 Tessar lenses. $170., **Cheaper models** - with simple lenses and without magazine backs - $122.

Reflex - **(756, 756/1)** - ca. 1910-1925 Graflex style SLR for 8.5x11cm (3¼x4¼") plates. (Examples: "Artists" reflex, Tudor, etc.) f4.5/150mm Tessar lens. Focal plane shutter to 1000. $98.
Folding Reflex - a very compact SLR which folds to about one-third the size of the box model. f4.5 Tessar or Dominar. $210.

Nero - ca. 1905 magazine box camera for 9x 12 cm plates. Guillotine sh., T&I. $64.

Niklas - ca. 1920's folding bed plate cameras. 6x9 and 9x12cm sizes. f4.5 Litonar or Tessar lens in Compur shutter. $33.

Nixe - ca. 1920's folding bed camera for 9x12 plates or 122 rollfilm. $56.

Periscop - 9x12cm plate camera. Alpha lens. $26.

Sirene - folding plate cameras, 6x9 or 9x12cm sizes. Economy models with f11 Periskop or f6.8 Eurynar lens. Ibso shutter. $22.

Stereo camera - for 122 rollfilm. f6.3 Zeiss lens. $195.

Stereo Ideal - folding stereo camera for 9x18 cm plates (like type 660). Twin f6.3 Tessar lenses. Compound shutter to 150. Twin black bellows. $180.

Stereo Ideal (type 651) - ca. 1910 folding bed stereo camera for 6x13cm plates. 90mm lenses (f4.5 or 6.3 Tessar or f6.8 Double Anast.) in Stereo Compound shutter. Magazine back. $175.

Stereolette - ca. 1912-1926 compact folding-bed type stereo camera for 45x107mm plates. Variety of available lens/shutter combinations. $162.

Stereolette Cupido (type 620) - $160.

Teddy - 9x12cm folding plate camera. f8/130 mm Extra Rapid Aplanat Helios or f6.8/135 Double Anastigmat Heklar. Automat sh. $18.

Toska - 9x12cm folding plate camera. Zeiss Double Amatar f6.8/135, or f8/130 Rapid Aplanat Helios. Ica Automat or Compound shutter. $22.

Trilby 18 - ca. 1912 magazine box camera for 6 plates 9x12cm, or 12 exp. on sheet film. Ica Achromat lens. Guillotine shutter, T & I. Automatic exp. counter. $100.

Trix - ca. 1915 cut film cameras in 4.5x 6cm and 9x12cm sizes. $46.

Trona - 6x9 or 9x12cm double extension plate cameras. f4.5 Tessar. Compur sh. $41.

Tropica 285 - Tropical model folding-bed 9x12cm plate camera. Square back style. Double extension bellows, finely finished wood body with brass trim. $384.

Victrix - ca. 1912-1925 folding bed camera for 4.5x6cm plates. Ica Dominar f4.5/75 or Hekla f6.8/75mm. Automat or Compur sh. Focus by radial lever on bed. $82.

ICARETTE - see Ica, above, Zeiss.
IDEAL - see Ica, Huttig, Zeiss, Burke & James.

IDEAL TOY CORP. (Hollis, N.Y.)
Kookie Kamera - ca. 1968. Certainly in the running for the most unusual camera design of all time, from the plumbing pipes to the soup can. It looks like a modern junk sculpture, but takes 1¾x1¾" photos on direct positive paper for in-camera processing. $30.

IDENT - see Cam-co.

IHAGEE Kamerawerk, Steenbergen & Co., Dresden, Germany.
Duplex cameras - *Ihagee used the name "Duplex for two distinctly different cameras:*
Duplex two-shuttered folding bed plate camera ca. 1920's. Square body. Focal-plane sh.

in addition to the front inter-lens shutter. This was the camera which inspired the name. Made in 6x9 and 9x12cm sizes. $138.

Duplex - (vertical format) - ca. 1940's folding bed plate camera. f3.5 or 4.5 Steinheil lens, Compur Shutter. Double extension. $36.

Exa - 35mm focal plane SLR. Models I, Ia, II, IIa, IIb - with normal lens (f2.8 Meritar or f2.9 Domiplan.) $31.

Exakta - (original model) - (A) - introduced in 1933, it was the first small focal plane SLR. For 8 exp. 4x6.5cm on 127 rollfilm. f3.5 Exaktar or Tessar. Focal plane shutter 25-100. Black finish. (Some models with slow speeds to 12 sec. Some models not synched.) $108.

Night Exakta - similar to model B, but wider lens flange size for special fast lenses. Not a common model, probably because of non-standard lens mount. It was available in all-black or in black & nickel. *Note: Some people think that the half-moon on the top of the viewing hood identifies this camera. Not true. The half-moon and rising sun is a trademark of the Ihagee company, and it appears on many Exakta models, as well as other Ihagee cameras. Don't be fooled into paying too much for another Exakta model. Measure and compare lens flange size.* With f2/80mm Biotar or Xenon - $210. ($340, EUR).

Exakta C - $120.
Exakta II - (Kine Exakta) - ca. 1935. For 35 mm film. Interchangeable bayonet-mount lenses: f2.8 or 3.5/50 Tessar, f2.8/50 Westar, f2/50 Schneider Xenon. $59.
Exakta V - ca. 1950. 35mm film. With normal lens as listed above. $65.
Exakta VX - ca. 1950's. 35mm. with lens as listed above for Exakta II. - $76.
Exakta VX IIA - $90.

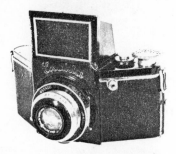

Exakta B - similar to model (A) above. Main body still black leather covered, but some models have chrome finish on metal parts. Focal plane shutter 25-1000, + slow speeds to 12 sec. and self timer. With normal lens (f2.8 or f3.5 Tessar or Xenar.) $117.

Exakta 66 - Single lens reflex for 12 exp. 6x6 cm. on 120 rollfilm. f2.8 Tessar or Xenar. Two distinct body styles:
Pre-war model - ca. 1938. Horizontal body style and film transport (like most 35mm cameras, or like the 6x6cm Korelle reflex.) FP sh. 12 sec. to 1/1000. $233.
Post-war style - vertical style, much like the twin-lens reflex shape, but with only one lens. $178.

Exakta Junior - similar to model B, but speeds only 25-500. No self timer. $112.

Ihagee folding plate cameras - 6x9 size - with f4.5/105 Tessar, Compur sh. $42. Larger 9x12cm size with similar lens/sh. $33.

Ihagee folding rollfilm cameras - for 8 exp, 6x9cm on 120 film. f4.5 anastigmat lens in Compur or Prontor shutter. $18.

Paff - ca. 1920's SLR box camera for 120 film. Simple meniscus lens, single speed sh. $55.

Parvola - ca. 1930's camera for 127 rollfilm. Telescoping front. Three models: 3x4cm, 4x6.5cm, and the "twin" or "two-format" model for either size. Could also use plates or packs. $60.

Patent Klapp Reflex - ca. 1920's compact fol-

ding SLR for 6.5x9 or 9x12cm. Focal plane sh. to 1000. F4.5 Dogmar, Tessar, or Xenar. $222.

Stereo camera - folding bed style for 6x13cm plates. Meyer Trioplan f6.3/80mm. Stereo Prontor shutter. $147.

Ultrix (Auto) - ca. 1930 folding bed camera for rollfilm. Small size for 4x6.5cm on 127 film. Larger size for 6x9cm on 120. $27.
Ultrix (Cameo, Weeny) - models with telescoping screw-out lens mount like the Parvola, above. $67.

IKKO SHA (Japan)
Start 35 - A simple plastic eye-level camera for 828 film, despite the name. This is one of few cameras for 828 film ever made outside of the United States. $22.

IKOFLEX, IKOMAT, IKONETTE, IKONTA - see Zeiss-Ikon.
ILOCA - see Witt.
ILOCA TOWER - see Tower.
IMPERIAL - see Herco.
INGENTO - see Burke & James.
INSPECTOGRAPH (fingerprint camera) - see Graflex.
INSTANTOGRAPH - see Lancaster
INTERNATIONAL RESEARCH CORP. - see Argus.
IRIS - see Universal Camera Corp.

IRWIN (U.S.A.) - cheap cameras such as Irwin Reflex, Irwin Kandor, etc. $6

ISO (Italy)
Duplex - ca. 1950 stereo camera for 24 pairs of 24x24mm exp. on 120 film. The 24x24 format was the common format for 35mm stereo, but putting the images side-by-side on 120 film advanced vertically was a novel idea. $124.

ISO, ISOFLASH, ISOLAR, ISOLETTE, ISO RAPID - see Agfa.

JAPY & CIE. (France)
le Pascal - ca. 1898 box camera with spring-

motor transport for 12 exp. 40x55mm on rollfilm. Meniscus lens with 3 stops. Shutter has 2 speeds + B. Leather covered wood & metal body with brass trim. The first motorized rollfilm camera. $450.

JEANNERET & CIE. (Paris)

Monobloc - ca. 1915-1925 stereo camera for 6x13cm plates. f4.5 Boyer Sapphir or f6.3 Roussel Stylor 85mm lenses. Built-in magazine. Pneumatic shutter. Metal body, partly leather covered. $176.

JEM (J. E. Mergett Co. Newark, N.J.)
Jem Jr. 120 - All metal box camera ca. 1940's. Simple lens & shutter. $5.

JIFFY - see Eastman.

JOS-PE (Joseph Peter, Hamburg & Munich)

Tri-Color Camera - ca. 1925 all-metal camera for single-shot 3-color separation negatives. Made in 4.5x6cm and 8.5x11cm sizes. $850.

JOUX - (L. Joux & Cie. Paris, France)
Alethoscope - ca. 1912 stereo camera for 45x 107mm plates. 5-speed guillotine sh. $150.
Ortho Jumelle Duplex - ca. 1895 rigid-bodied "jumelle" style camera for 6x9cm plates. f8/110mm Zeiss Krauss Anastigmat. Five speed guillotine shutter. Plate magazine. An uncommon camera. $150.

JUBILAR - see Voigtlander.
JUBILEE - see Bolsey.
JUBILETTE - see Balda.

JUMELLE - *The French word for "twins", also meaning binoculars. Commonly used to describe stereo cameras of the European rigid-body style, as well as other "binocular-styled" cameras where one of the two lenses is a viewing lens and the other takes single exposures. See French manufacturers such as: Bellieni, Carpentier, Gaumont, Joux, Richard, etc.*

JUWEL - see Hofert, Ica, Zeiss.
JUWELLA - see Balda.

KALART CO. (New York City)
Press camera - 3¼x4¼ size - f4.5/127mm Wollensak Raptar in Rapax sh. $110.

KALIMAR (Japan)
Kalimar A - ca. 1950's 35mm non-RF camera. f3.5/45mm Terionar lens. $10.

KALLOFLEX - see Kowa.
KAMRA - see Bell, Devry.
KAMARET - see Blair.

KAMERET JR. No. 2 - ca. 1930's Japanese box camera for 1¼x2" cut film. $12.

KAMREX - see Lancaster.
KARAT - see Agfa.
KARDON - see Premier Instrument Co.
KARMA - see Arnold.
KAROMAT - see Ansco, Agfa.
KAWEE - see Guthe & Thorsch.

KEMPER - (Alfred C. Kemper, Chicago)

Kombi - ca. 1890's. The mini-marvel of the decade. A 4 oz. seamless metal miniature box camera with oxidized silver finish. Made to take 25 exposures 1-1/8" square on rollfilm, then double as a transparency viewer. (From whence the name "Kombi"). Sold for $3.00 new, and Kemper's ads proclaimed "50,000 sold in one year." Although not rare, they are a prized collector's item. $108.

KENFLEX - Japanese 6x6cm TLR. f3.5 First lens. $18.

KENGOTT (W. Kengott, Stuttgart)
6x9cm plate camera - ca. 1920's. Folding-bed style. Double extension. f4.8/105mm Leitmeyr Sytar lens in Ibsor 1-125 sh. $28.

10x15cm. plate camera - with revolving back. Triple extension bellows. Kengott (Paris) Double Anastigmat f6.8/180mm lens in Koilos sh. 1-300. Leathered wood body. $72.
Tropical model 10x15cm plate camera - Steinheil Unofocal f4.5/150 lens in Kengott Koilos 1-100, T, B shutter. Candlewood body, Gold plated brass trim. Light brown leather bellows. $220.

KENT - Japanese 14mm novelty camera. $9.

KEWPIE - see Conley.

KEYS STEREO PRODUCTS (U.S.A.)
Trivision Camera - ca. 1950's for 6 stereo pairs or 12 single shots on 828 film. Fixed focus f8 lenses. Single speed shutter. $25.

KEYSTONE FERROTYPE CAMERA CO.
(Philadelphia, Pennsylvania)

Street camera - Suitcase style direct-positive street camera with ceramic tank inside. Various masks allow taking different sized pictures. $125.

KIEV - (Moscow, USSR) - ca. 1945-1960's 35mm RF camera (Contax copy). f2/50mm Jupiter lens. $66.

KILFITT (Heinz Kilfitt, Munich, Germany, Heinz Kilfitt Kamerabau, Vaduz, Liechtenstein, Metz Aparatebau, Nürnberg, Germany)
Mecaflex - A well-made 35mm SLR in an odd format (24x24mm) for 50 exp. on regular 35mm cartridge film. Interchangeable bayonet mount lenses, f3.5 or 2.8/40mm Kilar. Prontor-Reflex behind-lens shutter. Entire top cover of camera hinges forward to reveal the waist-level reflex finder, rapid-wind lever, exposure counter, etc. When closed, the matte-chromed cast metal body with its grey leatherette covering looks somewhat like a sleek, knobless Exakta. Not too many were made, and it was never officially imported into the United States. $200.

KINAX - see Kinn.

KINDER - Kindar Stereo camera - 35mm film in standard cartridges. f3.5 Steinheil Cassar lenses. $38.

KING (Germany)
Regula - 35mm cameras, various models: I, IIID, B, KG, PD etc. f2.8 Cassar, Gotar, or Ennit lens. $20.

KING CAMERA - (Japan) - Cardboard miniature box camera for single plate holder. Single speed shutter. Ground glass back. $15.

KING POCO - see Rochester.

KINN (France)
Kinax - folding camera for 8 exp. on 120 film. f4.5/105 Berthiot lens. $12.

KIRK - Stereo Camera, Model 33 - Brown bakelite body. $25.

KIYABASHI KOGAKU (Japan)
Autoflex - 6x6cm TLR for 120 film. f3.5 Tri-Lausar lens. $26.

KLACK - see Reitzschel.
KLAPP - *Included in the name of many German cameras, it simply means "folding". Look for another key reference word in the name of the camera.*

KLEFFEL - (L. G. Kleffel & Sohn, Berlin)
Field camera - ca. 1890. 13x18cm (5x7") horizontal format. Brown square-cornered bellows. Wood body w/ brass trim. Brass barrel lens. $160.

KLIMAX - see Butcher.
KLITO - see Houghton.
KLONDIKE - see Anthony.
KNACK DETECTIVE CAMERA - see Scovill.

KOCHMANN (Franz Kochmann, Dresden)
Korelle cameras- *There are several basic types of Korelle cameras which appear regularly on today's market, the most common of these by far is the reflex. All types, even if not identified by model name or number on the camera, are easily distinguished by size and style. For this reason, we have listed the*

Korelle cameras here in order of increasing size.

18x24mm (Korelle K) - Compact 35mm half-frame camera in vertical format. Body of thermoplastic is neither folding nor collapsing type. Shutter/lens assembly is a fixed part of the body. Front lens focusing. Tessar f2.8/35mm in Compur 1-300. $28.

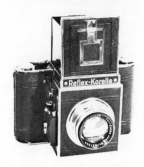

3x4cm - (style similar to the model K, or like a Wirgin Klein-Edinex) - For 16 exp. on 127 film. This model has telescoping front like the Edinex. Schneider Radionar f2.9/50. Compur 1-300, T, B. $52.

3x4cm - (strut-folding type) - for 16 exp. on 127 film. E. Ludwig Vidar f4.5/50mm lens in Vario or Compur shutter. $45.

4x6.5cm - (strut-folding rollfilm type) - for 8 exposures on 127 film. Schneider Radionar f3.5/75mm or Xenar f2.8/75mm. Compur or Compur Rapid shutter. ca. 1930. Basically the same as the Korelle "P" below, but with rounded ends added to the length of the body to house the film rolls. $61.

4x6cm - (Korelle "P") - for plates. Strut-folding type, similar to the above rollfilm model, but shorter and with square ends. A fine quality vest-pocket plate camera. Tessar f2.8/75mm, or f2.9 Xenar. Compur shutter 1-250. Leather covered metal body. $90.

Reflex Korelle - (also called Meister Korelle, & Master Reflex - introduced ca. 1934. Single lens reflex for 12 exp. 6x6cm on 120 film. (Probably the earliest 6x6cm SLR.) The first model is identifiable by the focal plane shutter 1/25 to 1/500 only, + B. Later models extended the range to 1/10-1/1000. First model has 62mm threaded lens mount. Later models switched to 52mm. $72. ($147. EUR).

KOGAKU - *Japanese for "Optical". This term is found in the name of many Japanese firms, usually preceded by the key name of the manufacturer. (However, if you are reading the name from a lens, it may only be the maker of the lens and not the camera.)*

KOLA - (Czechoslovakia) - ca. 1936. An unusual camera for various formats on either of two types of film. Takes 4x4cm or 3x4cm exp. on 127 film or 24x36mm exp. on 35mm film with different masks. Zeiss f2.8/60mm Tessar or f2.9/50mm Xenar. Compur shutter. We have only one on file - offered for $175.

KOLIBRI - see Zeiss.

KOMAFLEX - ca. 1960's SLR for 4x4cm on 127 film. (The only 4x4 SLR ever?) $50.

KOMBI - see Kemper.
KONAN - see Chiyoda Kogaku.
KONICA - see Konishiroku, below.

KONISHIROKU KOGAKU (Japan)
Konica - ca. 1951 35mm RF. f2.8 or 3.5 Hexanon lens. $49.

Konica II - $45.

Konica III - $55.

camera for 16 exp. 4.5x6cm on 120 film. Some post-war models with rangefinder. Hexar f4.5/75mm lens. $35.

KOOKY (Novelty camera) - see Ideal Toy.
KORELLE - see Kochmann
KORNER & MAYER - see Nettel.
KORONA - see Gundlach.
KOSMO KLACK - see Reitzschel.

KOWA OPTICAL
Kalloflex - ca. 1955. 6x6cm on 120. $35.

KRAUSS (G. A. Krauss, Stuttgart, E. Krauss, Paris)

Pearl (Baby) - folding camera for 16 exp. on 127 film. f4.5/50 Optor lens. $32.
Pearl II - (folding 6x9cm rollfilm) - ca. 1920's for 120 film. Typical folding-bed rollfilm camera style. $22.
Pearl II - (folding 4.5x6cm rollfilm) - ca. 1950 for 120 film "semi" or half-size frames. f4.5/75mm Hexar. Rangefinder (coupled on some models). $35.

Eka - (Paris, ca. 1924) - for 100 exp., 35x45 mm on 35mm unperforated film. Krauss Zeiss Tessar f3.5/50. Compur 1-300. $760.

Pearlette - ca. 1920's and 1930's folding (via trellis-type struts) camera for 4x6.5cm exp. on 127 film. Rokuohsha Optar f6.3/75mm in Echo shutter 25-100. $31.

Peggy I - (Stuttgart, ca. 1935) - 35mm strut-folding camera. Tessar f3.5/50mm. Compur shutter 1-300. $156.

Semi-Pearl - ca. 1930's -1950's folding bed

Peggy II - (Stuttgart, ca. 1935) - basically the same as Peggy I, but with coupled RF. Often with f2 or 2.8 Tessar. $160.

Photo Revolver - ca. 1920's for 18x35mm exp. on 48 plates in magazine or rollfilm in special back. $1,500.
Polyscop - ca. 1910 stereo camera for 45x 107 mm. plates in magazine back. $164.
Rollette - ca. 1920's folding rollfilm cameras, with Krauss Rollar f6.3/90mm lens in Pronto 25-100 shutter. Focus by radial lever on bed. $34.

Delta Periscop - ca. 1900 folding bed camera for 9x12cm plates. Krugener Rapid Delta Periscop f12 lens in Delta sh. 25-100. Wood body covered with leather. Red bellows.$50.
Jumelle-style magazine camera - for 18 plates, 6x10.7cm. Brass-barrel Periscop lens, leather covered wood body. Built-in changing magazine. $197.

Takyr - (Paris, ca. 1906) - strut-folding camera for 9x12cm plates. Krauss Zeiss Tessar f6.3/136mm. Focal plane shutter. $172.

KRUGENER (Dr. Rudolf Krugener, Bockheim / Frankfurt, Germany)
Delta folding plate camera - 9x12cm. Black leather covered wood body. Aluminum standard. Nickel trim. f6.8/120mm Dagor or Euryscop Anastigmat lens. Delta sh 25-100. $36.
Delta Magazine Camera - ca. 1892. For 12 exp. 9x12cm on plates which are changed by pulling out rod at front of camera. Achromat lens, simple spring shutter. ($360. EUR)

Simplex Magazine Camera - ca. 1889 TLR with changing mechanism for 24 plates, 6x8 cm. Steinheil or Periscop f10/100mm lens. Sector shutter. Polished mahog. ($740. EUR).

KULLENBERG, O. (Essen, Germany)
Field camera - 13x18cm - (5x7") Vertical format field camera with red tapered bellows, brass-barreled Universal Aplanat f8 lens with iris diaphragm. Rouleau shutter. $160.

KUNICK, Walter KG. (Frankfurt)
Petie - ca. 1958 subminiature for 16 exp. 14x 14mm on 16mm film. Meniscus f9/25mm in simple shutter. $23.
Tuxi - for 14x14mm on 16mm film. Achromat Röschlein f7.7/25mm lens in two-speed synch. shutter. $20.

Tuximat - 14x14mm on 16mm film. Meniscus lens, f7.7/25mm. Two-speed sync. shut. Simple built-in meter. $38.

KURBI & NIGGELOH - (Germany)
Bilora Bella 44 - 127 film. $10.

Bilora Blitz Boy - Red-brown bakelite box for 6x6cm on 120. $8.

Bilora Boy - ca. 1950 bakelite box for 4x6.5 cm exp. on 127. Simple lens/shutter. $8.

Bilora Radix - postwar - 24x24mm on 35mm Rapid cassettes. Biloxar Anast. f5.6/38mm. Behind-the-lens rotary shutter. $16.

K.W. (Kamera Werkstatten A.G.) - see Guthe.

LAACK - (Julius Laack & Sons, Rathenow)
Padie - 9x12cm folding plate camera. Laack Pololyt f6.8/135mm. Rulex 1-300 sh. $20.

LADIES CAMERA - see Lancaster.

LAMPERTI & GARBAGNATI - (Milan)
Detective camera - 9x12cm. ca. 1890. Polished wood body. Leather changing sack. (Without lens . . . $194.)

LANCASTER, J. (Birmingham, England)

Instantograph ½ plate view - ca. 1894. Wood body. Brass-barrel Lancaster lens. $174.
Instantograph ¼ plate view - ca. 1891. Brass barrel Lancaster f8 or f10 lens in Lancaster rotary shutter. Iris diaphragm. Tapered red bellows. Wood body. $197.

Kamrex - ca. 1900 ¼-plate camera. Red leather bellows. Mahogany with brass trim. $105.

Ladies Camera - ca. 1890's, ½-plate reversible-back camera. Achromatic lens, iris diaphragm. Single speed pneumatic shutter. $200.

Le Merveilleux - ca. 1890's ¼-plate camera. Aplanat lens. $175.

LANCER - see Ansco.
LeCOULTRE - see Compass.
Le Pascal - see Japy & Cie.

LEHMANN (A. Lehmann, Berlin)
Cane Handle Camera - ca. 1903. Obviously, a rare camera like this cannot be shackled with an "average" price. Two known sales were for $5,000. and $8,000.

LEICA - see Leitz, below.

LEIDOLF - (Wetzlar)
Leidox II - ca. 1951, for 4x4cm. Triplet f3.8/50mm lens in Prontor-S shutter to 300. $40.

Lordomat, Lordomatic - 35mm camera with interchangeable f2.8/50mm Lordonar. Prontor-SVS shutter. CRF & BIM. Two-stroke film advance. $31.

Lordox - Compact 35mm. f2.8/50 or f3.8/50. Pronto shutter. Body release. $28.

LEITZ (Ernst Leitz GmbH, Wetzlar)
Leica cameras - *All models listed are for full-frame (24x36mm) exposures, and all are listed in chronological order by date of introduction. Although we have included a few basic identification features for each camera, these are meant only for quick reference. For more complete descriptions, serial numbers, and history of each model, refer to a primary source of information such as "Leica Illustrated Guide" by James L. Lager; Morgan & Morgan, 1975, or to "A Brief Leica Chronicle" (E. Leitz, Inc. Rockleigh, N.J. 17647.)
Of all the cameras included in this price guide, the Leica cameras currently present the widest range of prices on the market for any given model. The current Leica-mania in the United States as well as optimistic collectors have inflated prices considerably on some models*

within the past few years. As the supply and demand of the market begin to stabilize, the wide variety of prices encountered will also become more stable, and the differential between prices in Europe and the U.S.A. will be reduced where it exists.

Note: In Europe, black models average about $25.00 higher than chrome models. The rare and unusual models command higher prices in the U.S.A. than in Europe, but the majority of the Leica cameras sell for comparable prices on both sides of the Atlantic.

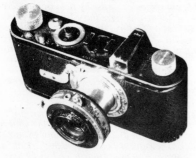

Ur-Leica (Replica) - Display model of the original 1913 prototype, reproduced by Leitz for museums, etc. $558.

Leica "A" - (I) - (1925-1930) - The first commercially produced model. Non-interchangeable lenses:
Anastigmat f3.5/50mm. (1925). Very few made. (perhaps 100-150). $5,000+
Elmax f3.5/50mm. (1925-1926). $4,300.
Elmar f3.5/50 (1926-1930). This model shows a significant difference between the US and European prices. $405 USA ($294 EUR).
Luxus - Gold-plated A-Elmar camera with lizard skin covering. $1,540 USA ($1118 EUR).

Leica "B" - (I) - (1926-1930) - The "Compur"

Leica. Approximately 1500 were made in two variations, both with Elmar f3.5/50.
Dial-set Compur (1926-29) $4,131 USA, ($3,000 EUR).
Rim-set Compur (1929-1930) $3746 USA, ($2,862 EUR.)

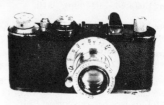

Leica "C" - (I) - (1930-31) - The first Leica with interchangeable lenses. Two variations:
NON-STANDARDIZED lens mount - Lenses were custom fitted to each camera because the distance from the lens flange to the film plane was not standard. The lens flange is not engraved, but each lens is numbered with the last three digits of the body serial number.
STANDARDIZED - The lens mount on the body has a small "o" engraved at the top of the body flange. Lenses now standardized and interchangeable from one body to another.
Either type, with f3.5/50mm. $270.

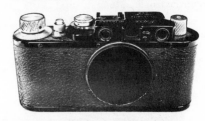

Leica "D" - (II) - (1932-1948) - The first one with built-in coupled rangefinder.
Body only (black or chrome) - $145.
With f3.5/50 Elmar. $206.

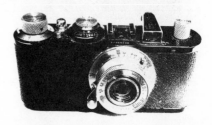

Leica "E" - (Standard) - (1932-1948) - Similar to the standardized "C", but with smaller (12mm dia.) rewind knob, which pulls out to make rewinding easier.
With f3.5/50 Elmar - $267 USA ($198 EUR).
W/ f2/50 Summar or Summicron - $295 USA.

after WWII (between 1950 and 1955) in the French occupied German state of Saarland, from pre- and post- war parts. Very few were made. The top of the body is engraved "Monte en Sarre" below the normal "Ernst Leitz, Wetzlar" engraving. $3025.

Leica "F" - (III) - (1933-1939) - The first model with slow-speed dial, carrying strap eyelets, and diopter adjustment on rangefinder eyepiece. Shutter to 500.
Body only (black or chrome) - $101.
W/ f3.5/50 Elmar - $151.
W/ f2/50 Summar - $140.

Leica "FF" (250) (Reporter) - (1934-1943) - Like Model F, but body ends extended and enlarged to hold 19 meters of 35mm film for 250 exposures. Only about 950 were made. Later models (called GG) are built on a model G body and have shutter speed to 1000.
$2,722 USA ($1988 EUR).

Leica "G" - (IIIa) - (1935-1950) - Basically like the "F", but with the addition of 1/1000 sec. shutter speed. Chrome only.
Body only - $83.
With f3.5/50 Elmar - $120.
With f2/50 Summar - $128.
With f2/50 Summitar - $148.

Leica (IIIa) - "Monte en Sarre" - Assembled

Leica "G" - (IIIb) - (1938-1946) - Similar to the IIIa, but rangefinder & viewfinder eyepieces are next to each other. Diopter adjustment lever below rewind knob.
Body only - $122.

Leica IIIc - (1940-1946) - Die-cast body is 1/8 inch longer than earlier models. One-piece top cover with small step for advance-rewind lever.
Body only - $91. ($118. EUR).
With f3.5/50 Elmar - $113.
With f2/50 Summar - $108.
With f2/50 Summitar - $119.

Leica IIIc - "K-Model" - The letter K at the end of the serial number and on the front of the shutter curtain stands for "kugellager", (ball-bearing). The ball-bearing shutter was produced during the war years, primarily for the military. Usually blue-grey painted.
$513.

Leica IIIc - Luftwaffe & Wehrmacht models - (Engraved "Luftwaffe Eigentum" or "W.H." respectively.) $1073.

Leica IIc - (1948-1951) - Like the IIIc, but no slow speeds. Top sh. speed 500. Body - $127.

Leica Ic - (1949-1951) - No slow speeds. No built-in finders. Two accessory shoes for mounting separate view & range finders.
$225 USA ($126. EUR).

Leica IIIf - (1950-1956) - Has MX sync.
Three variations:
"Black-dial" - shutter speed dial is lettered in black, with speeds 30, 40, 60.
"Red-dial" - Shutter speed dial is lettered in red, with speeds 25, 50, 75.
"Red-dial" with self-timer.
No significant price variation between models.
Body only - $105.
With f2/50 Summitar - $149.

Leica IIf - (1951-1956) - Like the IIIf, but no slow speeds. Three models: Black dial, Red dial, Red dial w/1000 sec.
Body only - $123.

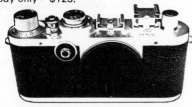

Leica If - (1952-1956) - No slow speed dial nor finders. Separate finders fit accessory shoes. Flash contact in slow speed dial location. Body only - $180. W/ 3.5 Elmar - $219.

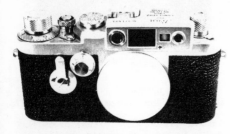

Leica IIIg - (1956-1960) - The last of the

screw-mount Leicas. Bright-line finder and small window next to viewfinder window which provides light for finder illumination. Body only - $255.
With f3.5 or 2.8 Elmar - $298.

Leica IIIg - Swedish Crown Model - (1960) - A batch of 125 black-finished cameras for the Swedish Armed Forces were among the very last IIIg cameras produced. On the back side of the camera and on the lens are engraved three crowns (the Swedish coat-of-arms). $3780 (camera and lens).

Leica Ig - (1957-1960) - Like IIIg, but no finders or self-timer. Two accessory shoes accept separate range & view finders. Top plate surrounds the rewind knob, covering the lower part when not extended. Only 6,300 were made. Body only - $413.

Leica Single-Shot - (ca. 1936) - Ground glass focus. Single metal film holder. Ibsor shutter. $1500.

Leica M3 - (1954-1966) - Two variations: Single-stroke film advance. Body only - $235. Double-stroke advance. Body only - $199.

Leica M2 - (1957-1967) - Like the single-stroke M3, but with external exposure counter. Finder has frame lines for 35, 50, & 90mm lenses. All early models and some later ones were made without self-timer. Body - $271.

LENINGRAD - Russian 35mm RF Leica copy. f3.5/50mm lens in Leica mt., Motor drive. $95.

LENZ - Novelty camera for 16mm film. $8.

LEONAR KAMERAWERK (Hamburg)
Leonar - 9x12cm folding plate camera. Leonar Aplanat f8/140mm or Periscop Aplanat f11/140mm. Sh. 25-100. $20.

LEOTAX - see Showa Optical Co.

LEROY (Lucien LeRoy, Paris)
Minimus - rigid body stereo. $225.

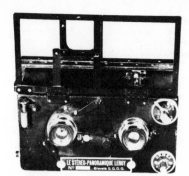

Stereo Panoramique - ca. 1906. Black, all-metal camera for 6x13cm plates in stereo, or by rotating one lens to center position, panoramic views. Krauss Protar f9/82 or Goerz Doppel Anast. f8.5/80mm. Five speed sh. $253.

LEULLIER - (Louis Leullier, Paris)
Summum Special - ca. 1925 for 6x13cm stereo plates. Roussel Stylor f4.5/75 fixed focus lens. Stereo shutter 25-100. Changing magazine for 6 plates. $150.

LEVY-ROTH (Berlin)
Minigraph - ca. 1915 camera for 18x24mm exp. on 35mm film in special cassettes. The first European still camera to use cine film. f3.5/54mm Minigraph Anastigmat lens. Flap shutter. $1600.

LEWIS (W. & W.H. Lewis, New York)

Wet Plate camera - ca. 1862. Large size, for plates up to 12x12". Folding leather bellows. Plates & ground glass load from side. A rare camera. We have one on record, less lens, for $650.

LIEBE (V. Liebe, Paris)
Monobloc - ca. 1920. For 6x13cm stereo plates. Boyer Saphir f4.5/85mm lenses in pneumatic spring shutter. Metal body is partly covered with leather. $180. *See also Jeanneret Monobloc.*

LIFE-O-RAMA III - German 6x6cm on 120. f5.6/75 or f3.5 Ennar. Vario sh., sync. $7.

LIGHTNING DETECTIVE CAMERA - see Benetfink.
LILIPUT - see Ernemann.

LILLIPUT DETECTIVE CAMERA - sold by Anthony. A detective camera in the shape of a miniature satchel. Takes 2½x2½" exposures on plates in double holders. $1500.

LINEX - see Lionel.

LINHOF PRAZISIONS KAMERAWERK, (V. Linhof, Munich)
Silar - for 10x15cm plates. Triple ext. bel. Meyer Aristostigmat f5.5/180mm lens in Compound shutter 1-150. $88.

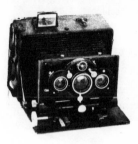

Stereo Panorama - ca. 1920. For 6x13cm exp. (stereo or panoramic). 2 Reitzschel Sextar f6.8/120mm lenses and one Reitzschel Linar f5.5/150mm. Compound shutter. Metal body, leather covered. $288.

Technika I - ca. 1930. Various sizes: 6x9, 9x12, or 13x18cm. With f4.5 Tessar in Compound or Compur shutter. $151.

LIONEL MFG. CO. (The train people)
Linex Stereo - ca. late 1940's plastic submini. for pairs of 16x20mm exp. on rollfilm. f8/30 lenses. Guillotine shutter, synched. $42.

LIPCA (Lippische Camerafabrik, Barntrup)
Rollop - ca. 1957 TLR for 6x6cm on 120. Ennit f2.8/80mm, or Enna f3.5/75mm. Prontor-SVS shutter 1-300. $82.

LITTLE WONDER - miniature box-plate camera for 2x2". Made of 2 cardboard boxes sliding into one another. $45.

LIZARS (J. Lizars, Glasgow)
Challenge, Challenge Dayspool - ca. 1905 for 3¼x4¼ exp. on rollfilm or plates. Leather covered mahogany construction. f6 or f8 Aldis or Beck lens, or f6.8 Goerz. $80.

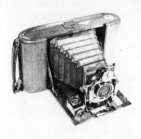

Challenge Dayspool (tropical model) - similar to the above model, but with polished Spanish mahogany body, rather than leather covered. Red leather bellows. $260.

Challenge Dayspool - 4½x6½" - ca. 1900. For rollfilm. Leather covered. Red bellows. Beck Symmetrical lens. $175.

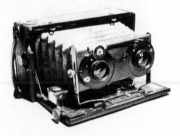

Challenge Stereo Camera, Model B - ca. 1905. For 3¼x6¾" plates. Teak with brass trim. B&L RR, or Aldis Anastigmat lenses in B&L Stereo shutter. $368.

Challenge Stereo Camera, Model 1-B - ca. 1910. A beautiful and finely finished stereo camera in Spanish mahogany with brass trim. Focal plane shutter. Aldis Anastigmat lenses. $750.

LLOYD - see Huttig, Ica.

LLOYD , Andrew J. & Co. (Boston)
Box camera - for glass plates in holders. $25.

LOEBER BROTHERS (New York) - The Loeber Brothers manufactured and imported cameras ca. 1880's and 1890's.
Folding plate camera - Full-plate, British. Fine polished wood, black bellows, brass trim. Brass-barreled lens w/ waterhouse stops. $185.

LOISIRS - French plastic rollfilm camera for 8 or 16 exp on 120 film. Radior lens, simple shutter, T & I. $28.

LONDON STEREOSCOPIC & PHOTO CO.
This company imported and sold under their own name many cameras which were manufactured by leading companies at home and

abroad. We are listing two cameras here which we can't positively link to another manufacturer.
Tailboard stereo camera - ca. 1885. Swift & Son 4" lenses, side board panel, 3½x6¼" plate. Thornton rollerblind shutter, dark maroon bellows. $500.
Wet plate camera - ca. 1855. 4x5" sliding box style. Light colored wood body (7x7½x6¼" overall) which extends to 10". London Stereoscopic Petzval-type lens in brass barrel. $2000.

LORDOMAT, LORDOX - see Leidolf.

LUBITEL - ca. 1949. Russian 6x 6cm TLR for 12 exp. on 120 film. T-22 lens, f4.5/75. Variable speed sh. 10-200. $25.

LUCIDOGRAPH - see Blair.

LUMIERE & CIE. (Lyon, France)

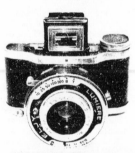

Eljy - ca. 1937 for 24x36mm exp. on unperforated 35mm film in special cassettes. Lypar f3.5/50mm lens in Eljy shutter. $49.
Luminor - 9x12cm folding-bed plate camera. $20.
Lumix F - simple folding 6x 9 rollfilm. $8.
Sinox - 6x9cm folding rollfilm. Nacor Anast. f6.3/105mm. Central shutter 25-100. $11.

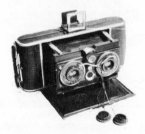

Sterelux - ca. 1920. Folding stereo camera for 116 rollfilm, 6x13cm format. Spector Anast. f4.5/80mm. $150.
No. 49 - box camera - for 122 film. $8.

LUNDELIUS MFG. CO. (Port Jervis, N.Y.)
Magazine Camera - ca. 1895 for 12 plates in

vertical format. Leather covered wood body. Measures 10x8x4½" overall. $140.

LURE - plastic miniature. $6.

LUTTKE (Dr. Lüttke & Arndt, Wandsbek, Hamburg, & Berlin, Germany.)
Folding rollfilm camera - 8x10cm. Lüttke Periplanat lens. Black leathered body with red cloth bellows. Nickel trim. $48.

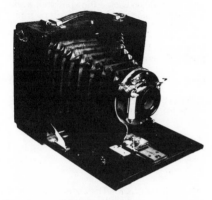

Folding bed plate camera - 9x12cm. Horizontal format. Lüttke Periscop lens with rotary stops. Brass shutter. Red-brown bellows. Black leathered wood body. $73.

LYRA - see Fuji Photo Film Co. -

MACKENSTEIN (H. Mackenstein, Paris)
Francia - Strut-folding stereo camera for 45x 107mm plates. ca. 1906. Max Balbreck or Sumo Aplanat lenses, guillotine shutter with variable speeds. Red leather bellows. $185.
Stereo Jumelle - ca. 1893 - for 18 plates 9x18 cm in magazine. Goerz Double Anastigmat 110mm lens, variable speed guillotine shutter. $197.

MACRIS-BOUCHER (Paris)

Nil Melior Stereo - 6x13cm. ca. 1920. Boyer Sapphir or E. Krauss Tessar f4.5 lens in seven-speed spring shutter. Large newton finder. 12- plate magazine. $120.

MADISON - I - folding camera for 6x6cm on 620 film. f4.5 lens. Sh. to 200. $12.

MAGIC INTRODUCTION CO. (N.Y.)

Photoret Watch Camera - ca. 1894 for 6 exp. ½x½" (12x12mm) on round sheet film. Meniscus lens. Rotating shutter. $350.

MAJOR - see Agfa.
MAKINA, MAKINETTE - see Plaubel.

MAMIYA CAMERA CO. (Tokyo)
Mamiya 6 - ca. 1950's. Basically, a folding-bed camera for 12 square exp. 6x6cm on 120. Some models featured the option of 16 vertical exposures 4.5x6cm as well. Camera body is in horizontal style. f3.5/75 Zuiko lens in Copal or Seikosha shutter. Coupled rangefinder. Unusual feature: Knurled focusing wheel just above the back door of the camera moves the film plane to focus while the lens remains stationary. $47.

Mamiya-16 - ca. 1950's subminiature for 20 exp. 10x14mm on 16mm film. Various models including: Original model, Deluxe (with plain, smooth body), Super (like orig. but w/ sliding filter), Automatic (built-in meter). No significant price difference among these models. $26.
Mamiyaflex - ca. 1940's-1950's. 6x6cm TLR cameras (Rolleiflex-style). Early models with f3.5/75mm lens. $35.

MANDEL, MANDELETTE - see Chicago Ferrotype Co.

MANHATTAN OPTICAL CO. (New York)
(See also Gundlach-Manhattan)

Bo-Peep, Model B - ca. late 1890's. 4x5 folding plate camera. Red bellows, brass shutter. (similar to other brands of same period.) $37.
Bo-Peep - 5x7" - Larger size. Double extension bellows. Brass lens w/ rotating stops. $75.

Night-Hawk Detective - ca. 1895 for 4x5" plates. Leather covered wood. String-set sh., T & I. Ground glass or scale focus. Rapid Achromatic lens. $365.

Wizard folding plate cameras:
4x5 size - Including Baby , Cycle, Wide Angle, Senior, Junior, A, and B models. $45.
5x7 size - including Cycle, B, and Senior models. $60.
Long-Focus Wizard, 5x7" - Including Cycle and Senior models. Triple extension bellows, RR lens, Unicum sh. $95.

MARION & CO., LTD. (London)
Perfection - 10x12" folding field camera ca. 1890. Fine polished wood. Dallmeyer f8 RR lens in brass barrel w/ iris diaphragm. $180.
Soho Reflex - Graflex-type SLR for 2¼x3¼. f4.5/120mm Tessar. Focal plane sh. $250
¼-plate size - (3¼x4¼") - with Ross Xpres f3.5/5½" lens. $185.
Soho Tropical Reflex - 3¼x4¼". Dallmeyer f3.5/150mm Dalmac, or Ross Xpres f3.5/6½" lens. Revolving back. Fine polished wood. Red bellows and viewing hood. Brass trim. A beautiful tropical camera. $1,800.

MARS - see Wunsche.
MARVEL - see Putnam.

MARVELFLEX - twin-lens-reflex. f4.5. $15.

MASCOT (Detective camera) - see Scovill.
MASHPRIBORINTORG - see Kiev.

MASON (Perry Mason & Co. - Boston)
Harvard camera - ca. 1890 for 2½x3½ plates. Meniscus lens. All metal. Black with gold pin-striping. $135.

MASTER REFLEX - The anglo version of the pre-war Meister-Korelle. **See Kochmann.**

MATCH-MATIC - see Argus.
MAXIMAR - see Ica, Zeiss.
MAY FAIR - see Houghton.

MAZO (E. Mazo, Paris)
Field & Studio camera - ca. 1900. For 13x18 cm. (5x7") on plates. Fine wood body, GG back, double ext. bellows. Horizontal format. Mazo & Magenta Orthoscope Rapid f8 lens in Thornton-Picard shutter. $208.

McBEAN - (Edinburgh)
Stereo Tourist - 9x18cm. Steinheil Antiplanat lens. Thornton-Picard shutter 1-225. $337.

MEC - see Feinwerk Technik.
MECAFLEX - see Kilfitt.
MEDALIST - see Eastman.
MEISTER KORELLE - see Kochmann Korelle

MEISUPPII — half-frame 35mm. $35.

MELIOR - see Macris-Boucher.
MEMO - see Agfa, Ansco.

MENDEL - (Georges Mendel, Paris)
Detective camera - for 12 plates 3¼x4¼. RR lens, rotating shutter, iris diaphragm. $138.

MENTOR, MENTORETT - see Goltz & Br.

MEOPTA (Prague, Czechoslovakia)
Flexaret - 6x6cm TLR. Belar f3.5/80mm in Prontor II sh. Crank wind, Lever focus. $25.

Mikroma - ca. 1949. 16mm subminiature. Mirar f3.5/20mm lens. Spring shutter 25-200. Rapid-wind slide. $70.
Mikroma II - ca. 1964. Similar. $69.

Stereo Mikroma - for stereo exposures on 16 mm film. Mirar f3.5/25mm lenses. Shutter 1/5-1000. $167.

MERCURY - see Universal.
MERGETT - see Jem.

MERIDIAN - 4x5 press/view. f4.5/135. $125.

MERIT - ca. 1935 German brown bakelite box for 4x6.5cm on 127 film. f11/75mm Roden-stock lens. T & I shutter. $25.

MERVEILLEUX - see Lancaster.
METEOR - see Universal.

METROPOLITAN SUPPLY CO. (Chicago)
King Camera - small 2x2x3½" cardboard camera for glass plates. $65.

MF Stereo Camera - 45x107mm plates. f6.8 Luminor lenses. $90.

MICK-A-MATIC - A 126 cartridge camera in the shape of Mickey Mouse's head. Meniscus lens in nose. $14.

MICRO - Japanese novelty camera. $9.

MICRO-16 - see Whittaker.

MIDAS - British 9.5mm hand-crank camera/projector. f2.5 lens. $73.

MIDG - see Butcher.
MIDGET - see Coronet, Houghton.
MIGHTY - see Tokyo Shashin.

MIKADO - 6x6cm. f3.5/75 Wester. $31.

MIKROMA - see Meopta.

MIKUT COLOR CAMERA - ca. 1937. For 3 color-separation negatives 4x4cm on a single plate 4.5x13cm. Mikutar f3.5/130mm. Compur shutter 1-200. $275.

MIMOSA 35MM CAMERAS
Mimosa I - ca. 1947 compact 35mm. Meyer Triplan f2.9/50. Compur Rapid shutter. Unusual boxy style for 35mm camera. $54.
Mimosa II - f2.9 Trioplan. Velax sh. 10-200. $22.

MINETTA - Japanese 16mm rollfilm novelty camera. $8.

MINEX - see Adams & Co.
MINICORD - see Goerz.
MINIMAL - see Ica.
MINIMUM - see Ica, Zeiss.
MINIMUS - see Leroy.

MINOLTA (Chiyoda Kogaku Seiko Co. Ltd., Osaka, Japan)
"A" type 35mm cameras - A, A2, A5, etc. f3.5 or 2.8 Rokkor. $27.
Autocord (Minoltacord Autoflex) - 6x6cm TLR (Rolleiflex-style). Early models without meters - $47.
Semi-Minolta, Auto Semi-Minolta - folding cameras for 16 exp. 4.5x6cm on 120 rollfilm. f4.5/75mm Coronar or Promar Anastigmat lens. Crown or Crown Rapid shutter. $35.

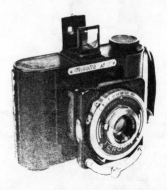

Minolta-Six - ca. late 1930's folding camera for 6x6cm exp. on 120 film. Horizontal body style. No bed. No struts. Standard pulls out with telescoping snap-lock frames around bellows. An unusual design in a camera format popular at the time. f4.5 or 5.6/80 Coronar lens in Crown shutter. $35.

Minolta 16 - subminiature ca. 1950's for 10x 14mm exp. on 16mm film in special cassettes. f3.5 or 2.8 Rokkor lens. 3-speed shutter - 25, 50, and 200. $19.
16-II - f2.8 Rokkor. 6 speeds. $22.
16-EE - f2.8/25mm Rokkor. Electric eye. $25.
16-EE-II - with case $19
16-MG - with case & chain. $35.
16-P - with case & orig. instr. $14.
16-PS - with case & strap. $18.
16-QT - with case, electr. flash, etc. $40.

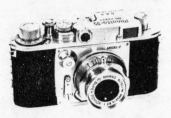

Minolta 35 - ca. 1948-1950's. Rangefinder cameras (Leica copies) for 24x32mm, and later 24x36mm on standard 35mm cartridges. Most commonly found with f2.8/45mm Rokkor. Models I, F, II, IIB. $85.

MINOX - *Subminiature cameras for 8x11mm exp. on 9.5mm film in special cassettes. The original model, designed by Walter Zapp, was made in 1937 in Riga, Latvia.*

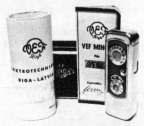

Original model - (stainless steel body) - Made in Riga, Latvia by Valsts Electro-Techniska Fabrika. Guillotine shutter ½-1000. Minostigmat lens, f3.5/15mm. $349.
Minox "Made in USSR" - Stainless steel model made during the short time the Russians held Latvia before the German occupation. (Approximately Spring to Fall, 1940). $480.
Minox II - made in Wetzlar, Germany. Aluminum body. $45.
Minox III - $46.
Minox III, Gold plated - $410.
Minox III-S - $60.
Minox A - Wetzlar. Complan f3.5. $66.
Minox B - built-in meter. - $59.

MINUTE 16 - see Universal.

MIRANDA G - 35mm SLR. $80.

MIROFLEX - see Contessa, Zeiss.
MIRROR REFLEX CAMERA - see Hall.

MITSUKOSHI (Japan)
Picny - ca. 1935 compact camera for 3x4cm (½-frame) exposures on 127 film. Very similar in size and shape to the Gelto-D by Takahashi, but rounded ends and better finish almost make it look like a stubby Leica. Even the collapsible lens mount is a direct copy of the Leica styling. $72.

MÖLLER (J. D. Möller, Hamburg, Ger.)
Cambinox - ca. 1956 - A combination of high quality 7x35 binoculars and a precision camera for 10x14mm exp on 16mm film. Interchangeable f3.5/90mm lenses. Rotary FP shutter 30-800. ($375. EUR).

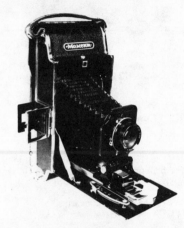

MOMENT (MOMEHM) - Russian copy of Polaroid 95. f6.8/135mm. "BTL" shutter, 10-200+B. Black bellows. $80.

MONITOR - see Eastman.
MONOBLOC - see Jeanneret, Liebe.

MONROE CAMERA CO. (Rochester, N.Y.)
(Merged in 1899 with several companies to form Rochester Optical & Camera Co.)
Folding plate cameras - ca. 1898. They fold to a very compact size, only about 1½" thick including brass double plateholder. Sizes:
2x2½" - (Vest Pocket Size) - $110.

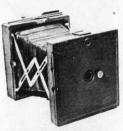

3½x3½ - (Pocket Size) - $125.
3¼x4¼ - (Pocket Poco A) - The last of the series by Monroe before the merger. $185.

Monroe Model 7 (5x7") - A "cycle" style plate camera. Double extension maroon bellows. RR lens, Gundlach shutter. This camera looks like the Rochester it is about to become. $90.

MONTANUS (Solingen, Germany)
Montiflex - 6x6cm TLR. Steinheil Cassar f2.8/80mm. Prontor-SVS shutter. $71.

MONTAUK - see Gennert.
MONTE - see Monti.

MONTGOMERY WARD & CO.
Model B - 4x5" - rapid conv. lens, Wollensak shutter. $55. *Note: Most of the cameras sold through Montgomery Ward were not marked with the company name. Sears was one step ahead of Wards in that respect.*

MONTI (Charles Monti, France)
Monte 35 - $8.
Monte Carlo - pre-war folding camera for 6x9 cm on 120 film. f3.5 or 4.5/90mm. $23.

MOORE & CO. (Liverpool, England)

Aptus Ferrotype Camera - ca. 1895 for 4.5x 6.3cm plates. Meniscus lens, black leather covered wood body. Suction bulb takes unexposed plate and swings it into position for exposure. $307.

MOSCOW (MOSKWA) - Russian copies of the Zeiss Super Ikontas.
Moscow 4 - copy of 6x9cm Super Ikonta. f4.5/110mm Industar. $61.

Moscow 5 - copy of Super Ikonta C. f3.5/105 lens. Sync. shutter. $75.

MOTORMATIC - see Eastman.
MULTI-EXPOSURE - see Simplex, Wing.
MULTIPRINT - see Buess.

MULTISCOPE & FILM CO. (Burlington, Wis.)

Al-Vista Panoramic Cameras - patents 1891-1901. Takes panoramic pictures (model no. gives film width in inches) in lengths of 4, 6, 8, 10, or 12 inches on rollfilm.
Model 4B - $135.
Model 5B - $157.
Model 5D - $191.
Overall average of all models - $154.

Model 5F - The convertible model. This camera has two fronts which use the same back. One front is the swinging lens panoramic , and the other is a folding-bed front which looks like the typical folding plate cameras of the day. An unusual and rare set. $360.

MURER & DURONI (Milan, Italy)
Express - Magazine box camera ca. 1900, for

various sized plates: 4.5x6cm, 6x9cm, 7x8 cm, 8.5x11cm (3¼x4¼'') and 9x12cm. Murer Anastigmat f4.5 or 6.3, focal length depending on size of camera. Focal plane sh. $67.

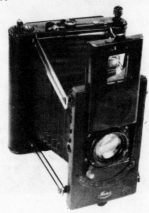

Folding plate cameras - Focal plane models - Strut folding style. In all the sizes listed above. $90.
Reflex - for 6x9cm plates. Murer Anastgmat f4.5/120mm. FP sh 15-1000. $92.
Stereo - folding camera for 45x107mm. Focal plane shutter, 15-1000. Murer Anast. f4.5/60mm. $300.

MURO SUTER - see Suter.
MUTSCHLER, ROBERTSON, & CO. - *Manufacturer of the "Ray" cameras, which were later sold & labeled under the "Ray Camera Co." name. see Ray.*

MYCRO - see Sugaya Opt. Co.
MYRACLE - see Sugaya Opt. Co.

NAGEL - (Dr. August Nagel Camerawerk, Stuttgart, Germany)
Nagel 18 - folding-bed plate camera, 6x9cm, ca. 1928. Like the Kodak Recomar, which was made by Nagel. With Nagel Anastigmat f6.3 or other normal lens - $64. With Leitz Elmar f4.5 lens - $208.

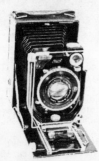

Nagel 30, 33 - Similar, but 9x12cm size.

Nagel Anast. f6.3/135, or Laudar. Compur shutter 1-250. $61.

Pupille - ca. 1930 for 16 exp. 3x4cm on 127. With Schneider Xenar f2, 2.9, or 3.5/50mm in Compur or Ibsor shutter. $163. With Leitz Elmar f3.5/50mm lens - $289.

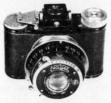

Ranca - ca. 1931. 3x4cm on 127 film. Similar to Pupille, but cheaper. Has front-lens focusing. Nagel Anast. f4.5/50mm in Ibsor shutter 1-150. $148.
Recomar 33 - for 9x12cm plates. Double ext. bellows. Compur 1-250, T, B. With normal f4.5/135 lens - $54. With Leitz Elmar f4.5/135mm lens - $305.
Regent - 6x9cm - Schneider Xenar f3.5/105 in Compur shutter 1-250. $40.
Vollenda - 4x6.5 on 127 or 6x9 on 120. With normal lens - $42. With Leitz Elmar - $276.

NATIONAL CAMERA (England)
Folding field camera - ½-plate - fine wood finish. Reversible back, tapered black bellows, Ross f6.3/7'' Homocentric lens. Thornton-Picard roller-blind shutter. $125.

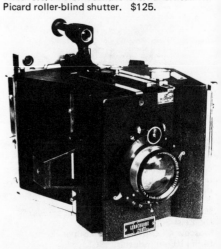

NATIONAL PHOTOCOLOR CORP. (N.Y.)

One-Shot Tri-color camera - 5x7", less lens. $225.

NELSON - see Ica.
NERO - see Ica.

NESCON 35 - f3.5/40mm. $13.

NETTAR, NETTAX - see Zeiss-Ikon.

NETTEL KAMERAWERK (Sontheim-Heilbronn, Germany) - *Formerly Süddeutsches Camerawerk - Körner & Mayer. Later became Contessa-Nettel in 1919 and Zeiss-Ikon in 1926.*
Argus - Monocular-styled camera, the precursor to the Contessa-Nettel Ergo. Right angle finder in monocular eyepiece. An unusual disguised camera, less common than the later Contessa and Zeiss models. $740.

Deckrullo - 9x12cm plate camera. Zeiss Tessar f6.3/135mm. FP sh 2-300. $135.

Folding plate camera - 9x12cm. Double ext. bellows. Tessar f6.3/135. Dial Compur 1-250. $48.

Sonnet (Tropical model) - 4.5x6cm - Tessar f4.5/75mm. Compound sh 1-300. Teakwood with light brown bellows. $340.

NEW GEM - see Wing.

NEW IDEAS MFG. CO. (N.Y.)

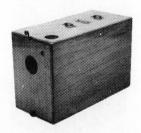

Magazine camera - Polished wood box detective camera. String-set shutter. $395.

NEW IDEAL SIBYL - see Newman & Guardia.

NEW YORK FERROTYPE CO.
Tintype camera - ca. 1906 professional model with three-section plateholder for postcards, 1½x2½" tintypes, and "button" tintypes. Two-speed Wollensak sh. With tank & black sleeve. $140.

NEWMAN & GUARDIA (London)

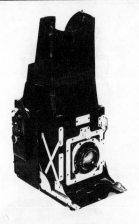

Folding Reflex - A single-lens-reflex which takes 6x9cm plates. Ross Xpress f2.9 lens. Folds to compact size. $140.
Magazine camera - ca. 1895. Wood box for 12 plates 9x12cm. Leather changing bag, meniscus lens. ($200. EUR). None on file USA.
Sibyl - folding-bed cameras ca. 1907-1920's. Rollfilm models and plate models:

Sibyl - 6x9cm plates - ca. 1907 - Tessar f6.3/120mm. N&G Special shutter. $120.
Sibyl Deluxe - 9x12cm. DEB. Zeiss Protar f6.3/122mm. N&G sh. 2-100. $95.

Baby Sibyl - 4x6cm - ca. 1913. Tessar or Ross Xpress f4.5/75. N&G sh. 2-200. $95.

New Ideal Sibyl - 3¼x4¼ plate - ca. 1913. f4.5/135mm Tessar. N&G sh. $85.

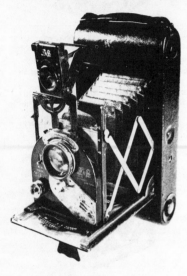

New Special Sibyl - for 6x9cm exp. on 120 rollfilm. Ross Xpress f4.5/112mm. N&G Special shutter. $80.

Special - Box magazine camera - for 3¼x4¼ plates. Internal bellows allow front of box to slide out for copy work or close-ups. $212.

NIC - see Contessa-Nettel.

NICCA CAMERA WORKS (Japan)
Nicca III - Leica copy. f2 Nikkor or f3.5 Similar. $100.
Nicca IIIS - copy of Leica IIIa. ca. 1955. f2/50mm Nikkor-H. FP sh 1-500. $165.

NIKON (NIPPON KOGAKU, Tokyo)
Nikkorex - ca. 1959 35mm SLR. f1.4/50mm Nikkor. Copal metal FP sh. 1-1000. $102.
Nikon F - f1.4/50 Auto Nikkor. $176.
Nikon S - $116.
Nikon S2 - $127.
Nikon S3 - $197.
Nikon SP - $196.
All of above with f1.4/50mm lens.

NIL MELIOR - see Macris Boucher
NIPPON KOGAKU - see Nikon, above.

NISHIDA KOGAKU (Japan)
Westar - for 120 film. f3.5/75mm. $18.

NITOR - see Agfa.
NIXE - see Ica, Zeiss.
NODARK - see Popular Photograph Co.

NOMAR No. 1 - metal box for 127 film. $14.

NORMANDIE - see Anthony.

NORRIS - 120 folding camera. f2.9/75 Cassar lens in Compur shutter. $31.

NORTON - see Universal.
NOVELETTE - see Anthony.

NOVIFLEX - German SLR ca. 1935 for 6x6 cm on 120 film. Schneider Radionar f2.9/75. $85.

OKAM - Czechoslovakia. ca. 1935. Box camera for 4.5x6cm plates. Meyer f6/105mm lens in Patent 2 disc shutter 5-1000. $180.

OLYMPUS KOGAKU (Japan)
Pen - original model - ca. 1959. for 18x24mm "half" frame exp. on 35mm. f3.5 lens. $35.
Pen D - f1.9. $40.
Pen F - f1.8/38mm. $127.
Pen FT - f1.8/38mm Zuiko. $166.
Olympus 35 - f2.8/48mm Zuiko. Shutter 1-500. Rangefinder. $32.

OMEGA - see Simmon, Konishiroku.

OMPEX - 16 - German subminiature similar to the Tuxi by Walter Kunick. $35.

ONITO - see Contessa-Nettel, Zeiss-Ikon.
ONTOBLOC - see Cornu.
ONTOFLEX - see Cornu.

OPEMA - Czechoslovakian Leica copy. Opemar f2. $75.

OPTIMA - see Agfa.
ORDINARY KODAK - see Eastman.

ORION WERK (Hannover)
Orion box camera - 6x9cm. f17 meniscus lens simple shutter. For glass plates. $60.
Folding plate cameras - 6x9 and 9x12cm sizes. Leather covered wood body with metal bed. f4.5 or 6.3 Meyer Trioplan, Helioplan, or Orion Special Aplanat. Vario or Compur sh. $27.
Orion Rio Tropical - ca. 1920 folding-bed 9x12cm plate camera. Teak & brass. Brown double ext. bellows. Xenar f4.5/150 in Compur shutter 1-150. $538.

ORIX - see Zeiss.
ORTHO JUMELLE - see Joux.

OWLA (Japan)
Owla Stereo - ca. 1958. Owla f3.5/35mm lenses. For stereo pairs on 35mm film. $40.

P.D.Q. - see Anthony, Chicago Ferrotype Co.
PD-16 - see Agfa.
PADIE - see Laack.
PAFF - see Ihagee.

PALMER & LONGKING -

Bellows style Daguerreotype camera - ½plate. $3,500. (One on record in 1975.)

PALMOS - see Ica, Zeiss.
PANDA - see Ansco.
PANORAM - see Eastman.

PAPIGNY - (Paris)
Jumelle Stereo - ca. 1890. for 8x8cm plates. Magazine back. Chevalier lenses. $260.

PARVOLA - see Ihagee.
PASCAL - see Japy & Cie.
PATENT DETECTIVE - see Schmid.
PATENT KLAPP REFLEX - see Ihagee.

PATENT — 3¼x4¼ magazine box camera with shifting front. $52.

PAX, PAXETTE, PAXINA - see Braun.
PEARL, PEARLETTE - see Konishiroku.
PECTO - see Columbia Optical & Camera Co.

PEERFLEKTA (East Germany) - ca. 1956 6x6cm TLR for 120. f3.5/75mm Pololyt in Prontor sh. 1-300. $22.

PEGGY - see Krauss.
PEN - see Olympus.

PENTACON (Dresden, Germany)
Contax FB - Zeiss Biotar f2/58mm. Focal plane shutter 1-1000. $80.
Pentacon - 35mm SLR. f2.8/50mm FP sh. ½-1000. $49.
Pentacon F - Meyer Primotar f3.5/50. $35.
Pentacon FB - Steinheil f1.9/55. $77.
Pentacon FBM - ca. 1950. f2 or 2.8. $57.

Penti - 18x24mm on 35mm film. Meyer Triplan f3.5/30. Gold colored with blue-green enamel. $23.

Werra - 35mm. Jena T. f2.8/50mm lens. 1-500 shutter. Olive green leather. $26.

PERFECT - see Photo Hall.
PERFECTA - see Welta.
PERFECTION - see Marion & Co.
PERFEX - see Candid Camera Corp.
PERIFLEX - see Corfield.
PERISKOP - see Ica, Krugener.

PERKA PRAZISIONS KAMERAWERK (Munich, Germany)

Perka - ca. 1922 folding-bed plate camera. Double extension bellows. Tessar f4.5/150 Compur 1-200. Construction allows tilting of back & lensboard (standard) for architectural photos. $56.

PERKEN, SON, & RAYMENT (London)

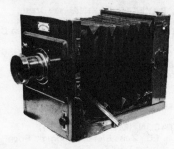

Studio camera - ca. 1890's. Full-plate (6½x8½ size). $130.

PERKEO - see Voigtlander.
PERLE - see Welta.
PETAL - see Sakura.
PETER, Joseph - see Jos-Pe.
PETIE - see Kunick.

PETITAX - German novelty camera for 14x14 mm exp. on rollfilm. f11/25mm lens. Simple shutter. $20.

PETITE - see Eastman.

PETRI CAMERA CO. (Japan)
Petri 6x6 - Folding camera for 6x6cm exp. on 120. Ikonta copy. ca. 1948. f3.5/75mm Sh. 1-200, sync. RF. $16.

PHOBA A.G. (Basel, Switzerland)
Diva - 6x9cm folding-bed plate camera. Titar f4.5/105mm. Compur. $24.

PHOTAK CORP. (Chicago)
Foldex - folding camera for 620. All metal. Octvar or Steinheil lens. $9.

PHOTAKE - see Chicago Camera Co.

PHOTAVIT-WERK, (Nürnberg, Germany)
Photavit - A compact 35mm camera for 24x 24mm exp. on standard 35mm film in special cartridges. $58. *(Description and photo are under the Bolta heading.)*

PHOTINA - German 6x6cm TLR, post WWII. Cassar f3.5/75 in Prontor SVS sh. $20.

PHOTOLET - ca. 1932. French. $50.

PHOTO MASTER - ca. 1948. for 16 exp., 3x4cm on 127 film. Rollax 50mm lens, single speed rotary shutter. Plastic body. $5.

PHOTO-PORST (Hans Porst, Nürnberg)
Makers of Hapo cameras. Hapo = HAns POrst.
Hapo 35 - ca. 1955. Folding 35mm. Enna Haponar f2.9/50mm. Prontor SVS 1-300. CRF. $25.

Hapo 36 - 35mm. Non-coupled RF. f2.8 Steinheil in Pronto sh. $22.
Hapo 66 - 6x6cm. Enna Haponar f3.3/75mm Pronto sync. sh ½-200. $41.

PHOTORET - see Magic Introduction Co.
PHOTO REVOLVER - see Krauss.
PHOTOSCOPE - see Ross.

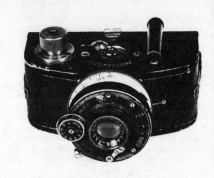

PHOTOSCOPIC (Brussels, Belgium) - ca. 1930, unusual designed early 35mm camera for 50 exp. 24x24mm on 35mm film in special cassettes. O. I. P. Gand Labor f3.5/45mm lens. Pronto or Ibsor shutter. $232.

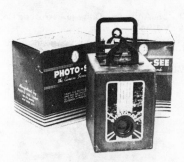

PHOTO-SEE - An art-deco box camera and developing tank for photos in 5 minutes. An interesting, simple camera. They would have beat Polaroid to the marketplace, but as rumor goes, the first batch of cameras were all made when it was discovered that the viewfinders were all on backwards. That was just enough discouragement, so they never printed the instructions or sold the cameras. $16.

PHOTOSPHERE - see Compagnie Francaise de Photographie.
PHOTO VANITY - see Ansco.

PHOTRIX QUICK B - $12.

PICCOCHIC - see Balda.
PICNY - see Mitsukoshi.
PICOLETTE - see Contessa, Zeiss.

PIGNONS AG, (Ballaigues, Switzerland)

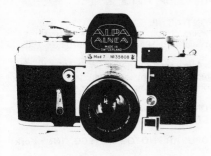

Alpa Alnea, model 7 - ca. 1952 35mm SLR. f1.8/50. FP sh 1-1000, sync. CRF. $134.

Alpa, model 6 - ca. 1958 35mm SLR. f3.5/ 50mm Alorar, or f1.9/50 Alpa Xenon. $147.

Alpa, model 9d - 35mm SLR ca. 1964. Tele Xenar 50mm lens. FP sh 1-1000. The first European camera with through-the-lens metering. $230.

Alpa Reflex - (original model) - ca. 1940. 35 mm SLR. Focal plane shutter 1-1000. Identical to the following Bolsey model. Both of these cameras were designed by Jacques Bolsey before he moved to the United States and started the Bolsey Camera Co. $300.

Bolsey - ca. 1938 35mm SLR. Bolca Anast. f2.8/50. FP sh. This is the camera which was originally called the Bolca, and grew into the Alpa line of cameras. $516.

PILOT - see Guthe & Thorsch.

PINETTA - 35mm camera. f2.8. $15.

PIONEER - see Ansco.

PIPON (Paris)

Magazine camera - ca. 1900 leather covered wood box for 9x12cm plates. Aplanoscope f9 lens. $60.
Self-Worker - ca. 1895. Jumelle camera for 9x12cm plates. Goerz Double Anastigmat 120mm lens. 6-speed guillotine sh. $210.

PITTSBURGH CAMERA CORP. (Penn.)
Ulca TSL - ca. 1935 for 20x20mm on rollfilm. Meniscus lens, simple shutter. Cast steel body. $28.

PIXIE - see Whittaker.

PLANOVISTA SEEING CAMERA LTD.
(London) - *Imported a camera with their name on it. Actually a Bentzin camera. See Bentzin.*

PLASCOP - see Ica.
PLASMAT GmbH - ROLAND - see Roland.

PLATOS — "Pocket Platos" - French 6.5x9cm folding plate camera. Splendor f6.2/90mm lens in Vario sh. $80.

PLAUBEL & CO. (Frankfurt, Germany)
Folding-bed plate cameras - 6x9 and 9x12cm sizes. Double extension bed & bellows. Anticomar or Heli-Orthar lens. Ibso or Compur shutter. $30.

Makina - ca. 1920 compact strut-folding sheet

film camera. f2.9/ Anticomar lens. Compur shutter. 4.5x6cm or 6.5x9cm. $111.

Makina II - Anticomar f2.9. Compur to 200. Coupled rangefinder. $157.

Makina III - ca. 1930. 6x9cm strut-folding camera. Anticomar f2.9/100mm. Rim-set Compur 1-200. CRF. $140.

Rollop - folding bed camera for 16 exp. 4.5x6 cm on 120 rollfilm. ca. 1935. Anticomar f2.8/75mm. Compur Rapid 1-250. Coupled rangefinder. $130.

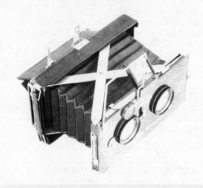

Stereo Makina - ca. 1930. Strut-folding stereo camera for 6x13cm plates. Anticomar f2.9/90 mm lenses in stereo shutter 1-100. Black bellows, Black metal body, partly leather covered. (We have only one listed - $560. EUR)

PLENAX - see Agfa, Ansco.
PLICO - see Eastman Flexo.
POCKET Z - see Zion.
POCO - see Rochester, Monroe.
POKA - see Balda.

POLAROID - *Polaroid cameras, using the patented process of Dr. Land, were the first commercially successful instant picture cameras which were easy to use, and were not in need of bottles of chemicals, etc. The idea of in-camera development is not new. Jules Bourdin invented a simple system which was marketed as early as 1860. Many other attempts met with mediocre success. Polaroid caught on and became a household word. We are listing these cameras strictly by number, without descriptions. They are quite common, and not very old. There is more supply than demand in the present market.*

J-33 -	$12.	100 -	$36.
J-66 -	$11.	110 -	$57.
SX-70 -	$78.	110A -	$51.
80 -	$11.	110B -	$56.
80A -	$11.	150 -	$20.
80-B -	$18.	180 -	$127.
95 -	$21.	210 -	$20
95A -	$19.	800 -	$21.
95B -	$24.	900 -	$22.

POLICE CAMERA - see Expo.
POLYSCOP - see Ica, Krauss.

PONTIAC (Paris)
6x9cm - folding rollfilm camera. Berthiot Special f4.5/105mm lens. Shutter 25-150. For 8 exp. on 120 film. $12.

3x4cm - for 16 exp. 3x4cm on 127 film. Berthiot f2.8/50mm coated lens in Leica-style collapsible mount. Focal plane shutter. $58.

PONTURA - see Balda.
PONY - see Eastman.

POPULAR PHOTOGRAPH CO. (New York)

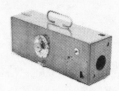

Nodark Tintype Camera - ca. 1899. All-wood box camera for 2½x3½ ferrotype plates. The camera has a capacity of 36 plates. $680.

POPULAR PRESSMAN (Busch, London)
3¼x4¼ SLR - Aldis Anast. f3.4 or Tessar f2.7/165mm. $137.

POUVA (Karl Pouva, Freital, Germany)
Start - ca. 1954 telescoping camera for 6x6cm exp. on 120 rollfilm. Duplar f8 lens. $10.

PRAKTI - *(Praktica, Praktiflex, Practina, Praktisix)* - see Guthe & Thorsch.
PRECISA - see Beier.
PREMIER - see Rochester.

PREMIER INSTRUMENT CO. (New York)

Kardon - ca. 1945. 35mm Leica IIIa copy. Made for the Signal Corps, and also for civilians. Ektar f2/47mm. Cloth FP shutter 1 to 1000. Coupled rangefinder. $137.

"PREMIUM" box-plate camera - ca. 1895. An unusual box-plate camera for single exp. 4x5". Black papered wood body. Primitive meniscus lens. Wooden lens cap. $210.

PREMO, PREMOETTE - see Eastman, Roch.
PRESSMAN - see Busch.
PRIMAR - see Bentzin.
PRIMO - see Sawyer, Tokyo Kogaku.
PROMINENT - see Voigtlander.
PUCK - see Thornton-Picard.
PUPILLE - see Eastman, Nagel.
PURMA - see Hunter.

PUTNAM - (E. Putnam, N.Y.)
Marvel - 5x8'' horizontal folding view camera ca. 1890. Scovill Waterbury lens with rotating disc stops. $118.

PYGMEE - see Carmen.

Q.P. - *(pronounced "Kewpie")*- Japanese novelty camera for 16mm paper backed rolls. $8.

Q.R.S. - see DeVry.
QUAD - see Close & Cone.
QUICK - see Photrix.
QUICK FOCUS KODAK - see Eastman.

RAACO - Box camera for 4.5x6cm. Cardboard construction. Meniscus lens. Segment shutter. $80. (only one listed, EUR).

RADIX - see Kurbi & Niggeloh.

RAJAR No. 6 - English folding camera for 120 film, ca. 1920's. T & I shutter. $22.

RANCA - see Nagel.

RAY CAMERA CO. (Successors to Mutschler Robertson & Co., Rochester, N.Y.)

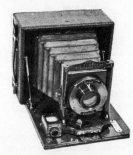

Ray No. 1 - ca. 1899. 4x5 wooden plate cam-

era. Red bellows. Brown leather covered. $38.

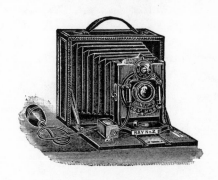

Ray No. 2 - 5x7 folding plate camera. Similar construction. Dark mahogany interior, red bellows, double pneumatic shutter. $45.

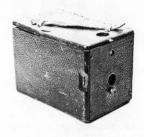

Ray Jr. - ca. 1897 for 2½x 2½ plates. $70.
Box camera - for glass plates, 3½x3½''. Rear section of top hinges up to insert holders. $50.

READYFLASH - see Ansco.
READYSET - see Agfa.
REALIST - see White.
RECOMAR - see Eastman, Nagel.
RECORD - see Huttig.

RECTAFLEX - (Italy)
Rectaflex Standard - ca. 1950 SLR. Schneider Xenon f2.8/50mm or Angenieux f1.8/50. Focal plane shutter 25-1300, synch. $105.

REDIFLEX - see Ansco.
REFLECTA - see Welta.

REFLEX CAMERA CO. (Newark, N.J.)
(Took over the Borsum Camera Co. in 1909.)

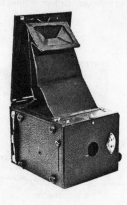

Junior Reflex - Box camera ca. 1903 for 3¼x 4¼ plates. Simple lens, 4-speed sector shutter coupled to mirror. A simple SLR box . $152.

Reflex camera - 4x5". slightly later model than above listing. Leather covered wood box with tall viewing hood. Internal bellows focus. Without lens - $225.
5x7 Reflex - ca. 1898. f16/210mm Anastigm. $325.

REGAL MINIATURE - for 127 film. $12.

REGENT - see Ansco, Eastman.

REGENT - 14mm novelty camera. Japan. $7.

REGULA - see King.
REGULAR KODAK - see Eastman.

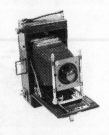

Focal plane postcard camera - A vertical styled folding plate camera in the post-card size, but with a focal plane shutter. ca. 1912. Cooke Anast. or Ilex RR lens in plain mount. $134.

REICHENBACH, MOREY & WILL CO., (Rochester, N.Y.)
Alta D - 5x7 folding plate camera. $80.

REICKA - see Wunsche.

REID & SIGRIST (Leicester, England)

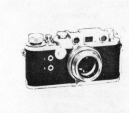

Patent Reflex Hand Camera - An early model leather covered 4x5" SLR box camera. Internal bellows focus. Focal plane shutter. Red focusing hood. Fine finished wood interior. Without lens - $375.

Reid - ca. 1953. Copy of Leica IIIb. Collaps. Taylor Hobson f2/50mm. FP sh 1-1000, sync. $176.

REITZSCHEL (A. Heinrich Reitzschel GmbH Optische Fabrik, Munich, Germany)

Clack - 9x12cm or 10x15cm ca. 1910. Red bellows, black leathered wood body, aluminum standard, nickel trim. f6.3 or f8. $62.

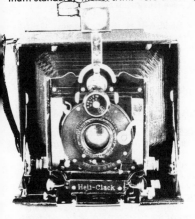

Heli-Clack - 9x12 or 10x15cm. Horizontal format folding plate cameras. Double ext. bel. Double Anast. f6.8 in Compound sh. $82.

Cosmo Clack Stereo - ca. 1914. 45x107mm format. Double Anast. f6.3, Reitzschel f4.5/60mm in Compur 1-250. Panoramic photos also possible. $178.
6x9 folding plate camera - Dialyt f6.8/105 in dial-set Compur 1-250. DEB. $36.
Special Wiphot - 9x12cm folding plate camera. Reitzschel Lesican Anast. f5.5/120mm in Compound sh 1-200. $59.

REPORTER CAMERA - see Ernemann.

RETINA, RETINETTE - see Eastman.

le REVE - ca. 1908 French folding camera for 3¼x4¼ plates or rollfilm with special rollfilm back. Becker f6.3 or Roussel f6.8/135mm Anastigmat lens. Unicum sh. red bel. $140.

REVERE -
Eyematic EE - ca. 1958. 127 film. Wollensak f2.8/58mm. $40.
Stereo 33 - Amaton or Wollensak f3.5/35mm. Sh. 2-200, MFX sync. Rangefinder. $64.

REVIEW - see Zorki Model III.

REX KAYSON - Japanese 35mm RF camera. f3.5/45mm lens. Compur 1-300. Looks like a small Leica M. $19.

REX MAGAZINE CAMERA CO. (Chicago)
Rex Magazine Camera - ca. 1899. 4x5 format. Simple lens & shutter. Unusual plate changing mechanism. $97.
Rex Magazine Camera - 2x2" format - the baby brother of the above model. $68.

REXO, REXOETTE - see Burke & James.

REYGONAUD (Paris)
Stand Camera - ca. 1870. Jamin Darlot lens, brass trim. For 8x 11cm plates. (We have just one on record. $500. EUR.)

REYNA - see Cornu.

REYNOLDS & BRANSON
Field camera - full plate (6½x8½) size. Without lens - $70.

RICHARD (Jules Richard, Paris, France)

Glyphoscope - ca. 1905. 45x107mm stereo camera of simple construction. Meniscus lens, guillotine shutter. All metal. $80.

Homeos - ca. 1914. The first stereo for 35mm film. 25 exp. on standard 35mm cine film. Zeiss Krauss An. f4.5/28. Guillotine shutter. (1 in 1975 @ $800.) (current estimate $2,000).

Verascope - simple models - ca. 1898. Fixed-focus lenses, single speed shutter. All metal body. $114.

Verascope - better models - with higher quality lenses and shutters. More common than the simple models. $144.

RICOH (Japan)
Golden Ricoh 16 - ca. 1955. Subminiature for 25 exp. 9x13mm on 16mm film. f3.5/25mm. Sync. sh. 50-200. $54.

Ricoh 35 - ca. 1955 Leica-style 35mm. f3.5, 2.8, or f2 lens. $36.

Ricohflex - ca. 1953. 6x6cm TLR. Ricoh Anastigmat f3.5. $23.

RIFAX - see Beier.
RIGONA - see Balda.

RIKEN OPTICAL (Japan)

Golden Steky - Subminiature for 10x14mm on 16mm film. Fixed focus f3.5/25mm lens. Shutter 50-200. With auxiliary f5.6/40mm telephoto lens - $125.

Steky - ca. 1949. Subminiature for 10x14mm on 16mm film. Stekinar f3.5/25mm Anast. Shutter 25, 50, 100. $30.

Steky II - **III** - **IIIa** - **IIIb** - $36.

RILEX - see Riley Research, below.

RILEY RESEARCH (Santa Monica, Calif.)
Rilex Press - 2¼x3¼ press camera. Tessar f4.5. Chrome & stainless. $98.

RIVAL REFLEX - 35mm SLR made in USSR ocupied Germany. Wetzlar Vastar f2.8/50mm. Focal plane shutter, synched. $38.

ROBRA - German folding camera. $30.

ROCHESTER - *Various official company names during the history of the company and its mergers: Rochester Camera & Supply Co., Rochester Optical Co., Rochester Optical & Camera Co., etc. Sold out to Eastman Kodak Co. in 1907 and became Rochester Optical Division, then Rochester Optical Department. See also Eastman Kodak Co. listings for later examples of many of the Rochester cameras, particularly the "Premo" line. Other companies which merged into the Rochester family included: Monroe Camera Co., Mutschler & Robertson (Ray Cameras), and Western Camera Mfg. Co. (Cyclone Cameras).*

Cyclone Cameras - (formerly Western, prior to 1901) :

Magazine Cyclone - No. 2, 4, or 5. ca. 1898. for 3¼x4¼ or 4x5" plates. Black leathered wood box. Meniscus lens, sector sh. $49.

Cyclone Junior - Plate box camera for 3½x3½" glass plates in standard holders. Top door hinges forward to load plateholders. A cheaper alternative to the more expensive magazine cameras. $25.

Cyclone Senior - Plate box camera, 4x 5" for standard plateholders. $29.

Favorite - 8x10". ca. 1890. Emile No. 5 lens with waterhouse stops. $180.

Handy - ca. 1892 detective box-plate camera. 4x5". Internal bellows focus. A simple, less expensive version of the Premier. $120.

Ideal - Folding view cameras. Cherry wood, brass trim. Sizes 4x5 to 8x10, ranging in price from $50-$125., depending on size.

Poco Cameras - First introduced in 1893. Listed here by size:

3¼x4¼ - Pocket Poco - Red bellows, single pneumatic shutter. $35.

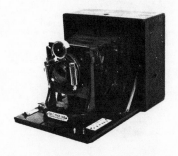

4x5 - Cycle Poco - Folding-bed plate cameras. Leather covered wood body & bed. Nicely finished wood interior. Often with B&L RR lens & Unicum shutter. Models 1—7, B, C. $49

5x7 - Cycle Poco - ca. 1902. Black leather covered wood body. Polished interior. Red bellows. RR lens, Unicum sh. Models 1—5. $54.
8x10 Poco - Similar, but larger. Double ext. bellows. B&L Symmetrical lens. $150.

Gem Poco Cameras:

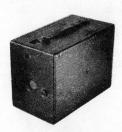

Gem Poco - 4x5" box for plates. Focuses by sliding lever at left front. Shutter tensioned by brass knob on face. $49.
Gem Poco - folding - ca. 1895. for 4x5" plates in standard holders. Red bellows. $60.

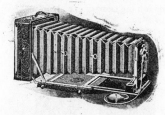

King Poco - 5x7" folding view. $70.

Telephoto Poco Cameras:
4x5 - ca. 1891 - Folding plate camera. Triple extension red leather bellows. B&L lens in Auto sh. Storage in back of camera for extra plateholders. $51.

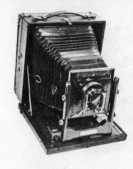

5x7 - ca. 1902 - Folding plate camera. Red leather bellows, double or triple extension. B&L RR lens, Auto shutter. $70.
6½x8½ and 8x10 sizes - $125.

Premier Cameras:

Detective box camera - ca. 1891 - Internal bellows focus with external control knob. Side panel opens to insert plate holders. Made in 4x5 and 5x7" sizes. $133.

Premier folding camera - ca. 1892. 4x5 or 5x7 size, for plates. B&L pneumatic shutter. $195.

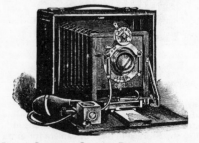

Premo Cameras: See also Eastman for their

continuation of the Premo line. Prices here are for cameras with normal shutter/lens combinations. (Often B&L lenses, Victor sh.)
4x5" - ca. 1900 folding plate cameras, including: Pony Premo, Star Premo, Premo A—E, 3B, 4, and 7. Red bellows. $54.
5x7" - ca. 1900 folding plate cameras, incl.: Pony Premo, Pony Premo Sr., Premo No. 6, Premo B. Red bellows. $60.

Long Focus Premo - Triple extension red bel. Sizes 4x5, 5x7, 6½x8½ inch. $65-90.

Reversible Back Premo - 5x7". Looks like a Long Focus Premo, but back shifts from horizontal to vertical. $82.

Rochester Stereo Camera - 5x7 or 6½x8½" size. B&L sh. Red bellows. $413.

Rochester View Cameras - misc. models: With folding bed, normal lens, maroon bellows. 4x5 size - $100. Other sizes to 8x10 - all averaged $130.

RODENSTOCK (Optische Werke G. Rodenstock, Munich)
Clarovid - ca. 1932 folding-bed rollfilm camera for 6x9cm exp. Trinar Anast. f4.5/105 or f3.8/105. Rim-set Compur 1-250. CRF. $56.

Folding rollfilm cameras - 4.5x6 and 6x6cm models for 120 film. Rodenstock Trinar f2.9 lens. Rim-set Compur 1-250. $26.
Folding plate/sheetfilm cameras - 9x12cm. f2.9, f3.8, or f4.5 Trinar. $31.

ROKUOH-SHA - (Pearl cameras) - see Konishiroku.

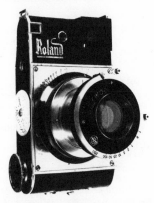

ROLAND - *(Various references attribute this camera to Plasmat GmbH, Dr. Roland, Dr. Winkler, all of Berlin. We suspect that a Dr. Roland Winkler probably owned Plasmat. Any readers who can supply accurate information are asked to do so. Thanks.)*
Folding camera for 4.5x6cm exp. on 120 rollfilm. ca. 1931. Telescoping front. Plasmat f2.7/70mm lens in rim-set Compur 1-250 sh. Coupled rangefinder. (1 listed in EUR. $799.)

ROLF - see Ernemann.
ROLFIX - see Franka.
ROLLEI, etc. - see Franke & Heidecke.
ROLLETTE - see Krauss.
ROLLOP - see Lippische Camerawerk (Lipca), also Plaubel & Co.

ROM (Italy)
Scat - ca. 1950 subminiature for 8x11mm exp. on 9.5mm film in Minox cassettes. f3.5 lens, revolving shutter. Leather covered metal body. Uncommon. ($100. EUR).

RONDINE - see Ferrania.

ROROX - 3x4cm (½-frame) on 127 film. $40.

ROSS (Thomas Ross & Co.)
Very few Ross cameras appear on the U.S.A market, so it is impossible for us to figure any averages. However, those we have on record compare with other British cameras of the same type and age.
Sutton Panoramic Camera - ca. 1861. This camera, made for Thomas Sutton by Ross, takes curved glass plates in special curved holders. And wet-plates at that! Only about 30 were made. Lens is water-filled and gives an angle of 120 degrees. We can only tell you

that two of these cameras sold at auction in 1974 for approximately $25,000 and $28,000.

ROUSSEL - (H. Roussel, Paris)

Stella Jumelle - ca. 1900. 9x12cm plates. Roussel Anti-Spectroscopique f7.7/130mm in 7-speed guillotine shutter. Leather covered wood body. ($260. EUR).

ROY ROGERS CAMERA — see Herco.

ROYER (France)
Savoyflex - 35mm SLR. Som Berthiot f2.8/50mm lens. Prontor Reflex inter-lens shutter, 1-500. $58.

RUBIX 16 - ca. 1950's Japanese subminiature for 50 exp. 10x14mm on 16mm cassette film. Hope f3.5/25mm. Shutter 25-100. $28.

RUBY REFLEX - see Thornton Picard.

RUTHINE - 35mm CRF camera. Friedrich Corygon f2.8/45mm. Shutter 1-500, B. $15.

SABRE 620 - $8.

ST. LOUIS - Reversible Back camera No. 116. ca. 1890. For 8x10" plates. With lens. $100.

SAKURA - (Japan)

Petal - Subminiature camera about the size of

SAKURA (cont.) — SCOVILL

a half-dollar. (Approx 30mm dia.) Takes 6
exp. on circular film. Oirg. price about $10.
Currently $43., USA, $172. EUR.
Octagonal model about 30% higher.

SAMOCA - (Sanei Sangyo, Japan)
Samoca Super - ca. 1956. 35mm camera for
36 exp., 24x36mm on standard cartridges.
Ezumar f3.5/50mm. Sh. 10-200. CRF, Built-
in selenium meter. $37.
Other models - (35, 35II, 35III) - ca. 1950's,
simpler models. $15.

SANDERSON CAMERA WORKS (England)
All Sanderson cameras incorporate the paten-
ted lens panel support system designed by Fre-
derick H. Sanderson. The majority of the ca-
meras were actually built by Houghton's.
Sanderson "Regular" and "Deluxe" models -
3x4", 3¼x4¼", and 3½x5½" sizes. Folding
plate cameras with finely polished wood inter-
ior. Heavy leather exterior. $143.

SAVOYFLEX - see Royer.

SAWYERS, Inc. (Portland, Oregon.)
Primo Jr. (also called Mark IV) - TLR for 4x4
cm on 127 film. Topcor f2.8 lens. Seikosha
MX shutter to 500. Auto wind. $91.
View-Master Mark II Stereo - for stereo pairs
on 35mm film. Trinar f2.8/20mm. $85.
View-Master Personal Stereo - ca. 1960. For
making your own view-master slides. Anast.
f3.5/25mm lenses. Brown & beige or black
models. $75.
Sawyers Europe - View-master Stereo Color -
The European model. Made in Germany. For
stereo exposures 12x13mm on 35mm film.
Rodenstock f2.8/20mm lenses and single-
speed shutter. $84.

SCAT - see Rom.

SCENEX - American black plastic novelty ca-
mera for 3x4cm exp. on 828 film. Meniscus
lens, single speed shutter. $11.

SCENOGRAPHE - see Cadot.

SCHIANSKY - Universal Studio Camera -
All metal, for 7x9¼" sheet film, with reducing
back for 13x18cm (5x7"). Zeiss Apo-Tessar
f9/450mm. Black bellows extend to 1 meter.
Only 12 were made. $491. (1 only - EUR).

SCHLEISSNER
Bower X - 35mm. Meritar f4.5 lens in Prontor
shutter to 200. $20.
Bower Jr. - 620 size, folding. Steinheil Cassar
f6.3/105mm. Vario sh. 25-200. $10.

SCHLEUSSNER (Dr. C. Schleussner Foto-
werke GmbH. Wiesbaden, Germany)
see Adox.

SCHMITZ & THIENEMANN (Dresden)
Uniflex - "Reflex Meteor" - ca. 1931 SLR box
for 6.5x9cm. Meyer Trioplan f4.5/105mm in
self-cocking Pronto shutter 25-100. $176.

SCHUL-PRÄMIE - see Agfa.
SCOUT - see Ansco, Herco, Eastman for
"Girl Scout" & "Boy Scout" models. See
Wittnauer, Seneca for cameras named "Scout"
which are not related to the scout clubs.

SCOVILL MANUFACTURING CO. (N.Y.)
Brief summary of name changes & dates:
*Scovill & Adams - 1889; Anthony & Scovill -
1902; Ansco - 1907. (See also Anthony and
Ansco.) Scovill produced some excellent
cameras, all of which are relatively uncom-
mon today.*

Detective models:

Antique Oak Detective - ca. 1890. 4x5" box-
plate camera finished in beautiful golden oak.
String-set shutter, variable speeds. $725.

Knack Detective - ca. 1891. The Antique Oak
Detective camera with a new name. $623.
Mascot - ca. 1890-1892. 4x5" format leather
covered wood box camera. Similar to the
Waterbury detective camera listed below, but
with an Eastman Roll Holder. String-set shut-
ter. $550.

Scovill Detective - ca. 1886. Leather covered box detective camera for 4x5" plates in standard plateholders. Entire top of camera hinges open to one side to reveal the red leather bellows (and to change plates.) The bottom of the camera is recessed, and the controls are located there, out of sight. A very uncommon detective camera. $850.

Triad Detective - ca. 1892. Leather covered 4x5" box detective camera for plates, roll-film, or sheet film. Variable speed string-set shutter. $450.

Waterbury Detective Camera - Original model. ca. 1888. Black painted all wood box. (But at least one leather-covered model has surfaced.) Side door for loading plates. Focused

by means of sliding bar extending through the base of the camera. Recessed bottom stores an extra plateholder. Two sizes:
4x5" - $533. 5x 7" - $675.

Waterbury Detective - Improved model - ca. 1892. Same as the original model, except focus knob is at top front. $485

Field/View cameras:
4x5" - Square black box with folding beds on front and rear. Bellows extend both directions. Top and side doors permit loading the plateholders either way into the revolving back when only the front bellows are being used. Nickel plated Waterbury lens. $145.

5x8" or 6½x8½" - ca. 1888. Horizontal format. Light wood finish. Brass barrel Waterbury lens. $118.
8x10" - ca. early 1880's. Light colored wood body. $175.

Stereo 5x8" - ca. 1885. All wood body. Scovill Waterbury lenses. $310.

Stereo Solograph - ca. 1899 - A compact folding stereo camera for 4x6½". Stereo RR lenses in Automatic Stereo shutter. $286.

Waterbury 4x5" view - ca. 1888. Folding-bed collapsible bellows view camera. Eurygraph 4x5 RR lens, Prosch Duplex shutter. $135.

SCREEN FOCUS KODAK - see Eastman.

SEAGULL -**No. 203** - Chinese 6x6cm TLR for 120 film. Copy of Zeiss Ikonta IV. 12 or 16 exp. on 120 film. f3.5/75mm. $40.

SEARS - see Seroco, Tower.

SECAM (Paris)

Stylophot cameras: Ca. 1950's "pen" style cameras, according to the name, but even if compared to the large deluxe European fountain pens, it ends up looking a bit hefty. The pocket clip is the closest resemblance to a pen. For 18 exp. 10x10mm on 16mm film in special cartridges. Shutter cocking and film advance via pull-push sliding mechanism which pushes film from cartridge to cartridge. Automatic exposure counter. Weight: 3 oz. (85 gr.) In our 1974 First Edition, these cameras were listed for $8 and $16., slightly less than most subminiatures. But rarity has outpaced utility. The result is the largest price increase percentage of any modern camera listed in this guide. **Stylophot "Standard" or "Color" model** - The cheaper of the two models, with fixed focus two-element f6.3 coated lens, single speed sh. (1/50 sec.). Original price - $15. Now - $75. **Stylophot "Luxe" or "Deluxe" model** - with f3.5/27mm Roussel Anastigmat lens. Iris dia-

phragm. Focus to 2½ ft. (0.8m). Single speed shutter (1/75) synched for flash. Original price - $33. This model very uncommon. $150.

SELECTA - see Agfa.
SELFIX - see Houghton.
SELF WORKER - see Pipon.
SEMI-AUTOMATIC - see Ansco.

SENECA CAMERA CO. (Rochester, N.Y.)

No. 9 Folding Plate Camera - 4x5". Maroon bellows. Velostigmat lens, Compur sh. $40.

Box-plate camera - 4x5", fixed focus. All black. $23.

Busy Bee - ca. 1903. 4x5" box -plate camera. Fold-down front reveals a beautiful interior. $85.

Chautauqua - 4x5" folding plate camera. Wollensak lens, Seneca Uno sh. A very plain all-black camera. $29.

Chief 1A - rollfilm camera. $9.

Competitor View - 5x7 or 8x10" - A folding field camera. Light colored wood or medium colored cherry wood. $89.

Filmet - ca. 1916 folding film-pack camera for 3¼x4¼" packs. Single speed shutter. Rotating disc stops. $18.

Folding plate cameras:
3¼x4¼ - Wollensak f16 lens, Uno sh. $27.
3¼x5½ - Black double-ext. bellows and triple convertible lens. $48.

5x7" - similar, black interior, black leathered wood body. 7" Rogers or Seneca Anastigmat in Auto shutter. $47.

Pocket Cameras:

Jr. No. 1 - 2¼x3¼ exp. folding rollfilm camera. Ilex sh. $23.
No. 3A - double ext. bellows, rapid convertible lens, Auto sh. 1-100. $32.
No. 29 - ca. 1905 folding plate camera for 4x5 plates. Seneca Uno sh. Lens f8. $26.

Scout cameras:
No. 2A Folding Scout - ca. 1916. Wollensak lens, Ultro shutter. $14.
No. 3 Folding Scout - ca. 1916. Ultro sh. $12.
No. 3A Folding Scout - ca. 1916. Seneca Trio shutter. 122 film. $10.
Box Scout - No. 2, 2A, 3, 3A - $7.

4x5" - Black leathered body with nickel trim. Double ext. bel. Seneca Uno or Auto sh. $35.

Stereo View - ca. 1910 - 5x7 format folding-

bed collapsible bellows view camera with wide front lensboard. Style similar to the Competitor view. Wollensak lenses. $226.

Trio No. 1A - folding camera for 120. $19.

Uno - ca. 1910. 3¼x4¼ folding filmpack camera. Leather covered wood body. Wollensak brass barrel lens. Black bellows. $17.

Vest Pocket - Compact folding camera for 127 film. f7.7 Seneca Anastigmat lens. Sh. 25-100. $28.

View Cameras -
5x7'' - Seneca Rapid convertible or Goerz Syntor f6.8 lens. Ilex shutter 1-100. Black double ext. bellows. Polished wood body. $78.

5x7'' Improved - Wollensak Planatic Series III lens. Auto sh. Black leather bellows, Fine wood body. $75.

6½x8½ Improved - Goerz Double Anastigmat f6.8/7'' lens in Volute sh. $65.

8x10'' including Improved model - With Wollensak Velostigmat Ser. 2, f4.5/12'' lens, or double anastigmat lens in Optimo or Wollensak Regular shutter. $138.

SEPT - see Debrie.

SEROCO - *An abbreviation for Sears, Roebuck & Co., whose cameras were made by other companies for sale under the Seroco name. The Conley company made many cameras for Sears around the turn of the century. (See also Tower for other Sears models).*
Delmar - box camera for plates. Top rear door hinges up to insert plateholders. Storage space for extra plateholders. For 3¼x4¼ plates or 4x5'' plates. $30.

Seroco 4x5'' folding plate camera - ca. 1901. Black leathered wood body with polished interior. Red bellows. Seroco 4x5 Symmetrical lens and Wollensak shutter are common. $50.
Seroco 5x7'' folding plate camera - similar to the above except for size. $58.
Seroco 6½x8½'' folding plate camera - Red double ext. bellows. $80.
Seroco Stereo - for 5x7'' plates. Brown leather covered mahogany body with polished interior. Red leather bellows. Wollensak Stereo shutter & lenses. $225.

SHALCO - Japan - Novelty camera. $10.

SHEW - (J. F. Shew & Co., London)

Eclipse - ca. 1890. 3¼x4¼" plates. Wray f8/5" lens in brass barrel. Thornton-Picard sh. Mahogany with dark brown bellows. $225.

Xit - ca. 1900. Almost identical to the Eclipse with aluminum and mahogany construction. $225.
Day-Xit - ca. 1910 variation of the Xit. Meniscus lens, synchro sh. Black leathered wood body. $120.

SHOWA OPTICAL WORKS, LTD. (Japan)

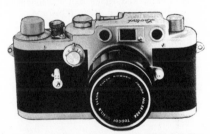

Leotax - 35mm Leica copy. f1.5 or 3.5 Similar or f1.8 or 3.5 Topcor lens. $96.
Semi-Leotax - folding camera for 4.5x6cm exp. on 120 film. f3.5 lens. $35.

SHUR—FLASH - see Agfa, Ansco.
SHUR—SHOT - see Agfa, Ansco, and below.

SHUR-SHOT — Tiny all-wood box plate camera for single exposures 2½x2½" on glass plates. simple rotary shutter. $185. *Note: this is not to be confused with the later model box cameras by Agfa and Ansco for rollfilms.*

SIBYL - see Newman & Guardia.
SICO - see Simons.

SIDA (Berlin)
Extra - ca. 1936 camera for 10 exp. 24x 24 mm on unperforated special rollfilm. Black cast metal body. Sida Optik f8/35mm lens. Single speed guillotine sh. $37.

SIGNAL - see Zeiss-Ikon.
SIGNET - see Eastman.
SILAR - see Linhof.
SILETTE - see Agfa.

SIMDA (Le Perreux, France)

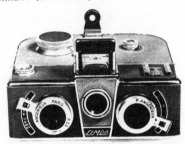

Simda Stereo - ca. 1950 stereo camera for 16 mm film. Fixed focus Angenieux f3.5/25mm lenses. Stereo shutter 1-250, sync. Grey covered metal body. ($228. EUR).

SIMMON BROTHERS, INC. (N.Y.)
Omega 120 - ca. 1954. A professional roll-film press camera for 9 exp. 2¼x2¾ on 120. Omicron f3.5/90mm lens. Sync. shutter 1-400. Coupled rangefinder. $206.

SIMONS (Wolfgang Simons & Co., Bern, Switzerland.)

Sico - ca. 1923, for 25 exp. 30x40mm on un-

perforated 35mm paper-backed rollfilm. Rudersdorf Anast. f3.5/60mm lens in focusing mount. Iris diaphragm to f22. Dial Compur shutter 1-300. Dark brown wooden body w/ brass trim. $1556. (1 only, EUR).

SIMPLEX, SIMPLEX STEREO, SIMPLEX ERNOFLEX - see Ernemann.

SIMPLEX MAGAZINE - see Krugener.

SIMPLEX POCKETTE — 16mm. f3.5. $25.

SINCLAIR - (James A. Sinclair & Co., Ltd., London)

Una - ca. 1895 ½-plate camera. Heavy wood construction. Folding type. Goerz f6.8/7" Double Anastigmat lens. Revolving back. $200.

SINGLO - French folding 9x12cm plate camera. $25.

SINGLO-TEX - German subminiature. Collapsing lens. $35.

SINOX - see Lumiere.
SIRENA - see Ica, Zeiss.
SIX-16, SIX-20 - see Eastman.

SMITH (John M. Smith, Chicago)
5x7 view camera - Wollensak RR lens. Regno shutter 1-100. Reversible back. Black leather covered, black interior. $42.

SOENNECKEN & CO. (Munich)
Folding camera - 6x9cm. - Double extension. Steinheil Unofocal f5.4/105mm lens. $20.

SOHO - see Marion.
SOLIDA - see Franka.

SOLIGOR I & II - 6x6cm TLR for 120 film. f3.5/80 Soligor in Rektor rimset sh. $20.

SOLINETTE - see Agfa.
SOLOGRAPH - see Scovill & Adams.

S.O.M. - 9x12cm folding plate camera. Berthiot f4.5/135 lens in dial Compur. $17.

SONNAR - see Contessa-Nettel.
SONNET - see Contessa-Nettel, Nettel.

SPARTUS CORP. (U.S.A.)
Spartus cameras - including Spartus 120, Spartus 35, 35F, Spartus folding, and Spartaflex. $8.

SPEED CAMERA - see Dallmeyer.
SPEED CANDID - see Candid.
SPEED KODAK - see Eastman.
SPEEDEX - see Agfa, Ansco.

SPEED-O-MATIC CORP. (Boston, Mass.)
Speed-O-Matic - an early instant-picture camera with meniscus lens, single speed sh. $15. (Clear plastic salesman's "demo" model)- $25.

SPIDO - see Gaumont.

SPIEGEL ELF - $16.

SPORT - see Adox.

SPUTNIK (U.S.S.R.)
Sputnik Stereo - ca. 1960 for 6x13cm stereo pairs on 120 film. f4.5/75mm lenses. Shutter 15-125. Ground glass focus. $150.

STANDARD - see Agfa.
STAR - see Robot.
STARFLEX - see Eastman (Brownie Starflex).
STARLET - see Eastman (Brownie Starlet).

STAR LITE - Japanese novelty camera. $6.

STARMATIC - see Eastman (Brownie Starm.)
START - see Pouva, Ikko Sha.

STEGEMANN (A. Stegemann, Berlin)
Field camera - 13x 18cm (5x7"). Mahogany body. Single ext. square cloth bellows. Normally with Meyer or Goerz lens. $151.

STEINECK KAMERAWERK (Tutzing)

Steineck ABC Wristwatch camera - ca. 1949. For 8 exp. on circular film in special magazine. Steinheil f2.5/12.5mm fixed focus lens. Single speed shutter. $295.

STEINHEIL (G. A. Steinheil Sons, Munich)
Casca I - ca. 1948 Leica copy. Culminar f2.8/50mm lens. FP sh., 25-1000. $125.

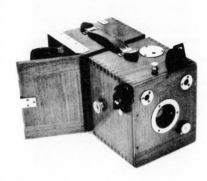

Detective camera - ca. 1895. For 12 exp. on 9x12cm plates. Wood body with nickel trim. Steinheil or Periskop lens. Rotary or guillotine shutter. $478. (EUR).

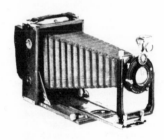

Tropical camera - 9x12cm plates. Double ext. brown tapered bel. Fine wood with nickel trim. $280.

STEKY - see Riken.
STELLA JUMELLE - see Roussel.
STERE-ALL - see Universal Cam. Corp.
STEREAX - see Contessa-Nettel.
STERELUX - see Lumiere.

STEREOCRAFTERS (Milwaukee, Wisc.)
Videon - ca. 1950's stereo camera for standard 35mm cassettes. Metal & plastic construction. Ilex Stereon Anast. f3.5/35mm lenses. Sync. shutter. $45.

STEREOCYCLE - see Bazin & Leroy.
STEREOFLEKTOSKOP - see Voigtländer.
STEREOLETTE - see Huttig, Ica.
STEROCO - see Contessa-Nettel.

STIRN (C. P. Stirn, Stirn & Lyon, N.Y., Rudolph Stirn, Berlin)

Concealed Vest Camera - Size No. 1 - ca. 1886 for 6 photos 1¾" diameter on 5" diameter glass plates. Original price, $10.00, and early ads proclaimed, "Over 15,000 sold in first 3 years." Needless to say, many are lost. $981.

STÖCKIG - (Hugo Stöckig, Dresden)
Union camera - Early folding plate cameras with leather covered wood body and finely polished interior. Made in 9x12 and 13x18 cm. sizes. With Meyer Anastigmat f7.2 or Union Aplanat f6.8 lens in Union shutter. Double extension bellows. $71.

STYLOPHOT - see Secam.
SÜDDEUTSCHES CAMERAWERK - see Nettel.

SUGAYA OPTICAL CO., LTD. (Japan)
Mycro Myracle, Model II - Hope Anastigmat f4.5. Shutter 25-100. Red leather. $19.

SUMMUM - see Leullier.

SUMNER (J. Chase Sumner, Foxcroft, Me.)
Stereo rollfilm box camera - similar to the No. 2 Stereo Kodak box camera. $385.

SUNART PHOTO CO. (Rochester, N.Y.)
Sunart folding view - ca. 1898. 4x5 or 5x7" sizes. Black leather covered wood body with polished cherry interior. Double extension bellows. B&L RR lens, Unicum shutter. 4x5 size - $44. 5x7 size - $60.

Sunart Jr. - 3½x3½ and 4x5" plate box cameras, similar in style to the Cyclone Sr. $25.

SUPERB — TESSCO

SUPERB - see Voigtländer.
SUPERFLEKTA - see Welta.
SUPER IKONTA - see Zeiss.
SUPER KODAK 620 - see Eastman.
SUPER NETTEL - see Zeiss-Ikon.

SÜTER (E. Süter, Basel, Switzerland)

Detective magazine camera - ca. 1890. Early model for 12 plates, 9x12cm. Periskop lens, guillotine shutter. Polished wood with nickel trim. $356. (EUR).

Detective magazine camera - ca. 1893. Later model for 20 exp. on 9x12cm plates. Suter f8 lens with iris diaphragm, rotating shutter. Leather covered mahogany box with brass trim. $280 (EUR).
Stereo Muro - ca. late 1890's for 9x18cm plates. f5/85mm Suter lenses. $300.

SUTTON PANORAMIC CAMERA - see Ross.
SYNCHRO (box camera) - see Agfa.

TAISEI KOKI (Japan)
Welmy Six - folding camera for 6x6cm on 120 film. Terionar f4.5/75mm or f3.5/75mm. Shutter 1-300. $16.
Welmy 35 - A non-RF folding 35mm camera. f2.8/50mm lens. $10.
Welmy Wide - ca. 1958. 35mm camera with Taikor f3.5/35mm lens. $15.

TAIYODO KOKI (Japan)
Beauty Super L - f1.9. $22.

Beautycord - 6x6cm TLR for 120. $24.
Beautyflex - 6x6cm TLR, ca. 1954. f3.5/80 mm Doimer Anastigmat lens. Simple sh. $26.

TAKAHASHI KOGAKU (Japan)
Gelto D III - ca. 1930's ½-frame 127 film camera. (3x4cm). Grimmel f3.5/50 mm collapsible lens. Gold & chrome finished. $31.

TAKIV - see Walker.
TAKYR - see Krauss.

TALBOT (Romain Talbot, Berlin)
Makers of the Errtee cameras. In German, the letters R.T. (for R. Talbot) are pronounced "Err-Tee".

Errtee button tintype camera - A cylindrical "cannon" for 100 button tintypes 25mm dia. Processing tank hangs below camera, and exposed plates drop through chute. Laack f4.5/60mm lens. Single speed shutter. $525.
Errtee folding plate camera - 9x12cm - Double extension bellows. Laack Pololyt f4.5/135mm lens. Compur sh. 1-200. $26.
Errtee folding rollfilm camera - for 9x12cm on rollfilm. Anast. Talbotar f4.5/105mm in Vario sh. 25-100. Brown bellows and brown leather covering. $24.

TANAKA OPTICAL CO., LTD. (Japan)
Tanack, Type IV-S - Copy of Leica IIIb. Tanar f2/50mm lens. Shutter 1-500. $125.

TARGET - see Eastman (Brownie, Hawkeye)

TAUBER - German 9x12cm folding plate camera ca. 1920's. Rapid Aplanat f8/135. $25.

TAXO - see Contessa-Nettel, Zeiss.
TAXONA - see Zeiss.
TDC - see Bell & Howell.
TECHNIKA - see Linhof.
TEDDY - see Ica.
TELECA (16mm) see Cyclops.
TELEPHOT VEGA - see Vega.
TENAX - see Goerz, Zeiss.
TENGOR - see Goerz, Zeiss.

TENNAR - folding camera for 620 film. $10.

TESSCO - see Contessa-Nettel.

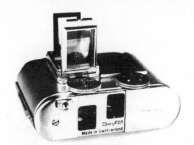

Dogmar or Ross Xpres f4.5 lens. Focal plane shutter 10-1000. $85.

Ruby Duplex Reflex - ¼-plate SLR, "tropical" model. Teak and brass. Double extension orange bellows. Focal plane shutter to 1000. Cooke Anastigmat f6.3 lens. $650.

Special Ruby Reflex - 2¼x3¼ - Cooke Anastigmat f4.5/5" lens. Focal plane shutter. $100.

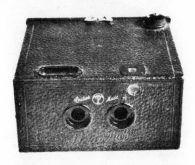

TESSINA - (Manufactured by Concava, S.A., Lugano, Switzerland.) - ca. 1960, for 14x21 mm exp. on 35mm film in special cartridges. The camera is about the size of a package of regular-sized cigarettes. It is a side-by-side twin-lens-reflex. One lens reflects upward to the ground glass for viewing. The other lens, a Tessinon f2.8/25mm, reflects the image to the film below. The film travels across the bottom of the camera. Shutter speeds 2-500. Spring-motor advance for 5—8 exposures per winding. $152.

THOMPSON (W. J. Thompson Co.) **Direct positive street camera** - $113.

THORNTON-PICARD MFG. CO. (Altringham, England)
Folding models:
Folding Ruby - 3¼x4¼ - Revolving back, fine wood interior, various correctional movements. Cooke Anast. f6.5 lens. $100.
5x7" folding plate camera - ca. 1890. Zeiss Unar f5/210mm. FP sh. 15-80. $152.
Puck Special - 4x5" plate box camera. Focus and shutter adjustable. $55.

Reflex models:
2¼x3¼ SLR - ca. 1925. Dallmeyer or Cooke lens. $85.
4x5" SLR - Wray Lustrar f4.5/6" lens. Focal plane shutter. $80.

Stereo Puck - ca. 1920's cheap rollfilm box for 6x8.5cm on 120 film. Meniscus lenses, simple shutter. Black covered wood body. $63.

THORNWARD DANDY - detective-type box-plate camera for 4x5 plates. $45.

THOWE CAMERAWERK (Freital & Berlin)
9x12cm folding plate camera - ca. 1910. Leather covered wood body. Doxanar f6/135mm. Shutter 25-100. $30.
9x12cm horizontal-format field camera - Rear bellows extension. Blue square bellows with black corners. Meyer Primotar f3.5/115mm. $92.

TICKA - see Houghton.
TINTYPE CAMERAS - see **American Minute, Chicago Ferrotype, Popular Photograph, New York Ferrotype, etc.**

TISDELL & WHITTELSEY (pre-1893)
TISDELL CAMERA & MFG. CO. (post-1893)
(New York)

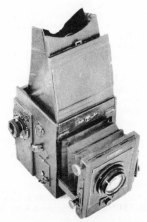

Ruby Deluxe - ca. 1912. ¼-plate SLR. Goerz

T & W Detective Camera - ca. 1888. Detective box camera for 3¼x4¼ plates. All wood box. Truncated pyramid rather than bellows for focusing. Achromatic meniscus lens. $1,200.

Tisdell Hand Camera - ca. 1893. In 1893, the name of the T & W Detective Camera was changed to "Tisdell Hand Camera". Leather covered. Internal bellows focus. $650.

TIVOLI - ca. 1895 English ½-plate camera. Mahogany body. Rectilinear lens. $225.

TOGODA OPTICAL CO. (Japan)
Toyoca 35 - ca. 1955. 35mm camera. f2.8 Lausar or f3.5 Owla 45mm lens. $15.

TOKYO KOGAKU (Japan)
Primo Jr. - 4x4cm TLR for 127 film. Sold in the U.S.A. by Sawyers. $90.

TOKYO SHASHIN (Japan)
Mighty - (Made in Occupied Japan) - Subminiature for 13x13mm exp. on 16mm rollfilm. Meniscus lens, single speed shutter. $15.

TOM THUMB - see Automatic Radio Mfg. Co.

TONE - 16mm subminiature. f3.5/25mm lens in 3 speed shutter. $35.

TOP - Japanese subminiature. 14x14mm exp. on special 16mm rollfilm. Meniscus lens, single speed shutter, aluminum body. $28.

TOSCA - see Ica.
TOURIST - see American Camera Mfg. Co., Blair, Eastman, Hare, McBean, Sandringham, Vive.

TOWER, TYPE 3 - Made in Occupied Japan, and sold by Sears. Copy of Leica III. Nikkor f2/50mm is most common lens. $85.

TOWER STEREO - Made in Germany by Iloca for Sears. Isco-Westar f3.5/35mm lenses. Prontor-S shutter 1-300. $51.

TRAMBOUZE (Paris)

Plate camera - 13x18cm - (5x7"). With brass barreled f8 lens. $162. (EUR)

TRAVELER - Japanese novelty camera. $5.

TRAVELER REFLEX - Simple plastic TLR. Shutter 25, 50. $12.

TRIAD CORPORATION (Encino, Calif.)
Fotron & Fotron III - Grey and black plastic cameras of the 1960's, originally sold by door-to-door salesmen for prices ranging from $150 to $300 and up. The cameras were made to take 10 exposures 1x1" on special cartridge film, 35mm wide. They featured many high-class advancements such as built-in electronic flash with rechargeable batteries, electric film advance, etc. At the time these cameras were made, these were expensive features. Still, the Fotron camera campaign is considered by many to be the greatest photographic "rip-off" of the century. $28.

TRIAD DETECTIVE CAMERA - see Scovill.
TRI-COLOR CAMERAS - see manufacturers such as Devin, Jos-Pe, Mikut, National.
TRILBY - see Ica.
TRIO - see Seneca, Welta.
TRIPLE VICTO - see Victo.
TRI-VISION - see Keys Stereo Products.
TRIX - see Ica, Zeiss.
TRONA - see Ica, Zeiss.
TROPICA - see Ica.

TRUMPREFLEX - German-made 6x6cm TLR sold in the U.S. by Sears. Parallax correction accomplished by the taking lens tilting up at close focusing distances. Meyer f3.5/75mm or Triolar f4.5/75mm lens. Sh. 1-300. $33.

TURRET CAMERA CO. (Brooklyn, N.Y.)
Panoramic camera - ca. 1905. For 4x10" panoramic views. $325.

TUXI, TUXIMAT - see Kunick.
TWINFLEX - see Universal Camera Corp.
TWO-SHUTTERED CAMERA - see Ernemann.

TYNAR CORP. (Los Angeles, Ca.)
Tynar - ca. 1950. For 10x14mm exp. on specially loaded 16mm cassettes. f6.3/45mm lens. Single speed guillotine shutter. $15.

UCA (Uca Werkstatten fur Feinmechanik & Optik, Flensburg, Germany) *Associated with the Elop Kamerawerk of Flensburg.*

Ucaflex - ca. 1950 35mm SLR. Elolux f1.9/50mm lens. FP sh. 1-1000. $176.

ULCA - see Pittsburgh Camera Corp.

ULTRA FEX - French post-war camera for 6x9cm on 120 rollfilm. Bakelite body. Fexar lens. Simple shutter 25-100. $10.

ULTRIX - see Ihagee.
UNA - see Sinclair.
UNCA - see Foitzik Trier.

UNDERWOOD - **(E. T. Underwood, Birmingham, England)**
Field camera - 8x11cm. Rear extension bellows. Underwood f11 brass-barrel lens with iris diaphragm. Thornton-Picard shutter. Square leather bellows, swing-out ground glass. $128.

UNETTE - see Ernemann.

UNGER & HOFFMANN (Dresden)
Verax - precision folding plate cameras. In 4.5x6cm and 6.5x 9cm sizes. Single extension bellows. f3.5 or 4.5 lens. Compound shutter 1-300. Ground glass back. $50.

UNIFLASH - see Universal Camera Corp.
UNIFLEX - see Schmitz & Thienemann, also Universal Camera Corp.
UNION - see Stockig.
UNITED STATES CAMERA COMPANY - see Hetherington & Hibben.

UNITED STATES CAMERA CORP. (Chicago)
Box & TLR cameras - cheap cameras such as Reflex, Rollex, Vagabond, etc. $5.

UNIVERSAL CAMERA CORP. (N.Y.C.)
Buccaneer - ca. 1945 35mm RF camera. f3.5/

50mm Tricor lens. Chronomatic sh. 10-300. Built-in extinction meter, flash sync, coupled rangefinder. $12.
Corsair I & II - ca. 1941. For 24x36mm exp. on perforated 35mm film in special cartridges. Univex f4.5/50mm lens in rimset sh. 25-200. Flash sync., extinction meter. $15.
Iris - ca. 1940. Heavy cast-metal camera for 6 exp. 1-1/8 x 1½" on No. 00 Universal film. Vitar f7.9/50mm. Ilex sh. $13.

Mercury (Model CC) - ca. 1938. The first Mercury model. Takes 18x24mm vertical exposures on Universal No. 200 film, a special 35mm wide film. Tricor f3.5/35mm lens and rotating focal plane shutter 20-1000. $25. ($75 EUR)
Mercury II (Model CX) - ca. 1940. Similar to Mercury CC, but for 65 exp. on standard 35 mm film. Tricor f2.7/35mm. Rotary shutter 20-1000. $23. ($71. EUR)
Meteor - for 620 rollfilm. $15.

Minute 16 - ca. 1950's 16mm subminiature. Resembles a miniature movie camera. f6.3 meniscus lens. Guillotine shutter. $14. ($61. EUR).
Norton - cheap black plastic camera for 6 exp. 1-1/8 x 1½ on No. 00 rollfilm. Similar to the Univex A. Stamped metal viewfinder on back of body. $13.
Roamer I - folding camera for 8 exp. 2¼x3¼" on 620 film. f/11 coated lens, single speed sh., flash sync. $8.
Roamer II - similar. f4.5 lens. $12.
Roamer 63 - folding camera for 120 or 620 film. Universal Anastigmat Synchromatic f6.3/100mm lens. $17.
Stere-all - ca. 1954 for pairs of 24x24mm exp. on 35mm film. Tricor f3.5/35mm lenses, single speed shutter. $37.
Twinflex - ca. 1941. For 1-1/8 x 1½" (29x38 mm) on No. 00 rollfilm. Plastic TLR. Meniscus lens, simple shutter. $14.
Uniflash - cheap plastic camera for No. 00 roll-

film. f16/60mm Vitar lens. With original flash & box - $11.

Uniflex, Models I & II - ca. 1948 TLR for 120 or 620 rollfilm. Universal lens, f5.6 or 4.5/75mm. Shutter to 200. $18.

Univex, Model A - ca. 1936. The original small black plastic gem for No. 00 rollfilm. Similar to the Norton above, which is a later model. Wire frame sportsfinder attached to front of camera, and molded plastic rear sight. (Cost $0.50 when new.) $11.

Univex AF - ca. late 1930's. A series of compact collapsing cameras for No. 00 rollfilm. Cast metal body. Various color combinations. $14.

UNIVERSAL JUWEL - see Ica.
UNIVERSAL PALMOS - see Zeiss.

UNIVERSAL RADIO MFG. CO.

Cameradio - ca. late 1940's. 3x4cm TLR box camera built into a portable tube radio. Like the Tom Thumb listed under Automatic Radio Mfg. Co. $95

UNIVEX - see Universal Camera Corp., above.
UNO - see Seneca.
UR-LEICA - see Leitz.

UTILITY MFG. CO. (New York)
Misc. cheap cameras - including Girl Scout Falcon, Falcon , Falcon Miniature, Carlton, Press Flash, etc. $5.

VAG - see Voigtlander.
VALSTS ELEKTRO TECHNISKA FABRIKA- see Minox.
VANITY KODAK - see Eastman.

VAUXHALL - folding camera for 120 film, styled like Zeiss Super Ikonta. For 12 or 16 exp. on 120 film. f2.9 lens. CRF. $35.

VEGA (Geneva, Switzerland)

Vega - ca. 1900 folding book-style camera for plates. The camera opens like a book, the lens being in the "binding" position, and the bellows fanning out like pages. Plate changing mechanism operates by opening and closing the camera. $380.

VELOCIGRAPHE - see Hermagis.
VELOX MAGAZINE CAMERA - see Hurlbut.

VENA (Amsterdam, Netherlands)
Venaret - Telescoping camera for 6x6cm exp. on 120 film. f7.7/75mm doublet lens. Simple shutter 25, 50. Leather covered metal body. Nickel trim. $17.

VENTURA - see Agfa.
VERASCOPE - see Busch, Richard.
VERAX - see Unger & Hoffmann

VICTO (England)
Folding field cameras:
Full plate - ca. 1900. Polished wood, black bellows, Thornton-Picard roller-blind shutter, brass barrel lens. $150.
Half-plate - "Triple Victo" - ca. 1890. Triple extension. Taylor Hobson Cooke brass-barrel lens. Mahogany body. $90.

VIDEON - see Stereocrafters.

VIEDEBOX - metal box camera. $4.

VIEW-MASTER - see Sawyer.

VIFLEX - ca. 1905. Unusual SLR box camera

for 4x5" plates, or sheetfilm. When folded, viewing hood becomes carry case. $165.

VIGILANT - see Eastman.
VIKING - see Agfa, Ansco.

VINTEN - (W. Vinten, Ltd., London) Aerial reconnaissance cameras - for 95 exp. 55mm square on 70mm film. $215.

VIRTUS - see Voigtlander.

VISCAWIDE - (Japan)
Viscawide 16 Panoramic - ca. 1961 for 10 exp. 10x52mm on specially loaded 16mm film. Ross f3.5/25mm lens. Shutter 60-300. Angle of view - 120 degrees. $150.

Vive No. 4 - ca. 1899 - focusing model. $55.
Vive Tourist - ca. 1897 - Like the Vive No. 1, but for 4x5" plates. $65.

VISCOUNT - see Aires.

VITA-FLEX - German 6x6cm TLR for 120 film, ca. 1940. f4.5 lens. $12.

VITESSA - see Voigtlander.
VITO - see Voigtlander.
VITOMATIC - see Voigtlander.
VITRONIA - see Voigtlander.

VIVE CAMERA CO. (Chicago)

Vive Stereo - for stereo pairs on 3½x6" plates. Similar to the No. 1, but stereo. $485.

VIVID - see Bell & Howell.
VOGUE - see Coronet.

VOIGTLÄNDER & SON (Braunschweig)

M.P.C. (Mechanical Plate Changing) - Magazine plate box cameras ca. 1900. Side crank advances plates. Two sizes: for 4¼x4¼" or 4x5" plates. $46.
Vive No. 1 - ca. 1897. The first U.S. camera to use the dark-sleeve to change plates in a camera. For 12 plates 4¼x4¼". Simple lens & shutter. $80.

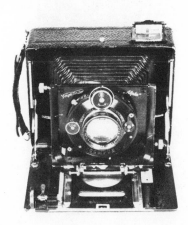

Vive No. 2 - ca. 1897 - an improved model of the Vive No. 1, with a self-capping shutter, & with viewfinder at the center front. $45.

Alpin - ca. 1910 folding plate camera for horizontal format 9x12cm plates. Voigtländer Collinear f6.8/120mm or Heliar f4.5/135mm lens. Koilos, Compound, or Compur shutter. Black tapered double-extension bellows. All metal body, black painted. $140.

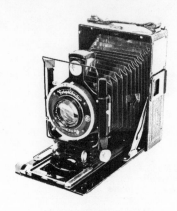

Avus - folding plate cameras:
6x9cm - Skopar f4.5/105. Compur 1-250. $31.
9x12cm - Skopar f4.5/135. Compur. $37.

Bessa cameras:
Folding rollfilm models - ca. 1936-1949. Various shutter/lens combinations, including Voigtar, Vaskar, and Skopar lenses f3.5 to f7.7. Singlo, Prontor, or Compur shutters. $21.
Bessa RF - ca. 1936. f3.5/105mm Heliar, Helomar, or Skopar. Compur sh. $105.
Bessa I - f3.5/105 Skopar or Helomar, or f4.5 Vaskar. $54.
Bessa II - ca. 1960. CRF. f3.5/105 Heliar or Skopar, or f4.5 Apo-Lanthar. $159.
Bessa 6x6 "Baby Bessa" - ca. 1930. f3.5/75 Voigtar or Skopar, or f4.5 Vaskar. $33.
Bessamatic - 35mm. Skopar f2.8/50mm. $69.

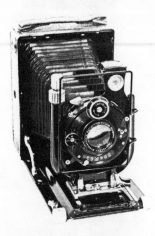

Bergheil folding plate cameras:
4.5x6cm, Deluxe - Brown leather. Heliar f4.5/75mm lens. ($410. 1 only, EUR)

6x9cm - ca. 1930. Heliar f4.5/105. Compur 1-250. $61.
6x9cm Deluxe - Green leathered body and green bellows. f3.5 or 4.5/105 Heliar. Compur 1-200. Nickel trim. $176.

9x12cm - ca. 1925. Heliar f4.5/135mm. Compur sh. $51.
9x12cm Deluxe - Green leather & bellows. $232.

10x15cm - ca. 1924. Skopar f4.5/165 or Kollinear f6.3/165. Compur sh. $90.

Brilliant - ca. 1933. Cheap TLR camera. f6.3 or 7.7 Voigtar, f4.5 Skopar, or f3.5 Heliar lens,/75mm. Quite common. $20.

Daguerreotype "cannon" - ca. 1875 copy of the original 1841 Voigtlander brass Daguerreotype camera. 31cm long, 35cm high. Makes 80mm diameter image. ($1,280. EUR).

Folding plate cameras (misc. models) - $44.

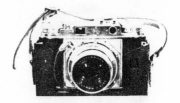

Prominent 35mm - ca. mid-1950's. Price depends on lens:
f3.5 Skopar - $60.
f2 Ultron - $92.
f1.5 Nokton - $109.

Folding rollfilm, misc. models - $20.

Inos II - ca. 1930's folding bed camera with self-erecting front. For 6x9cm exp. on 120. Skopar f4.5/105mm. Compur to 250, or Embezet shutter to 100. $40.
Inos II - Two format model - for 6x9cm or for 4.5x6cm with reducing masks. Skopar f4.5/105mm. Compur 1-250. $100 (EUR)

Jubilar - folding camera for 6x9cm on 120. Voigtar f9 lens. $15.

Perkeo - 3x4cm - ca. 1938. Folding camera with self-erecting front. For 16 exp. 3x4cm on 127 film. Camera can be focused before opening, via external knob. Heliar or Skopar f3.5 or 4.5/55mm lens. $82.
Perkeo I - ca. 1960. folding camera for 6x6cm exp. on 120 film. Prontor shutter. F4.5 Vaskar or f3.5 Color Skopar lens. $32.
Perkeo II - similar, but with Synchro-Compur shutter. $40.

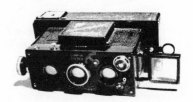

Stereflektoskop - ca. 1913 stereo cameras with plate changing magazine. 45x107mm and 6x 13cm sizes. Heliar f4.5 lens, Compur shutter. This is a three-lens reflex, the center lens for 1:1 reflex viewing. This style was later used in the Heidoscop and Rolleidoscop cameras:
45x107mm size - $176. ($215. EUR)
6x13cm size - (less common) - $206 USA, ($248. EUR).

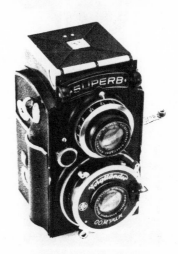

Prominent - ca. 1932. Folding camera for 6x9 cm on 120 film, or 4.5x6cm with reducing masks. Self-erecting front. Coupled split-image rangefinder. Extinction meter. Heliar f4.5/105mm lens in Compur 1-250 shutter. $350. USA ($508. EUR).

Superb - ca. 1933 TLR for 120 film. Skopar f3.5/75mm. A prism reflects the settings for easy visibility. $120. ($160. EUR).

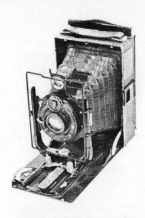

Vag - ca. 1920's folding plate cameras, 6x9 & 9x12cm sizes. f6.3 Voigtar or f4.5 Skopar in Ibsor or Embezet shutter. $29.

Virtus - ca. 1935. Similar to the Prominent, but smaller, and more common. For 16 exp. on 120 film. Automatically focuses to infinity upon opening. Heliar f3.5/75mm. Compur shutter 1-250. $138.

Vitessa - ca. 1950. 35mm camera. f2.8 Color Skopar or Ultron. Synchro Compur 1-500. Coupled rangefinder. $65.
Vitessa L - ca. 1955. Ultron f2/50mm. CRF. Built-in meter. $60.
Vitessa T - F2.8/50 Color Skopar. Sync. Compur 1-500. CRF. $67.

Vito - ca. 1950. 35mm. Skopar f3.5/50mm. Compur 1-300. $22.
Vito II - ca. 1950. 35mm. Color Skopar f3.5, or Ultron f2. Prontor or Compur sh. $29.

Vito IIa - $40.
Vito III - ca. 1950. f2 Ultron. Synchro Compur, 1-500. CRF. $61.
Vito B - f3.5 Skopar. Prontor SVS. $31.
Vito C - f2.8/45mm Lanthar. Prontor. $25.
Vito Automatic - f2.8/50 Lanthar. Prontor Lux sh. $30.
Vitomatic - f2.8 Skopar, Prontor. $39.

Vitrona - ca. 1964. 35mm. f2.8/50 Lanthar. Prontor shutter 1-250. Built-in electronic flash. Never made in any large quantity, because they were novel and expensive. $80.

VOKAR CORPORATION (U.S.A.)
Vokar I - ca. 1946. 35mm RF camera. f2.8/50mm Vokar Anastigmat lens in helical mt. Leaf shutter 1-300. $90.

VOLLENDA - see Eastman, Nagel.
VOLTA - see Zeiss-Ikon.

VOSS (W. Voss, Ulm, Germany)
Diax II - ca. 1940's 35mm RF camera. Xenon f2/45mm lens in Synchro-Compur 1-500 sh. Coupled rangefinder. $32.

WABASH PHOTO SUPPLY (Terre Haute, IN)
Direct positive camera - ca. 1935. Wood body. Ilex Universal f3.5/3" portrait lens. Dimensions 5x8x20". With enlarger & dryer. $150.

WALKER MANUFACTURING CO. (Palmyra, New York)
Takiv - ca 1892. Cardboard & leatherette construction. Multiple exposures for 4 pictures, each 2½x2½" on dry plates. Rotating shutter and lens assembly. Septums for 4 exp. at rear. $1200.

WALTAX - Japanese folding camera for 120 rollfilm. f3.5/75mm lens. ca. 1950's. $16.
Waltax Jr. - Copy of Ikonta A. For 16 exp., 4.5x6cm on 120. f4.5/75mm lens. Shutter 25-150. $13.

WALZFLEX - ca. 1950's 6x6cm TLR for 120 film. f3.5/75mm Kominar lens in Copal shutter. $22.
WALZ-WIDE - 35mm. f2.8 Walzer lens. $17.

WANAUS (Josef Wanaus & Co., Vienna)
Full-plate view camera - ca. 1900. Field-type camera for 13x18cm (5x7") plates. Light colored polished wood, nickel trim. Gustav-Rapp Universal Aplanat lens , waterhouse stops. Geared focus, front & rear. $160.

WARA - see Balda.
WARANETTE - see Wauckosin.

WARDFLEX - 6x6cm TLR for 120 film. f3.5/80mm lens. Shutter 1-200. $26.

WATCH CAMERAS - see Expo, Houghton, Magic Introd. Co., Steineck, etc.
WATERBURY - see Scovill.

WATSON (W. Watson & Sons, London)

Half-plate field camera - ca. 1885-1887. Fine wood body, brass trim. Thornton-Picard roller blind shutter. Watson f8 brass barrel lens. $195.

WAUCKOSIN (Frankfurt, Germany)
Waranette - folding rollfilm camera for 5x8cm. f6.3/85mm Polluxar lens in Vero sh. 25-100. $40.

WEGA - see Afiom.
WELMY - see Taisei Koki.

WELTA KAMERA WERKE (Waurich & Weber, Freital, Germany)
Welta 6x6cm - on 120 film. F4.5 Weltar, or f2.8 Tessar/75mm. Compur sh. $20.
Welta 6x9cm - folding plate camera. Orion Rionar, Meyer Trioplan, Tessar, or Xenar f4.5/105mm lens. Ibsor sh., 1-125. $34.
9x12cm folding plate camera - f3.5 Rodenstock Eurynar, or f4.5 Doppel Anastigmat 135mm lens. Compur shutter. $20.
10x14cm - Two-shuttered model - for plates. Goerz Dogmar f4.5/165mm in Compur front shutter to 150. Rear FP sh. to 200. $112.

Welta Perfekta - ca. 1934. Folding TLR of unusual design for 6x6cm exp. on 120. Meyer f3.5, or Tessar f3.8/75mm lens. Compur sh., 1-300. $162.

Welta Perle - folding camera for 16 exp. 4.5x 6cm on 120 film. f2.8 Xenar, or f2.9 Cassar lens. $31.

Welta Reflekta - 6x6cm TLR for 120 film. f3.5 or 4.5 Pololyt lens. Blitz shutter. $19.

Welta Superfekta - ca. 1932. Folding 6x9cm TLR for 120 film. An unusual design, similar to the Perfekta, above. Pivoting back for taking horizontal pictures. f3.8/105mm Tessar or Trioplan lens. Compur shutter. $165.

Welta Trio - 6x9cm on 120. f4.5/105mm in rimset Compur. $13.

Weltaflex - ca. 1950 TLR for 6x6cm On 120. Ludwig Meritar f3.5/75mm in Prontor 1-300 shutter. $37.

Weltax, Weltax Jr. - ca. 1939. 4.5x6 & 6x9cm models for 120 film. Xenar or Tessar f2.8, or Trioplan f3.5/75mm in Compur or Prontor shutter. $24.

Welti - ca. 1935 folding 35mm. Tessar f2.8, or Xenar f3.5/50mm in Vebur, Cludor, or Compur shutter. $28.

Weltini - ca. 1937 folding 35mm with CRF. F2 Xenon, or f2.8 Tessar in Compur. $29.

Weltix - folding 35mm. f2.9/50mm Steinheil Cassar lens in Compur shutter. $29.

Weltur - ca. 1930's. For 16 exp., 4.5x6cm on 120 film. Similar to the Super Ikonta. With coupled rangefinder, and one of the many available 75mm lenses: f2.8 Xenar, f2.9 Trioplan, f2.8, 3.5, or 3.8 Tessar. $73.

WENK (Gebr. Wenk, Nürnberg, Germany)
Wenka - post-war 35mm camera with interchangeable Leica-thread Xenar f2.8/50mm lens. Behind the lens shutter. $57.

WENO - see Eastman.
WERRA - see Zeiss, Pentacon.
WESTAR - see Nishida Optical.

WESTERN CAMERA MFG. CO. (Chicago)
The Cyclone cameras listed here were made in 1898, before Western became a part of Rochester Optical & Camera Co. in 1899. See Rochester for later models.
Cyclone Sr. - 4x5 plate box camera - Not a magazine camera. A 4x5 size box camera with top rear door to insert plateholders. $27.
Cyclone Jr. - 3½x3½" plate box camera. $37.
Magazine Cyclone No. 2 - $45.
Magazine Cyclone No. 3 - 4x5" - $41.
Magazine Cyclone No. 4 - 3¼x4¼ - $48.
Magazine Cyclone No. 5 - 4x5" - $45.

WHITE (David White Co. Milwaukee, Wis.)
Realist - (not stereo) - German-made 35mm camera. f3.5 Cassar or f2.8 Cassar lens. $36.

Realist 45 - (not stereo) - German made 35mm camera. f3.5 Cassar lens. $45.
Stereo Realist - 35mm stereo camera, ca. 1950's. f3.5 lenses, case, flash - $60. With f2.8 lenses, case, and flash - $114.
Stereo Realist Macro - $315.

WHITE HOUSE PRODUCTS (Brooklyn, N.Y.)
Beacon - rollfilm camera for 127 film. Plastic lens, simple spring shutter, black plastic body. $9.
Beacon II - $8.

WHITTAKER (Wm. R. Whittaker Co., Ltd., Los Angeles, Calif.)
Micro 16 - Subminiature for 16mm film in special cassettes. Cartridge to cartridge feed. Ca. 1950's. Meniscus lens, single speed shutter. $18 USA. ($80. EUR)
Pixie - black plastic 16mm subminiature wriststrap camera. f6.3 lens. With case - $25.

WIDELUX - see Canon.

WILCA Automatic - West German subminiature for 24 exp. 10x19mm on 16mm film in special cassettes. Wilcalux Filtra f2/16mm. Sync. Prontor shutter. Coupled selenium meter. $176. (EUR).

WINDROW - ca. 1940's plastic 35mm camera. $10.

WINDSOR STEREO - $35.

WING (Simon Wing, Charlestown, Mass.)
Multiplying View Camera - ca. 1862. Multiple images on single collodion plate 4x5'' format. Mahogany body, shifting front. $700.

New Gem - ca. 1901. For 15 exp. on 5x7''

plates. Sliding front lens panel. $800.

WINKLER (Dr. Winkler & Co., Berlin) - see Roland.
WIPHOT - see Reitzschel.

WIRGIN (Gebr. Wirgin, Wiesbaden, Germany)

Edinex - ca. 1930's compact 35mm camera, almost identical to the Adox Adrette. Telescoping front. Film loads from bottom. Early models, without rangefinder, with f4.5, 3.5, 2.8, or f2 lens. $22. ($44. EUR).

Klein-Edinex - **(127 film)** - ca. 1938. Similar to the 35mm model, but for 3x4cm exp. on 127 film. Steinheil Cassar f2.9/50mm lens. $45. USA. ($90. EUR).

Edixa 16 - ca. 1960. For 12x16mm exp. on 16mm film. Schneider Xenar f2.8/25. $49.

Edixa Electronica - ca. 1955 35mm SLR. Fully automatic with selenium meter. Culminar or Xenar f2.8/50mm lens. Compur sync. sh., 1-500. $48.

Edixa Reflex - 35mm SLR, Exakta mount. ca. 1960. f2.8 Isconar or Westanar. Focal plane shutter to 1000. $36.

Edixa Stereo - 35mm stereo. Steinheil Cassar f3.5/35mm lenses. Vario shutter. $55.

Gewirette - ca. 1937. 3x4cm exp. on 127 film. Telescoping front, like the Edinex 127. Film loads from the top. $46.

Wirgin folding camera - 6x9 rollfilm. - For 120 film. Schneider Radionar f4.5, or Gewironar f8.8 or 6.3 lens. $18.

Wirgin 6x6cm TLR - ca. 1950. Rodenstock Trinar f2.9/75mm. Built in extinction meter. $25.

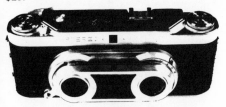

Wirgin Stereo - 35mm - Steinheil Cassar f3.5/35mm lenses. $49. ($97 EUR).

WITT ILOCA (Hamburg, Germany)
Iloca I, II, IIa - ca. 1930's to 1950's simple 35mm camera. (Models II & IIa have CRF.) f3.5/45mm Ilitar lens in Prontor shutter. $22.

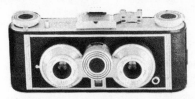

Iloca Stereo - Models I & II - ca. 1950's 35mm stereo camera for 24x24mm pairs. Ilitar f3.5 lenses, 35mm or 45mm. Prontor-S shutter to 300. $49. ($105. EUR).
Tower - (see **Tower**).

WITTNAUER
Scout - 35mm. Chronex f2.8/45mm. $50.

WIZARD - see **Manhattan**.

WOLLENSAK STEREO - 35mm stereo camera. f2.8 lenses. $72.

WONDER AUTOMATIC CANNON - see **Chicago Ferrotype Co.**

WONDER CAMERA - Magazine box camera for 2½x3½" glass plates. $60.

WORLD'S FAIR CAMERA - see **Eastman**.

WÜNSCHE (Emil Wünsche, Reick b/Dresden)
Field camera - ca. 1900. Wood body. For 5x7" (13x18cm) plates. Wünsche Rectilinear Extra Rapid f8 brass barrel lens. $131.
Mars 99 - ca. 1895 box-plate camera for 9x12 cm plates. Aplanat f12/150mm lens. Rotating shutter. $340 EUR. (None listed USA.)
Reicka - ca. 1912. Folding plate camera for 9x12cm. Double ext. bellows. Rodenstock Heligonal f5.4/120mm lens in Koilos 1-300 shutter. Leather covered wood body. $61.

XIT - see **Shew**.
YALE - see **Adams & Co.**

YASHICA (Japan)
Yashica 16 - subminiature for 10x14mm on 16mm cassette film. ca. 1958. f2.8 or 3.5/25mm Yashinon lens. $19.
Yashica 44 - ca. 1956 TLR for 4x4cm on 127 film. F3.5 lens. $40.
Yashica A - TLR. $35.
Yashica Atoron - subminiature for 9.5mm film (Minox cassettes). f2.8 lens. $45.
Yashica Atoron Electro - with black finish, $85. With transparent body - $130.
Yashica D - 6x6cm TLR. $72.
Yashica Rapide - ca. 1900. 35mm half-frame. Unusual style - stands vertically like a pocket-sized transistor radio. Interchangeable Yashinon f2.8/28mm lens in Copal 1-500 shutter. Built-in meter. $48.
Yashica Sequelle - ca. 1960. 35mm half-frame for 18x24mm. Styled like a movie camera. f2.8/28mm Yashinon lens in Seikosha-L sh. Built-in meter. $60.
Yashica YF - (Leica M3 copy). f1.8. $100.

ZECA - see **Zeh, below**.

ZEDEL - folding sheet film camera for 6.5x9 cm holders. Wallace Heaton Zedellax f4.5/120 mm lens in Compur shutter. $30.

ZEH (Paul Zeh Kamerawerk, Dresden)

Zeca - 9x12cm - folding sheet-film camera. 135mm lenses: f6.3 Schneider Radionar, f6.8

Jena, f2.9 Zecanar or Xenar. Leather covered wood body. $27.

Zeca - 6x9cm - folding sheet-film camera. Steinheil f6.8 or Periskop f11 lens. Vario shutter, 25-100. $18.

Zeca-Flex - ca. 1930's folding 6x6cm TLR for 120 film. F3.5/75mm Schneider Xenar lens. Viewing lens is f2.9. The folding style 6x6cm reflex never became popular, so this model, along with the Perfekta and Superfekta from the neighboring suburb of Freital, was not made in large quantities. $170.

ZEISS, ZEISS-IKON *(Before 1926, the Carl Zeiss Optical Co. was located in Jena. In 1926, Contessa-Nettel, Ernemann, Goerz, Ica, and Carl Zeiss merged to form Zeiss-Ikon, and the headquarters became Dresden. After WWII, Zeiss-Ikon A.G. was located in Stuttgart, West Germany. Some camera models were still being made in the Jena and Dresden factories, but they were not really "Zeiss-Ikon" cameras, even though some bore the Zeiss-Ikon trademark. We have listed several of these models in the Zeiss section, since there really is no other place for them.)*
We have attempted to list Zeiss catalog numbers with these cameras whenever possible, to help in identification. Often, these numbers appear on the camera body. Sometimes, especially on U.S.A. models, they are not on the camera itself, but only in the catalog. Basically, the first half of the number designates the camera model. The second half of the number indicates negative size, and is standard from one model to another. A new or improved model usually changes only the last digit of the first number, generally increasing it by one. Hopefully, this information will help the user of this guide to locate his Zeiss camera by name, number, illustration, or a combination of the three.

Adoro - folding plate camera. Tessar f4.5/105 in Compur shutter. $31.

Adoro - tropical model - (230/7) - folding plate camera for 9x12cm. Teak wood body, brown double extension bellows. f4.5/135 Double Anastigmat lens in Compur sh. $175.
Baldur - metal box camera for 6x9cm exp. on 120 film. Goerz Frontar lens. Simple shutter T, & I. $24.
Bebe - 6x9cm folding camera. Xenar f4.5/135 in Compur shutter. $38.
Bob - (510/2, 521/2) - 6x9cm folding cameras. Nettar f7.7/105mm, or Novar f4.5. Gauthier shutter 25-75, B, T. $15.
Bobette II - (548) - ca. 1927 folding camera for 22x33mm on 35mm film. Ernostar f2/42 mm lens. Shutter ½-100. Leather covered body. Black bellows. The first miniature rollfilm camera with f2 lens. $280 (EUR).

Box Tengor cameras:
"Baby box" - (54/18) - for 3x4cm exp. on 127 film. Ca. 1930. Goerz Frontar f11, or Novar f6.3/50mm. Metal body. Simple shutter. $36.
Box Tengor - (54/12) - for 4x6.5cm exp. on 127 film. All metal body. Goerz Frontar lens. Simple shutter. $25.
Box Tengor - (54) - for 4.5x6cm exp. on 120 film. (½-frame 120). ca. 1934. Goerz Frontar lens. Adjustable focus by means of supplementary lens. Single speed shutter. Flash synch. $33.

Box Tengor - (54/2 - pre-war) - (56/2 - post-war) - for 6x9cm exp. on 120 film. Metal

body. Adjustable focus with supplementary lens. Single speed shutter. $16.
Box Tengor - (54/15) - 6.5x11cm (2½x4¼") on 116 rollfilm. All metal box. Goerz Frontar lens. $33.

Cocarette - (519/2) - folding camera for 6x9 cm exp. on 120 film. F4.5 Tessar or Dominar Anastigmat. Rimset Compur 1-250. Focus via radial lever on bed. $25.

Contaflex cameras:

Contarex EE (nicknamed "Bullseye") - f2/ 50mm Planar lens. $200.

Contax I - (540/24) - ca. 1932. 35mm. Black body. F1.5 or f2 Sonnar, or f2.8 or 3.5 Tessar lens. FP sh. to 1000. $192.

Contaflex - (860/24) - 35mm TLR - The original Contaflex model, ca. 1935. F1.5 or f2 Sonnar, or f2.8 Tessar. Metal focal plane sh., 5-1000. $586. USA. ($899, EUR).
Contaflex I - (861/24) - ca. 1950's. 35mm SLR. Tessar f2.8 lens. $52.
Contaflex II - (862/24) - ca. 1954. Similar to Contaflex I, but with built-in meter. $60.
Contaflex III - (863/24) - ca. 1958. Synchro-Compur 1-500. $68.
Contaflex IV - (864/24) - Interchangeable Tessar f2.8/50mm. Synchro Compur 1-500. Built-in meter. $79.

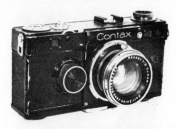

Contax II - (543/24) - ca. 1936. Chrome body with black leather. Lenses as above. Focal-plane shutter 2-1250. $105.
Contax III - (544/24) - ca. 1936. Tessar f2.8, or Sonnar f1.5 or f2 lens. FP ½-1250. $111.
Contax IIa - (563/24) - With f2 Sonnar - $104. With f1.5 Sonnar - $149.

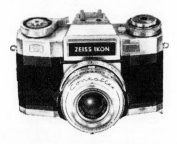

Super Contaflex - 35mm SLR. f2.8/50mm Tessar lens. $106.

Contax IIIa - (564/24) - With f2, 1.5, or 1.2 Sonnar. $126. USA. ($167. EUR).

Contax D - ca. 1953 35mm SLR. Made in the

old Jena factory in USSR occupied East Germany. Zeiss Jena Biotar f2, Hexar f2.8, or Tessar f2.8. FP sh. to 1000. $80.

Contax "no name" - mfd. in "USSR occupied Germany". $97.

Contax S - ca. 1950. Made in East Germany. The first 35mm prism SLR. Victor f2.9 or Biotar f2. $86.

Contessa - (533/24) - ca. early 1950's folding 35mm camera. Tessar f2.8/45mm lens. Sync. Compur sh. 1-500. CRF, BIM. $78.

Contessa-Nettel folding plate cameras - 6x9cm or 9x12cm sizes. After the merger which formed Zeiss-Ikon, the Contessa-Nettel plate cameras retained their own name in addition to the new corporate name during the period of change-over. $40.

Contina - (526/24) - 35mm camera with CRF. Novar f3.5/45mm. Prontor SVS sh., 1-300. Synch. $32.

Donata - (227/7) - 9x12cm double extension plate camera. Tessar f4.5/135mm lens in Compur 1-200. Leather bellows. $25.

Ergo - (301) - ca. 1926. Monocular shaped disguised camera with right-angle viewing. A continuation of the Contessa Ergo and the Nettel Argus. F4.5/55mm Tessar. $680.

Ermanox - Although Zeiss-Ikon was the manufacturer after 1926, all Ermanox cameras are listed under Ernemann.

Folding plate cameras, folding rollfilm cameras - misc. unidentified models - Rollfilm models - $15-20. Plate models - $20-30.

Hologon camera - ca. 1969. Extreme wide angle 35mm camera. Non-interchangeable f8/15mm Hologon lens. Fixed f8 opening. Focal plane shutter 1-500. Changeable maga-

zine. Only 1,000 made. $495. ($680. EUR

Icarette - folding-bed rollfilm cameras: Various sizes. $32.

Ideal - folding-bed plate cameras:
6x9cm - (250/2) - $33.
9x12cm - (250/7) - $45.

Ikoflex - 6x6cm TLR cameras for 120 film:
Ikoflex I - (850/16) - ca. 1934. Novar f3.5 or 4.5/80mm lens. Shutter 25-100. $102.
Ikoflex Ia - (854/16) - ca. 1952. Tessar or Novar f3.5/75mm. Prontor 1-250. $50.
Ikoflex Ic - (886/16) - ca. 1956. F3.5 Tessar or Novar. $60.
Ikoflex II - (851) - ca. 1938. Tessar f3.5. $53.
Ikoflex IIa - (855/16) - ca. 1953. Tessar f3.5/75mm. Synchro Compur 1-500. $52.
Ikoflex III - (853/16) - ca. 1939. Tessar f2.8/75mm. Compur Rapid 1-200. Albada finder. $90. USA. ($169. EUR).

Ikomat cameras - (re-named Ikonta after 1936) :
Ikomat - (520) - ca. 1935. Folding camera for 4.5x6cm exp. on 120 film. Nettar, Novar, or Tessar f4.5 lens in Derval shutter. $32.

Ikomat - (520/2) - ca. 1930's folding camera for 6x9cm (2¼x3¼") on 120 film. 105mm lens in Derval shutter. $35.

Super Ikomat A - (530) - ca. 1935 folding camera for 4.5x6cm exp. on 120 rollfilm. Tessar f2.8. Re-named Super Ikonta A after 1936. $76.

Ikonette cameras:
Ikonette - (504/12) - ca. 1928. For 4x 6.5cm exp. on 127 film. (full frame). $18.
Ikonette - (500/24) - Cheap plastic 35mm camera. F3.5/45mm Novar Anastigmat lens in Pronto 15-200 shutter. Front lens focus. Unique lever around lens. One push winds film. Second push fires shutter. $12.

Ikonta cameras: folding rollfilm cameras.
Ikonta 3x4cm - (520/18, 521/18) - For 16 exp. 3x4cm on 127 rollfilm. Novar f4.5 or 6.3/50mm lens. Derval shutter 25-75, T, B. Front lens focusing. Wire frame finder. $40. (Note: the 521 models were post-1936 and had double exp. prevention and body release.)
Ikonta 4.5x6cm - (520, 521) - For 4.5x6cm exp. (half-frame) on 120 film. Novar f6.3, 4.5, or 3.5. Tessar f3.5 or 4.5. Telma, Compur, Compur Rapid, or Prontor shutter. $33.
Ikonta 6x6cm - (520/16, 521/16, 524/16) - For 2¼x2¼" exp. on 120 film. Novar f3.5 or 4.5. Tessar f3.5. Pronto, Zeiss-Ikon, Klio, or Compur Rapid shutter. $39
Ikonta 6x9cm - (515/2, 520/2, 521/2, 523/2, 524/2) - For 8 exp., 2¼x3¼ on 120. Wide assortment of Tessar, Novar, Nettar, and Dominar lenses. Compur, Prontor, Zeiss-Ikon, Klio, Gauthier, Derval, Telma shutter. $34. USA. ($23, EUR).
Ikonta 6.5x11cm - for 2½x4¼" exp. on 116 rollfilm. An uncommon size. $20.
Ikonta 35mm - (522/24) - for 24x36mm exp. on standard 35mm film. Novar or Xenar lens, Prontor, Derval, Zeiss, or Gauthier shutter. $33. USA ($22. EUR).

Super Ikonta cameras:

Super Ikonta B - (530/16) - for 11 exp. 6x6 cm on 120 film. F2.8/80mm Tessar lens in Synchro Compur shutter. $99.
Super Ikonta BX - (533/16) - Similar to the "B", but with dual range meter. $124.

Super Ikonta C - (531/2) - for 8 exp. 6x9cm, (2¼x3¼") on 120 film. Tessar or Novar f3.5/105mm. Compur shutter 1-500. $73. USA, ($139. EUR).

Super Ikonta A - (531) - ca. 1950's, for 16 exposures 4.5x6cm on 120 film. Tessar, Xenar, or Novar f3.5/75mm lens. Compur Rapid shutter. Coupled rangefinder. $86.

Super Ikonta D - (530/15) - for 6.5x11cm, (2½x4¼") exp. on 6l6 film. Tessar or Triotar f4.5/120mm. Compur Rapid or Klio shutter. Coupled rangefinder. Uncommon size. $133.

Miroflex - ca. 1930's focal plane SLR:
6x9cm - **(859/2)** - Tessar f3.5 or 4.5. Focal plane shutter to 2000. $125.

Kolibri - **(523/18)** - ca. 1930. For 3x4cm exp. (half-frame) on 127 film. Telescoping front. Tessar f3.5/50mm in Compur 1-300 sh. Made only a few years. $152. ($216 EUR).

9x12cm - **(859/7)** - Tessar f4.5/165mm lens. FP shutter to 2000. $170.

Nettar - folding cameras for 120 film: Made in 2 sizes: 4.5x6cm (512) and 6x9cm (512/2). With Novar or Nettar f4.5 or 6.3 lens in Compur shutter 1-250. $25. USA ($15. EUR).

Nettax - **(538/24)** - ca. 1937. 35mm camera similar to the earlier Super Nettel, except that it has a collapsing lens mount rather than the bed and bellows. It is like a cross between the Super Nettel and the Contax. Novar f4.5 lens. Focal plane shutter. $144.

Night Kolibri - ca. 1931. Same as the Kolibri, but with f2/45mm lens. (rare) ($600. EUR.)

Maximar cameras:
Maximar A - **(207/3)** - For 6.5x9cm plates. ca. 1940. Tessar f4.5/105mm. Compur sh. Double ext. bellows. $49. ($69. EUR).

Maximar B - **(207/7)** - ca. 1940. for 9x12cm plates. Double ext. Bellows. Tessar f4.5/135 lens in Compur 1-200 shutter. $46.

Nettel (Super) - **(536/24)** - Folding-bed horizontal style 35mm. Tessar f3.5 or 2.8/50mm. Focal plane shutter to 1000. Self-erecting front via cross-struts & bellows. $155.

Nettel (Tropical) - Fine wood folding cameras with brown leather bellows and nickel trim. Tessar f4.5 lens and Focal plane shutter to 2000.:
6.5x9cm - (871/3) - $225.

10x15cm - (871/9) - ($660. EUR).

Orix - (306/9 and 308/9) - folding plate cameras for 10x15cm plates. F6.8 Goerz, or f4.5 Tessar lens in Compur shutter. $115.

Palmos cameras - *Made by Carl Zeiss before the merger which formed Zeiss-Ikon.*
Minimum Palmos - ca. 1902. Wood bodied folding plate camera for 9x12 plates. Zeiss Tessar or Goerz Dagor lens. Focal plane shutter. Red leather bellows. Black leather covered body. ($180. EUR).

Universal Palmos - ca. 1898 folding camera 9x12 or 10.5x16.5cm size. With lens and shutter. ($136. EUR).
Stereo Palmos - ca. 1905. For stereo exp. on 9x12cm plates. Tessar f4.5/75mm lenses. Variable speeds. Black bellows. ($315. EUR).

Picolette - (545/12) - ca. 1927. For 4x6.5cm exposures on 127 rollfilm. Tessar f4.5/75mm. $56.

Nixe - folding cameras for rollfilm or plates. Various sizes from 2¼x3¼" through 3¼x5½". Prices widely scattered, many sellers "fishing" for high prices. Keeping this in mind, you may find the averages useful:
$60. USA ($41. EUR).

Onito - ca. 1927. 6x9cm size (126/2) and 9x12cm size (126/7). Novar Anastigmat f6.3. Derval shutter 1-100. $31.

Sirene - (135/5) - folding sheet-film camera for 3¼x4¼" exposures. F6.3 or 4.5/135mm lens. $24.

Taxo - (122/3) - folding sheet film camera for 6.5x9cm exp. $17.

Taxo - (122/7) - similar. for 9x12cm films. Novar f6.3/135. Derval shutter. $20.
Taxo - deluxe model - (126/7) - With radial focus lever on bed. 9x12cm size. $45. USA, $75. EUR.

Taxona - ca. 1950. *The Taxona is the DDR successor to the pre-war Zeiss Tenax.* For 24x24mm exp. on 35mm film. Novenar or Tessar f3.5 lens. Tempor 1-300 sh. $26.

Tenax I - ca. 1938. 35mm camera for 24x24 mm exposures. Novar or Tessar f3.5 lens. Compur shutter 1-300. $52.

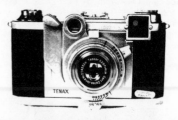

Tenax II - Interchangeable lens model, using the same bayonet system as the Nettax, and appearing much like the Nettax. f2 Sonnar or f2.8 Tessar. Compur Rapid shutter 1-400. Coupled rangefinder. $60. ($165. EUR)

Trix - (185/7) - 9x12cm plate camera. Double Anastigmat f6.8/135mm. Dial Compur. $35.

Trona - folding plate cameras:
6.5x9cm - (210/3) - f4.5/105 Tessar. $18.
9x12cm - (210/7) - f4.5/135 Dominar. $25.

Volta - folding plate cameras:
6.5x9cm - (135/3) - f4.5/105 Dominar. $20.
9x12cm - (135/7) - f6.3/135 Novar. $20.
Deluxe model - with radial focus lever on bed. (146/3, and 146/7) - $48.

Werra - ca. 1955. 35mm made in East Germany. Tessar f2.8/50mm. Compur Rapid 1-500. Self-timer. Olive green leather. $24.

ZENIT - (Russia)

Zenit 3, Zenit B - 35mm SLR cameras. $48. Including one of the various "normal" lenses.

ZENITH EDELWEISS - folding 620 rollfilm camera. $8.

ZENITH KODAK - see Eastman.

ZENOBIA - see Daiichi Kogaku.

ZION (Ed. Zion, Paris)

Pocket Z - Folding camera for 6.5x9cm plates. Rex Luxia or Boyer Sapphir lens. Dial Compur shutter. Leather bellows. Metal body. $60.

ZORKI - (USSR)
35mm cameras, copies of various Leicas.
Zorki - ca. 1952. Leica II copy. F3.5/50mm. Industar or f2/50 Jupiter. $39.
Zorki C - Leica III copy. $30.
Zorki I - Leica IIIa copy. $75.
Zorki III - f2.8. CRF. $59.
Zorki IV - ca. 1955. Jupiter f2/50mm lens. FP shutter 1-1000. CRF. The most common model. $61. ($38, EUR).
Zorki V - $35.

Notes:

Notes:

Notes:

Notes: